FASHION RENDERING WITH COLOR

Written and Illustrated by

BINA ABLING

Prentice
Hall

Upper Saddle River, New Jersey 07458

Library of Congress Cataloging in Publication Data

Abling, Bina.
 Fashion rendering with color / Bina Abling.
 p. cm.
 ISBN 0-13-014460-6
 1. Fashion drawing. I. Title.
TT509 .A245 2000
741.6'72—dc21

 00-039192

Publisher: Dave Garza
Director of Production and Manufacturing: Bruce Johnson
Acquisitions Editor: Neil Marquardt
Marketing Manager: Ryan DeGrote
Editorial Assistant: Susan Kegler
Managing Editor: Mary Carnis
Production Liaison: Denise Brown
Production Editor/Interior Design: Laura Cleveland/WordCrafters
Composition: Publishers' Design and Production Services, Inc.
Art Director: Marianne Frasco
Cover Design: Liz Nemeth
Cover Art: Bina Abling
Printing and Binding: Banta, Eden Prairie, MN

Prentice-Hall International (UK), Limited, *London*
Prentice-Hall of Australia Pty., Limited, *Sydney*
Prentice-Hall Canada, Inc., *Toronto*
Prentice-Hall Hispanoamericana, S.A., *Mexico*
Prentice-Hall of Japan, *Tokyo*
Prentice-Hall Singapore Pte. Ltd.
Editora Prentice-Hall do Brasil, Ltda., *Rio de Janeiro*

1 0 9 8 7 6 5
ISBN 0-13-014460-6

DEDICATION

As a child I drew whenever I could on whatever was available. Crayons and colored pencils were precious objects of fact and fantasy. I drew what I knew and what I didn't I drew anyway. To me then, and now, a blank page was the bearer of unlimited potential. Hard to say, back in those years, if I had talent—but I did have drive. It took me a long time to learn all of this but it was knowledge that I wanted. So I drove myself to realize my own potential.

Along the way I was inspired by the works of fabulous illustrators like Barbara Pearlman and Antonio Lopez. Teachers like Fred Brenner gave their talent and energy to encourage me. Women of strength and character—my aunt Betty Kelly and my mother-in-law Elaine Gross—lovingly embrace my career. My husband, Fred, happily applauds my success. Success is still feeling like a kid with crayons who loves to draw whenever, wherever I can.

CONTENTS

Chapter 1
Introduction to Media Choices 1

This chapter introduces the tools and materials for fashion illustration and design in both marker and watercolor rendering. The characteristics of most of the media choices are given a brief visual application for easy identification. This chapter introduces all of the supplies that will be used in this book.

Chapter 2
Line Quality 13

This chapter demonstrates the pen and pencil development of line quality. This visual definition builds on the introduction in Chapter 1 and is a bridge to the technique of line holding in later chapters. The outline contour is the basis for line quality and is the foundation for all sketching.

Chapter 3
Flesh Tones 23

This chapter shows the first step in rendering fashion flesh tones in both marker and watercolor. It explores the full range of coloring fashion beauty for the industry. It demonstrates the relationship between fabric choice and flesh tones; for example, a fabric with a dark color value may look best next to a warm skin color of a lighter or darker tone.

Chapter 4
Solid Color Fabrics 45

This chapter teaches you how to explore solid-color fabrics using one color plus shading. You will learn how to work with light sources from different directions—or without a source—and to create shading using solid colors.

This chapter shows you how to render summer-weight transparent fabrics with flesh tones underneath. It introduces techniques for rendering white fabric on white paper and on colored papers. The chapter reviews some of the shading techniques from the preceding chapter and shows you how to adapt them to new looks.

This chapter focuses on simple prints in spring weights, particularly warm-weather fabrics with patterns on a white background. Learning to illustrate easy geometric prints is the key to developing more complex prints and provides the skills you need to do more intricate rendering.

This chapter introduces rendering techniques for heavyweight, cold-weather fabrics. It shows you how to develop the surfaces and textures of winter weaves. It also shows you how to incorporate more complex mixed-media rendering into your illustrations.

This chapter covers rendering knits in textures for all seasons. It provides a basic introduction to yarn types as illustrated in garments. Marker and watercolor techniques are used to create solutions for surface interest in machine- and hand-knit fabrics.

PREFACE

This book is a blend of my career and my hobby. Business and pleasure merged into writing and drawing for a living. Add to this the bonus of being a teacher who helps students whose goals are the same as mine. For me, sketching is a passion, an art form, and a paycheck.

If you are reading this book, you know that the skills in your mind are far ahead of your hand. You know that you are ready to create more for yourself but you need to know how to do it faster, better, and easier. You are ready to take your talent further.

The information in this book will give you the confidence and the expertise to explore your own imagination, your creative sources. I want you to be inspired to follow your fashion direction, in any media, in a single sketch or for a whole portfolio. This book is about your drawing style, not mine. By the end of Chapter 11 you will have a stronger definition of what you want to draw and how you are going to do it.

This book is about the business of rendering for fashion. Its purpose is to turn a difficult job into an easy one once you know the basics. Time-saving rendering techniques are translated into the art of doing a sketch quickly as well as beautifully. The structure of this book was designed to give you a crash course in coloring. It's a bit like mixing kindergarten freedom with college-level controls.

The first chapter gives you a brief rundown on the media choices in this book. It's all about options; you won't get locked into any one direction here. The next two chapters on figures, flesh tones, and fashion faces establish some preliminary sketching and rendering techniques. Chapter 4 builds on those skills and translates them into solid, flat-color fabric rendering. It also introduces shading with or without a light source. The following chapters move on into other fabric choices, from spring to fall, from easy to more complex materials.

After you've assimilated the methodology, Chapter 10 shows you how other artists have put their skills to work. This chapter gives you a business focus for learning rendering techniques and shows how to turn them into your own style.

Chapter 11 delves into rendering for croquis. Croquis, also called roughs or thumbnails, are the true test of quick or partial rendering. They are the "briefs" versus a total "finish." Croquis are jotted down, rolling quickly onto the page, done in large or small numbers in a group. In a clip of 20 figures or 40 pieces, they speed up the rendering process because they represent ideas in a moment of inspiration.

This book is meant to be a source of reference as well as a manual for practice and development. Keep it along with all of your own work from these pages as a guide or as a reminder of how hard you worked to reach your goals.

CHAPTER 1

INTRODUCTION TO MEDIA CHOICES

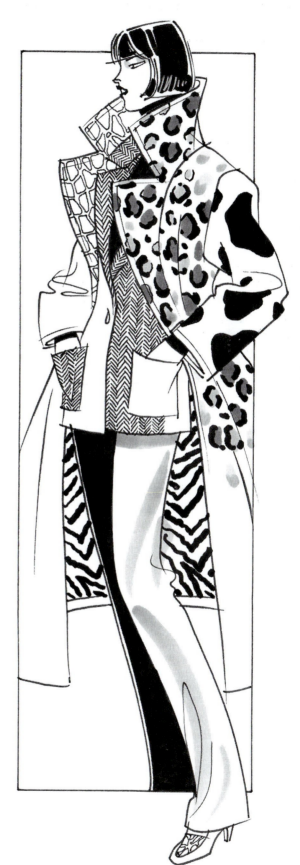

The goal of this book is to simplify basic rendering skills that are directly related to the fashion design and illustration industry. The skills that you will learn in this book are job-oriented rendering techniques. Rendering for the fashion industry is based on working quickly, meeting a deadline. Working on art in a time crunch means doing it as well and as fast as you can. This book will explore media options as career tools for today's market. Your artistic goals are beginning to divide between a fine arts approach and what is going to get the job done. It is not your creativity that is limited, just your time. Mixing business and art is not always easy, but it can be a lot of fun as a career choice. Perfecting your skills does get expensive as you go though all of the supplies that it takes to learn how to render. Success has a price tag. Consider it an investment in yourself as you purchase, practice, and improve on the media choices through trial and error. The total cost of creating a portfolio should be covered in your first week's paycheck. So imagine yourself on the job and visualize your new income. Feel better? I did.

PENCILS

Pencils come in a wide range of bodies and types of lead. Most pencils are bound in wood, but some are all graphite with a thin plastic shell. There are also different types of cartridge (lead) holds with or without eraser tips that you buy separate leads for. Pencil leads come in three properties: H for hard (more compressed), B for soft, and HB for a mixture of both. You need to use practice and experience as your guide to buying pencils. Test out a variety of them before you decide on just one. HB leads are great for a bold, dark line, while 4H leads create a subtle light line. One pencil can perform both bold and subtle lines, based on talent and control, but it is important to know their possibilities. You want to understand and evaluate their range for similarities as well as differences.

Another factor to consider in pencils is their vulnerability to breakage. Their leads are fragile. Drop a pencil and it may fracture the interior lead so that it will break or splinter when sharpened. Store them properly and buy the right type of sharpener based on the width of the pencil or the size of the lead that fits into the cartridge holder.

Here are some generic types of pencils that are suitable for fashion design illustration.

1. **Mechanical.** A cartridge holder in pen form that carries individual leads in a click or feed system.
2. **Wood body.** This is the most common form of pencil. Always sharpen the opposite end from the label, otherwise you will lose its H or B definition.
3. **Graphite or ebony.** All-lead pencils encased in a thin plastic shell or coating. This thicker lead can be sturdier.

Pencil properties are determined by the compression or contents of their leads. Their ability to display texture is based on pressure and release in a drawing technique.

1. **Hard leads** (H) make a lighter, thinner line with less smudging ability. They range from 2H up to 12H or so for increasing hardness and lightness in line.
2. **Soft leads** (B) make a darker, thicker line with the ability to smudge. The range is from 2B up for increasing softness and density in line.
3. **In between leads** (HB) make a line of middle value of dark and light. It is in between soft and hard.

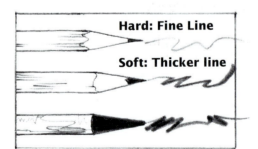

Plastic Casing, All-Lead Pencil

Hard: Fine Line

Soft: Thicker line

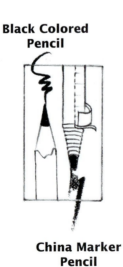

Black Colored Pencil

China Marker Pencil

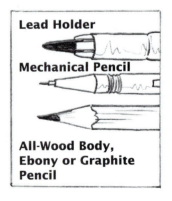

Lead Holder

Mechanical Pencil

All-Wood Body, Ebony or Graphite Pencil

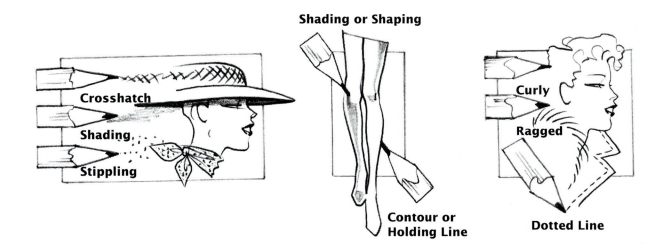

Shading or Shaping

Crosshatch

Shading

Stippling

Contour or Holding Line

Curly

Ragged

Dotted Line

COLORED PENCILS

Colored pencils usually come in all-wood bodies. All major brands perform consistently and come in three categories.

1. **"Thin" colored pencils** are capable of a finer line than regular colored pencils. Compare the lead widths of thin and regular pencils by looking at the ends of the pencils.

2. **Regular colored pencils** have definite differences in thickness. These pencils make a coarser, broader-based line than the thin ones.

3. **Water-soluble or watercolor pencils** produce as fine a line as the thin colored pencils. They react to and blend with water, while the others will not. To create the desired effect, water can be added before or after coloring with these pencils.

Some styles of drawing have names like cross-hatching, stippling, and shading. Cross-hatching is a vertical over horizontal structure of lines. Stippling is done with a series of dots in a random or sequential pattern. Shading happens by dragging the side of your pen or pencil back and forth or by smudging your line to create a contoured form or shadow. Texture can be created in line through rounded, curly shapes or by ragged sharp lines or through short, abbreviated dashes as you skip your line across the page.

Erasers come in two basic forms, in any size. Grey putty erasers can be molded or pulled into any shape to be cleaned for reuse. They do not leave shavings on the page. The second form is a plastic or hard rubber eraser. It is firm and flexible, but keeps its shape. It does leave shavings on the page. The putty eraser lifts a pencil line off the page. The plastic or rubber eraser strips away the line, but with overuse it can remove some of the paper's surface as well.

MARKERS

Markers can be a lot of fun, but choosing the right ones can be confusing. There are new brush types and many options in nibs, points, and wedge tips, not to mention refills. You have to judge their merits based on trial and error within the context of paper choices. Preference can be based on cost or performance. It also depends on the amount of coverage or space to fill on a page that defines pencil lines. But, through practice and application, you will discover which markers work the best for you.

Keep in mind that it can be a problem to mix different brands of markers together in a sketch. Coloring in separates or units in a sketch might be fine, but blending one on top of another could be difficult (but not impossible) to control due to the different chemical content in different brands of markers.

You should be aware that markers have a definite odor because of their chemical content. Try working in a classroom or an office where lots of markers are being used and you will understand the need for proper ventilation while using this medium.

Make sure the top is on tightly after you have finished using any marker. Some tops make a clicking or snapping noise so that you know that they are on completely. Uncovered markers spill or dry out and become useless.

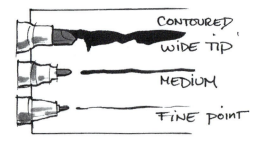

PENS

Pens, like all of the other drawing tools, must be comfortable in your hand, dependable on your paper, and bleed-proof next to other media. The comfort depends on the manufacturer's design for grip and your drawing hand position. To find the pens that suit you buy a variety and practice with them. Two other factors to consider are the volume of ink and the pen point. The best way to control the volume of ink is to buy a pen with refills. You must test the pen point to prove to yourself that it can hold up under steady use. Some pens can't; their points or nibs fuzz out, get scratchy as the point recedes into the pen's body, or bend and break off. It is also essential to determine how bleed-proof the ink is next to other media, regardless of the manufacturer's advertising promises.

You have to test it out in a practice sketch before applying any pen in a final, finished sketch. Remember that each pen's ink may, after use, have a different reaction to different markers, depending on their chemical content. Sometimes, as you'll learn in the following chapters, it is just a matter of letting one pen line dry before applying the next.

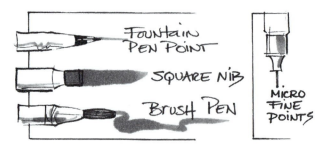

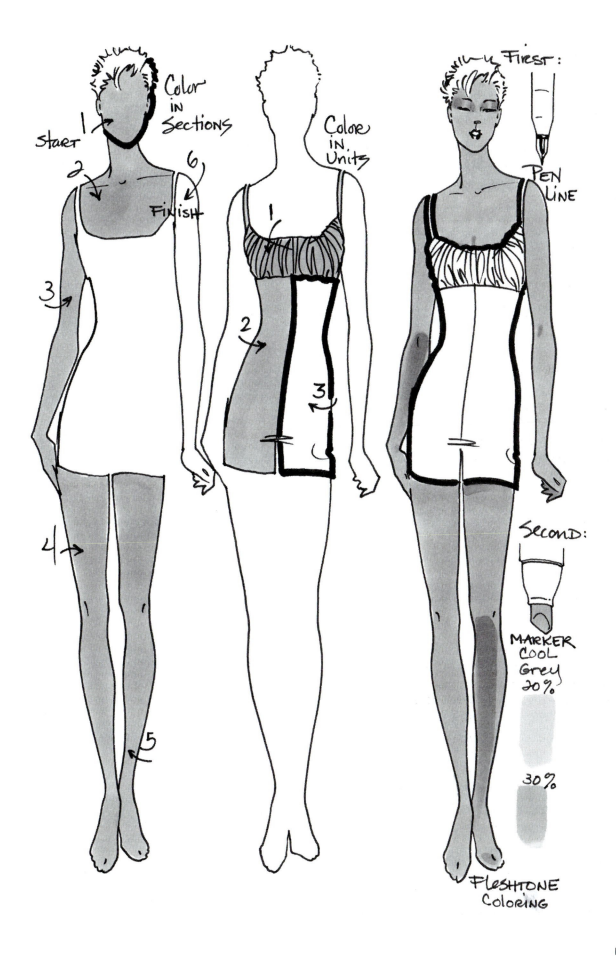

Color in Sections

Start

Finish

1
2
3
4
5
6

Color in Units

1
2
3

First:

Pen Line

Second:

Marker Cool Grey 20%

30%

Fleshtone Coloring

PAPERS

Papers come in a variety of forms: in pads of determined sizes or as single sheets purchased individually. They carry a classified weight measured in pounds per ream (500 sheets) and have two basic categories of surface characteristics. A 30-pound paper is thinner and less firm than an 80-pound paper. There are lighter, finer weight papers. Then comes crisper, heavier cover stock papers, and after that you are into boards. The two basic categories for papers are hot press and cold press. Hot-pressed papers are smoother and have a more polished, glossier surface. The cold-press papers have varying degrees of pebbled or rough-textured surfaces. These surfaces have names like a "vellum finish." Papers are labeled for their content, color, and use. Content information includes percentage of recycled fibers. Content also includes PH balance (acidity), or the paper may be archival (acid-free) and will not yellow with age. Labels also state if the paper is good for marker or watercolor use. You must read the label on the pad or paper to guarantee performance.

For the fashion industry, the most common papers include tracing (overlay sheets) paper, vellum (a better grade tracing paper), all-purpose paper (for preliminary sketching), and quality fine papers (for finishes or portfolio). There are myriad other choices in papers for all types of illustration. Those mentioned are just a beginning—an introduction to the range—and are not exclusive to the suggested uses discussed here.

Tracing papers. Cloudy tissue-like transparency but firmer, stronger paper. They come in at least two weights, some thicker than others. Parchment tracing paper is another type that is crisper, less flexible. All can be used for overlays, correction, and rough sketching.

Vellum papers. Heavier in weight, still a bit transparent, with milky white coloring. They can be more durable and more expensive than tracing papers. They can be used for all preliminary sketching and serve the same purpose as tracing papers.

All-purpose papers. Basic bond paper of medium qualities with varying levels of performance and durability. Middle- to light-weight papers can be used for multiple rough drawings or for croquis books for sketching ideas.

Marker papers. All brands have differences in performance level as well as a definite front to back page reaction to markers. The top side (front) responds to markers. The flip side (back of page) does not in most pads. Some of these pads are more transparent than others due to the weight of the page.

Watercolor papers. Sold in pads or by the sheet, these hot-press or cold-press surfaces have two ranges. One is for fine art use and is too rough or pebbly. The other is just right for fashion illustration because it's smooth enough to take line as well as paint. Look for medium or vellum "finishes"—something that is not so slick or shiny that it won't take watercoloring well.

WATERCOLORS

There are four basic types of watercolors to choose from when rendering a fashion sketch. They are dots or square cakes, tubes of gouache, jars of tempera or poster paint, and, of course, bottles of ink.

The dots or square cakes of watercolor usually come in sets ready to handle water. Their colors on the page are often transparent and are described as translucent. Gouache comes in tubes and needs to be mixed on a palette. Although gouache can be diluted enough to look transparent, its coloring is usually referred to as opaque; you don't see through it on the page. The dots and square cakes are best mixed in small quantities to cover smaller areas in a sketch. Gouache can be mixed in any vol-ume and is good for large areas in a sketch as well as smaller ones.

Tempera or poster paints in jars or in powder form (like some metallic mixes) are also described as opaque in coloring. This type of watercolor is viscous and thick. It can be used as is or diluted. Inks, like dyes, are intense in concentrated form. Their colors can be incredibly brilliant as well as translucent.

These four types of watercolors can be easily blended together to achieve a wide spectrum of coloring. Gouache is often used as a base with dabs of tempera or a drop of ink mixed in. The range of colors in gouache makes it best suited to match to fabric colors in a sketch.

BRUSHES

Brushes are made with a variety of tip shapes, shaft lengths, and tip fiber content. For fashion design illustration, rounded, pointed tips are the first choice. The flat, fanned, and filbert tips are used as back-ups for novelty effects or broader cover-age. The shaft length is for balance and weight. Since our work is closer to the page (as opposed to further away from a canvas), shorter lengths are preferred. Fiber content runs the gamut from man-made to natural, and factors into the price of your brush. A well-made natural fiber that is properly cared for can last for years, so the cost factors out over the life of your brush. Natural fibers are the hairs of camel, squirrel, sable, and so on. Some are blended. Sable brushes are considered bet-ter, but that is up to you. Some of the man-made fiber brushes are fine depending on the job, however they can stain even after being rinsed clean. The stain will not inter-fere with the brush's performance.

A good middle-priced brush should have some "body" to it, meaning that it re-sists bending over to the touch. Brushes without body will easily flop over or sag to the touch.

The tip size of brushes is indicated by numbers. A zero or #1 brush will be finer and tiny, while a #8 will be quite full at the tip.

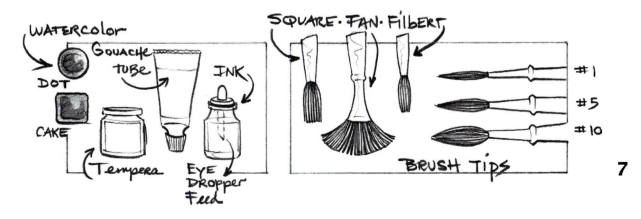

Mixing

To mix a color in a consistent, even tone, balance your ratio of water to color in equal parts. Too much water overly dilutes a color and looks wet on the page. Too much pigment in a mix and your painting will streak and look thick or gummy. Mix the water and paint together gently. Heavy stirring or overmixing will create bubbles that ruin a flat wash.

Coloring

You can paint directly off of the top of a dot or cake. Put a drop of water on top of the watercolor cake to dissolve its hard, coated surface. Painting from the wet top of a dot or cake gives immediate, albeit uneven, coloring. Gouache and poster paints work best when mixed with water before use. Inks are too intense before mixing with water. All of the watercolor types can be mixed on a palette first for an even, consistent color in any volume.

Brushes

Brushes need care and careful storage. New brushes usually have a stiff coating layer that will rinse off. Never leave your brushes sitting in water or paint and always rinse the paint off of your brush. The bristles are delicate; they can bend, fray, and break off if neglected. After use and a rinse, realign the tip of the brush with your fingers. Smooth the sides of the bristles back to their original shape.

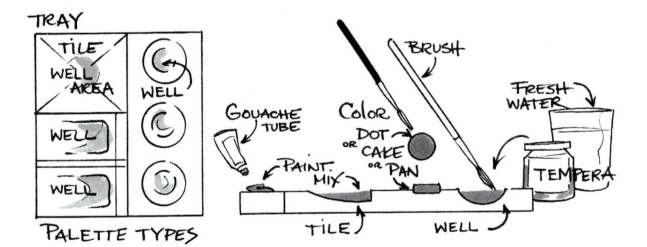

Palettes

Watercolor palettes often consist of square, round, or rectangular white plastic trays. They have tile or bowl shapes that form wells to hold different amounts of your watercolor mixtures. These different sizes, widths, and depths accommodate anything from the smallest job to a large one. A palette should give you room to create a well of consistent color in a pool of water to color ratios. Multimedia mixes—when you combine inks with gouache, for instance—can stain the palette but that will not cause problems as long as it is cleaned properly. When rinsing and cleaning, do not use an abrasive cleanser; it will leave a residue that could ruin your next mixture on the palette.

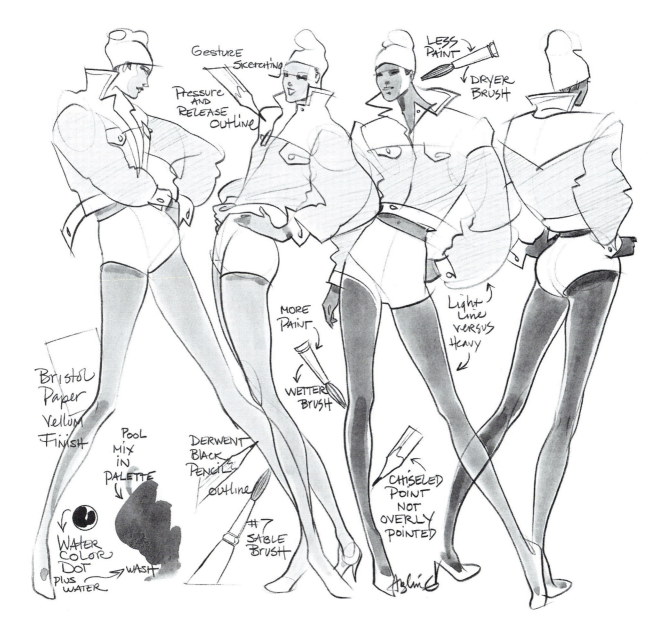

DESK TOP

You can use a flat-top desk, tilted easel, or art table that is a combination of the two. The slanted surface offers optimum working conditions because it can free up your hand. The slanted desk or easel helps you to draw from your shoulder, which creates a more fluid, looser hand motion in line. Sketching on a flat-top desk is fine but it often leads to the tight finger positions used with handwriting as you lean into the page instead of away from it. As in writing, resting on your elbow slows down your drawing. So work in a position that frees up your arm.

Drawing is a skill, a technique that is separate from the skill (or art) of handwriting. You should be looking up over your table or easel when sketching from a model or a reference pose in a book or a photograph. You'll think less and react more to the visual image instead of concentrating on a word or specific spelling as in writing. To attain model drawing's creative edge in fashion, you need to be far enough away to see head to toe yet close enough to discern the face.

Your supplies—pencils, brushes, and so on—should be placed on the same side as your drawing hand. This way you won't lean over and smudge or spill something as you reach across your sketch. Conversely, your light source should be on the opposite side of your drawing hand so as not to cast shadows (from your drawing arm) across the page. If you're buying a lamp, look for one with full spectrum bulbs or get one with a combination of incandescent and fluorescent bulbs to maximize your light but minimize eye strain that comes from artificial lighting.

Light boxes help you to see through (most) opaque papers so that you can transfer an image. That image might be your original sketch or a rough image that you wish to transfer, correct, or change onto a finer (thicker) paper for a finished drawing. Tracing should never involve copying someone else's work. To use the light box, delicately tape your first page onto the glass. Lay the second sheet of paper on top of the first and lightly tape them together. Do this so that your image doesn't shift, slip, or move as you are redrawing from your original.

Flat files are designed to store pads and paper. They can keep your work smooth, flat, and away from harmful light. (Keep all papers away from heat as it will make them brittle.) Do not leave your pads open or stacked haphazardly, leaning sideways ready to warp. Lay the pads or drawings in a stack with the largest on the bottom. Uneven stacking leads to bent papers that are vulnerable to creasing and wrinkling.

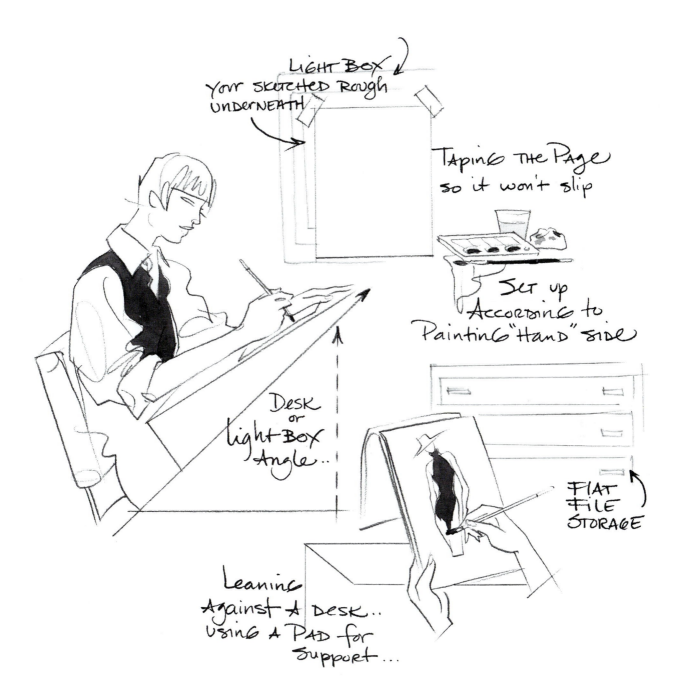

LIGHT BOX

Your sketched Rough UNDERNEATH

TAPING THE PAGE so it won't slip

Set up According to Painting "Hand" Side

Desk or Light Box Angle...

FLAT FILE STORAGE

Leaning Against A Desk... using A PAD for Support...

11

SUPPLIES

Create a log for yourself listing what supplies you have and where you purchased them; include the price. Your supplies are crucial. When starting an assignment, you don't want to suddenly run out of a color or realize that you do not have a good pencil sharpener. Have backup supplies such as an extra water cup or a second palette. Make sure that you have enough paper or that the pads have more than three sheets left in them. The store where you bought your supplies is important, especially if you have found that each store in your area carries different items. If you shopped out of your area, find out if they will deliver. Get a catalogue. Learn to ask for supplies by name type or brand name. For example, certain companies that make markers or gouache label their blues with a variety of names. Where did you get your palette? What do you ask for if you need a new one? Be specific if you need a pen . . . which one? Price is another factor. It is important to know how much your supplies are going to cost if you have to price out a freelance job.

ASSIGNMENT

Create a reference page. Take one sheet or a page of paper to test out the range of your media choices and your style options. Try out thick, thin, soft, and light lines. Practice some cross-hatching, shading, and stippling textures. Familiarize yourself with the variety inherent in different types, brands, and prices of art supplies. Eventually, every artist finds his or her favorite pens, pencils, papers, and so on through trial and error. It just takes practice. Practice at this stage should be considered reference as you research these options.

CHAPTER 2

LINE QUALITY

Sketching involves drawing a series of lines. These lines have a visual impact, and the perception of these lines is described as bold or delicate, energetic or static, and so on. These descriptions are referred to as line quality. Interpretations of line quality are relative to individual styles and media choices.

Often the lines in a sketch are a mix of pressure and release of your pen (pencil, etc.) on the paper as you draw. More pressure on the pen creates bolder, darker lines in a sketch. Releasing pressure turns the same line into a lighter, more delicate stroke on the page. Together pressure and release create a variety in your line as you are sketching. To master line quality, keep your drawing looking spontaneous, fresh, and lively on the paper . . . whether it took five minutes or three hours to do. A sketch without line quality looks dull, static, or traced which ultimately means boring. Monotonous lines are for clarity as in writing but drawing lines should look immediate and new and have flair. The basic principle of handwriting (not including the art of calligraphy or fine art printing) is to keep your fingers to the page making short nicks in line. Drawing is the opposite: you draw from the shoulder moving your hand in broad strokes, gliding across the paper. One line is a task, the other is the performance. All lines are unique, like signatures, but line quality can be elusive. You either have it or you don't in any given sketch.

LINE QUALITY

Line quality is the vitality or energy in a line as you sketch. This energy brings the outline contour into focus on the page. It sets the pace for the visual impact of your drawing. For the watercolor section, you can work on your line quality through pencil. Explore the hard and soft as well as the light and dark lines in your sketching methods. To practice your line quality, you can:

- Work on tracing paper overlays to fine-tune your sketching line.
- Draw directly onto your paper for a spontaneous approach to your line.
- Start with a gesture to bolster the structure in your drawing as you define your line.

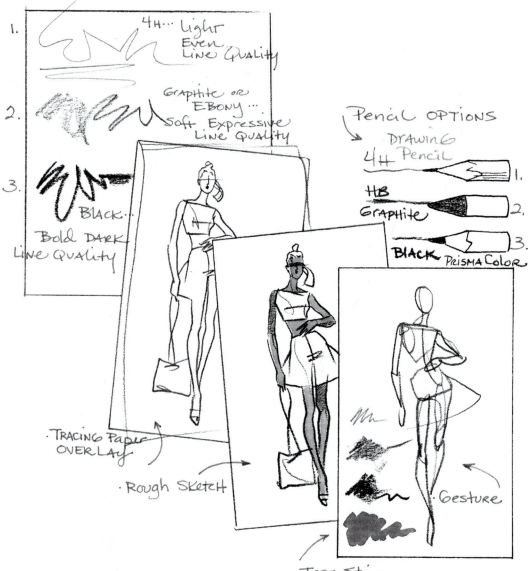

Another definition of line quality examines how tight or how loose a line becomes in a drawing method. A tighter line quality speaks to its precision or control. It can be a more formal line with a finished, structured look. A loose line quality creates a certain ease through a relaxed, informal look. It is a freer line. The results of using either type of line should appear effortless. The goal of line quality is spontaneous expression. The irony here is that you have to work very hard to make it look so easy. All line qualities vary in style and interpretation from artist to artist. That is the beauty of line quality; it is in the eye of the beholder.

1. This figure has a loose line quality and was done with a graphite pencil.
2. Black colored pencil was used on this figure for a combination of both lose and tight lines.
3. This figure has a tight, clean edge of a line.

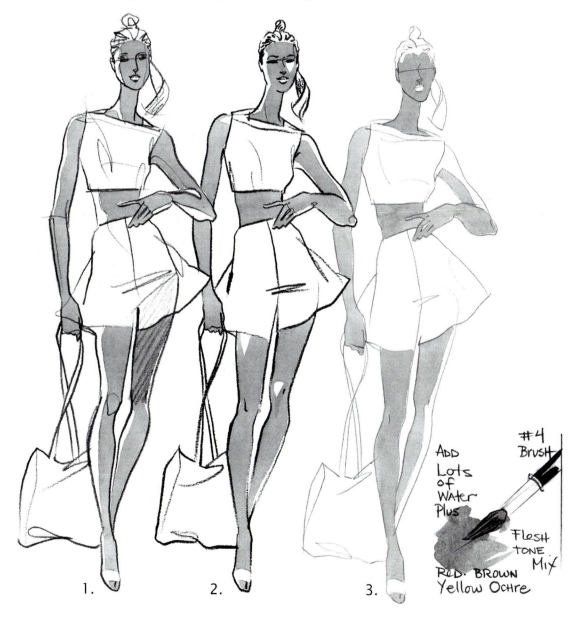

1.　　2.　　3.

ADD Lots of Water Plus

#4 Brush

Flesh tone Mix

RED. BROWN Yellow Ochre

OUTLINE CONTOUR

Outline contour refers to the edge of your drawing. This line edge is a border, it frames the shape and content of your sketch. It also defines the interior nuances and supplies a visual vitality. This vitality is called line quality. To express line quality in your outline contour, you need to explore your options. In this chapter the pen line options are illustrated for the marker portion.

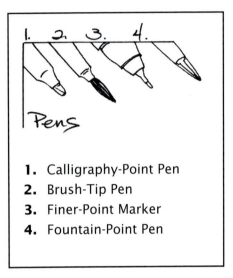

1. Calligraphy-Point Pen
2. Brush-Tip Pen
3. Finer-Point Marker
4. Fountain-Point Pen

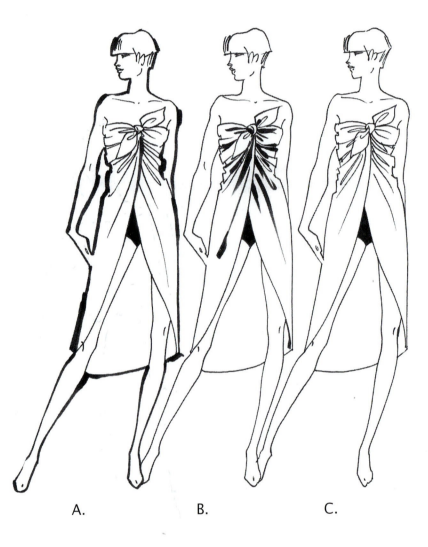

A. B. C.

A. A brush tip or a broader point can be used to establish a bolder silhouette, outlining the sketch in a thicker line.

B. Here the edge has been done in a finer line. The thicker line has been used to emphasize the interior instead of the exterior.

C. For this illustration, the fine line was used exclusively without a thicker line treatment.

LINE QUALITY INTERPRETATIONS

Line quality is the next phase for your outline contour. It is dictated by your sketching style and what you have to draw. Line quality is used to express style and visual messages in an instant of recognition. The example on this page is a fashion statement. The garment can be seen clearly on or off the figure in this style of drawing. This line quality expresses the nuances of the fabric and the fit of these garments in a specific pose. In fashion that is the goal in any type of personal drawing style.

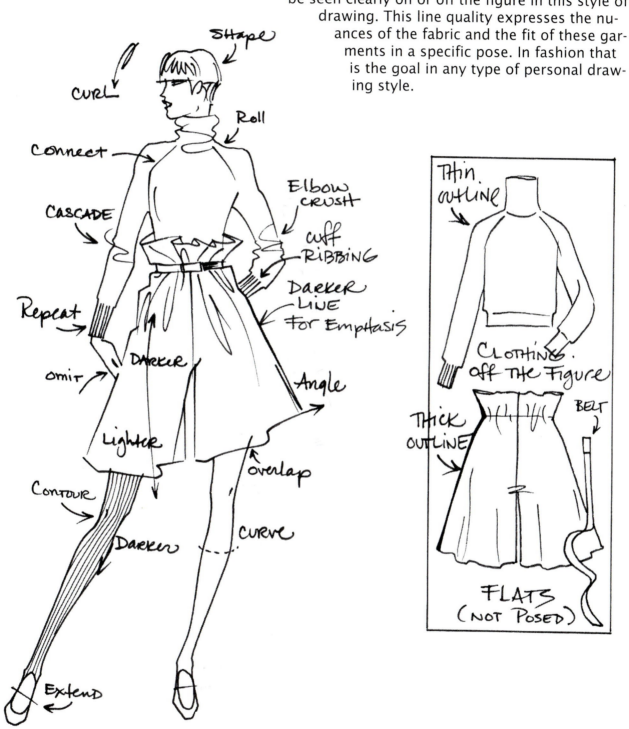

LINE CONTENT

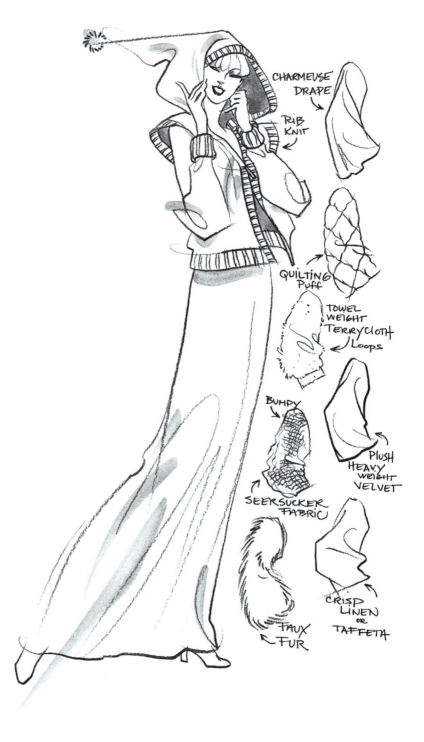

CHARMEUSE DRAPE

RIB KNIT

QUILTING PUFF

TOWEL WEIGHT TERRYCLOTH LOOPS

BUMPY

SEERSUCKER FABRIC

PLUSH HEAVY WEIGHT VELVET

CRISP LINEN or TAFFETA

FAUX FUR

Line content is another form of line quality. Content is the ability to convey variety in a line without the help of color or shading. The line quality references on this page communicate visually the variety of fabrics. Each fabric type in the illustrated examples has separate visual codes in line quality (content) that demonstrate their specific outline fabric nuances. All of these fabric were done in a pencil line, but it is not the media choice that creates the line quality. It is the content in that fabric's line, whatever the media choice may be. This is the way you need to practice line quality nuance for fabric varieties.

DESIGN DETAILING

Another function of line quality is to define the different aspects of design detailing in an outfit. The theatrical sketch on this page is an example of these functions. There are at least nine different aspects of this sketch that need definition through a variety in line qualities. They have been listed in isolation from the figure to exaggerate their definitions. All of this variety was performed by one specific pencil, but pen can do the same. For each separate unit of line quality distinctions, there is still a relationship to the whole picture. No one part distracts from the other. It is through line quality that you can create this instant recognition of a fashion statement in your sketch.

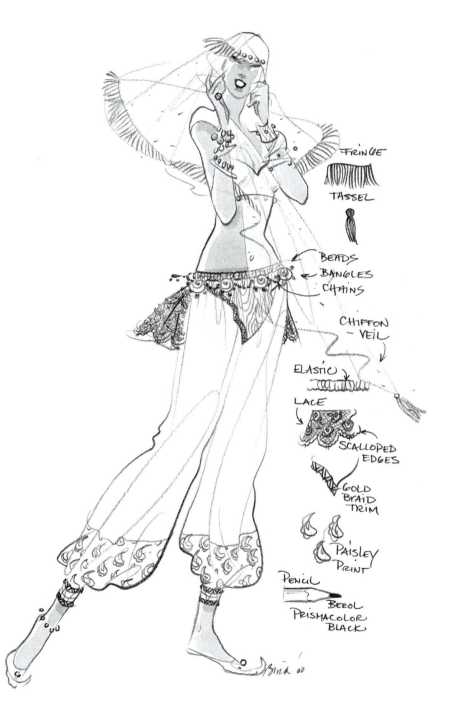

FRINGE

TASSEL

BEADS
BANGLES
CHAINS

CHIFFON
VEIL

ELASTIC

LACE

SCALLOPED
EDGES

GOLD
BRAID
TRIM

PAISLEY
PRINT

PENCIL

BEROL
PRISMACOLOR
BLACK

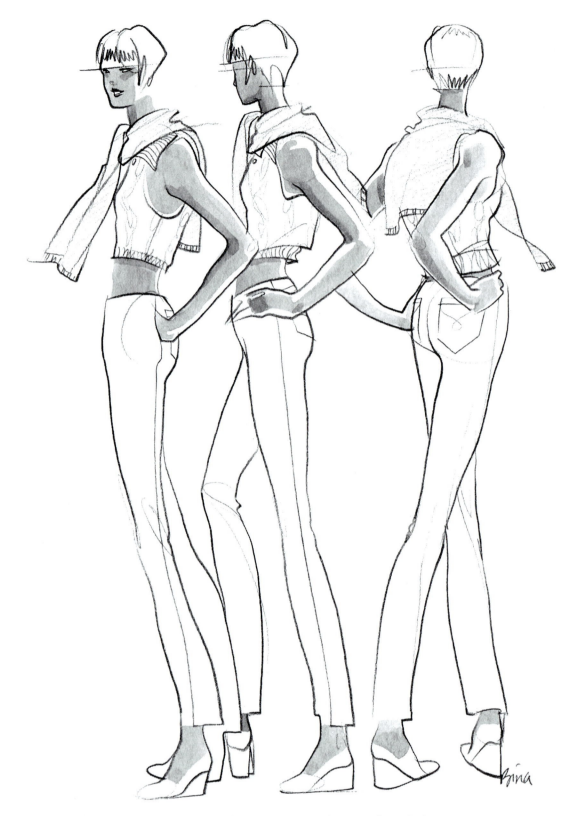

Line quality in pencil sometimes can be more elusive than it is in pen. Pen line is more constant and consistent in coloration and the flow of its ink. Pencil, on the other hand, gets its color and consistency from your hand, from the pressure and release by your hand as you draw.

20

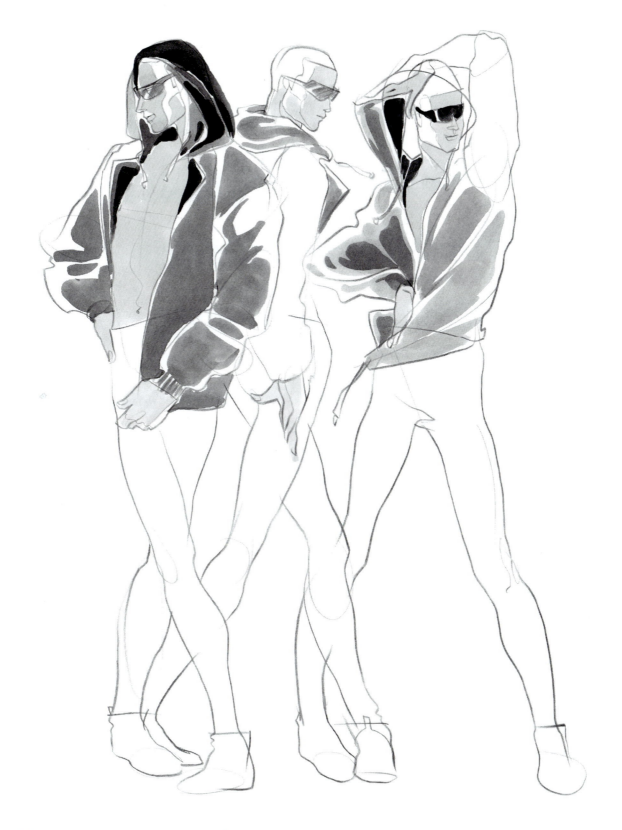

These pages show two sets of examples of pencil line quality mixed with a similar looseness in painting style that present one point of view in expressive line quality. In Chapter 10, several guest artists with other drawing skills will give you a broader view of style and the range in line quality for fashion sketching.

SUPPLIES

Marker paper pad: Bleed proof, 11 × 14

 Markers: Brand variety (different manufacturers)
 Broad or wedge tip plus fine-tip black

Watercolor pad or single sheets: Vellum finish, approximately 11 × 14

 Pencils: Brand variety; ebony—graphite
 Wood body or holder
 2B—HB—soft—2H—medium

 Colored pencils: Fine regular, black

Tracing paper pad: 11 × 14 (not parchment)

Brushes: #1 and #7 to explore a brush line

ASSIGNMENT

This will take two pages. The first is for experimental lines of discovery and control. The second page is for figure work, utilizing line for contour and visual impact. The first page should be an exercise of both light and dark lines. Some lines should be sharp, architectural, and angular. Other lines should be smooth, fluid, and organic. Some lines should merge the sharp edge and smooth one for a combination of the two. The second page needs pressure and release in the line as it creates the figure on the page. Try one figure stylized and the other in a classic, realistic version. Try to keep your line loose; it will look more spontaneous. Quite the opposite, a slow tight line can look dull and traced.

CHAPTER 3

FLESH TONES

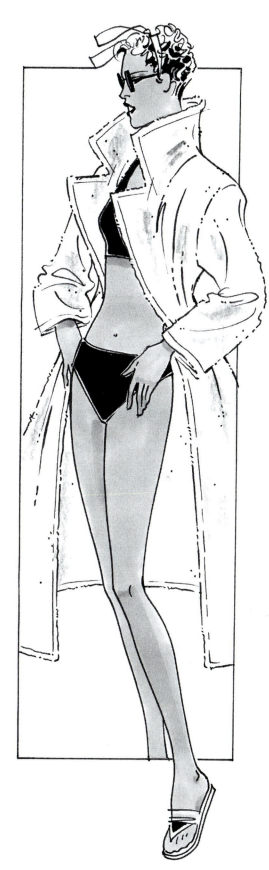

It is critical to acknowledge racial diversity when you learn to render flesh tones. Think of that when you are picking out flesh tone colors in paint or marker. Imagine all of the nationalities that you want to represent. You can begin with three or four flesh tone colors to practice your rendering. Add to these the secondary colors that you need to shade with on the body and your options begin to multiply.

Professionally, flesh tone rendering is under time constraints. To save time, many designers and illustrators select only one or two flesh tones especially for a large grouping of figures that needs to be done quickly. Another factor in the business of fashion is a fabric's color. You will learn to match your flesh tone, in a drawing, to the fabric so that it does not clash or fade away in comparison to it. For a fashion sketch that sells a garment, the flesh tone must compliment the outfit. (In a portrait, for example, it could be the other way around.)

This chapter will start off with preliminary work in half tones—greys that represent the color values of the natural coloring of flesh. You can easily translate any of the lessons in these greys into your choice of matching (value) flesh tone colors.

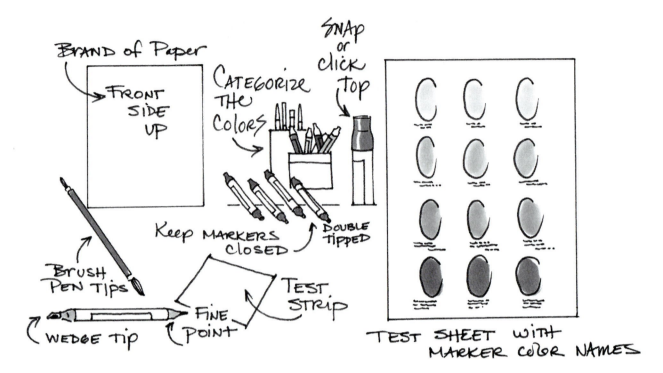

BRAND OF PAPER → FRONT SIDE UP

CATEGORIZE THE COLORS

SNAP or CLICK TOP

Keep MARKERS CLOSED

DOUBLE TIPPED

BRUSH PEN TIPS

WEDGE TIP

FINE POINT

TEST STRIP

TEST SHEET WITH MARKER COLOR NAMES

SETTING UP FOR MARKERS

Setting up for markers is quick and easy. Line up the markers either by color value or by category. For instance, separate those that are for the base colors from others that are for shading. You can also arrange your markers by colors for flesh tone and colors for rendering hair. How you line them up or bunch them together in a container is up to you. You just want to make sure that you don't reach for the wrong color in the middle of your rendering. You'll suddenly realize that you have ruined your sketch by switching colors by accident because you picked up the wrong marker. Remember to work on the top side of your marker paper. Save one sheet for a test strip as you identify each marker's color. Check the tip of your lighter colored markers to make sure that they have not been smudged with another marker's color value. Make sure to listen for a snap or feel a click as you replace the marker's cover. A tight cap on your marker will prevent it from drying out. When you are dealing with markers, you can easily work on a flat-top surface.

24

TEST SHEET FOR MARKERS

Creating a test sheet or page for markers is crucial. It will be your guide to which brand and what color of marker gave you a specific tone when you used it alone or in combination with another marker. The range of flesh tones in markers is not quite as wide as it is in watercolors; it still is limited to the manufacturer's selections. Set up your test sheet with about nine heads to explore your options. Make a list of all of your markers by brand and color name, for instance, desert tan, light tan, or suntan. Then write down which ones look best as the shading value, as in light tan shading on a sand base.

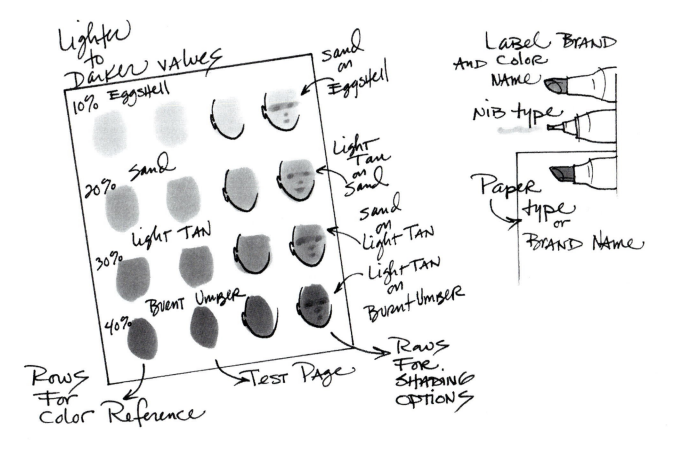

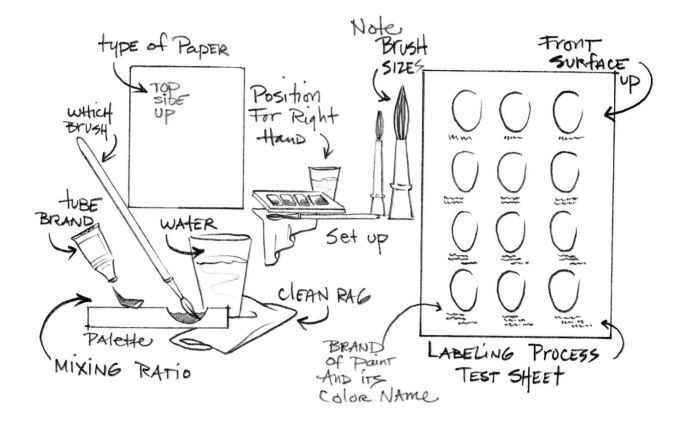

SETTING UP FOR PAINTING

The setup for painting takes longer and is more involved than that for using markers. You also need more equipment. The setup for painting includes the time it takes to mix the exact color that you want at the correct tint. For equipment, you need a palette, brushes, a rag for wiping the brushes, plus one or two water cups—one for rinsing and one for mixing. Next, line up the number of (as in gouache) tubes of paint that it takes to make your colors. Select the paper according to the surface. Make sure you are using it face up: the back of the page is the wrong side to paint on. Make sure that your palette is dust- and lint-free. It should have enough wells for multicolor mixes. A reminder: Never leave your brush soaking tip down in your water cup; it will permanently bend your brush tip. Set up your desk or art table according to left- or right-handed use so you don't accidentally reach over the page, spilling or dripping on the way over it. Right-handed painters set up on the right side and vice versa. While painting, it is best to work on a slanted surface.

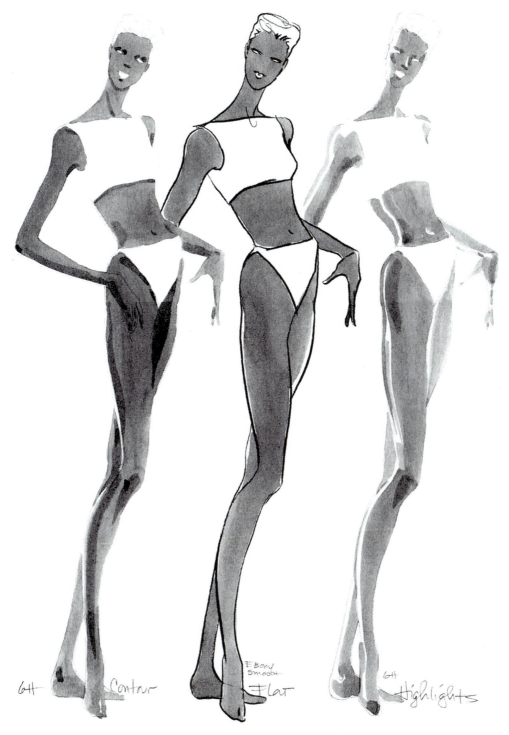

6H — Contour

Ebony
Smooth
Flat

6H — Highlights

You should also do a test sheet for paints. Label the brands of paper and paints as well as the color names. What is different here is that you may be mixing these names together, for instance Van Dyke born with a smidgen of yellow ochre or a bit of flame red. Next you want to do a test sheet on a completed flesh tone rendering to see how the brush, the color wash, and the paper are interacting. After you have more experience with mixing colors, you can then begin to practice different methods or styles in rendering flesh tones, comparing each style to the other with and without outline contour to get a feel for your finished or looser techniques.

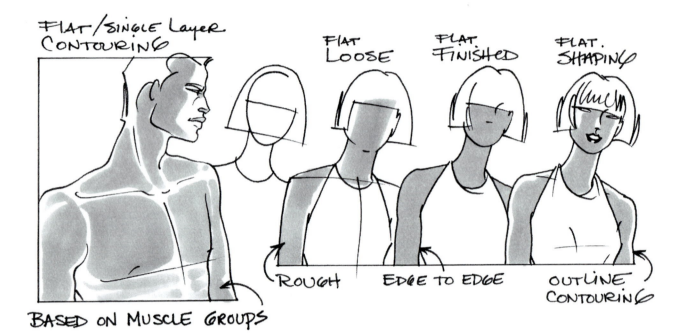

FLAT/SINGLE LAYER CONTOURING

BASED ON MUSCLE GROUPS

FLAT LOOSE

ROUGH

FLAT FINISHED

EDGE TO EDGE

FLAT. SHAPING

OUTLINE CONTOURING

RENDERING FLESH TONES

Rendering, as a coloring technique, is as open to styling as a line drawing. There are lots of options to interpreting flesh tone color placement on the fashion figure. This is how different styles become individual looks. To simplify flesh tone rendering, I have chosen less complicated basic styles that should be easy to practice. This gives you a place to start without overwhelming you with technique and gives you time to let your own style evolve.

Flesh tone can be colored in on the body in sections imitating the contours of the muscles. It can be rendered totally flat, edge to edge up to the outline. You can also render your flesh tone by shaping it subtly on one side. You shape it along the interior of your outline. Another version of flesh tone rendering is to match it to a loose croquis sketch which can accommodate rougher flesh tone placement. The croquis is a quick sketch that has that unplanned look to it. One the other hand, a finished sketch that is drawn with more precision is given tighter rendering with the flesh tone. This sketch looks more finalized; polished rather than rough in comparison to the croquis version.

Now that you have agonized over learning how to render a flawless, perfect flesh tone in paint or marker, working to obliterate streaks or imperfections, let me remind you that in fashion sketches the flesh tone is usually secondary to the color of the clothes. The flesh tone is almost an accessory to the industry. It is there to enhance all the important features of a garment. So relax and learn to do a flesh tone that is consistent in color but loose in style. That doesn't sound dramatic, but it isn't supposed to. These are some examples of model drawing gestures—quick sketches on which I practice rendering flesh tone with both style and speed without sacrificing too much accuracy. To that end I color less than the outline, staying far inside of the form rather than slipping outside of it. That would appear sloppy in my classical style of figure sketching. See what works for you. Loosening up takes a lot of practice, so don't be discouraged. Hopefully these loose examples will relieve you of your desire for perfection. Perfection takes too long when you are trying to meet a deadline.

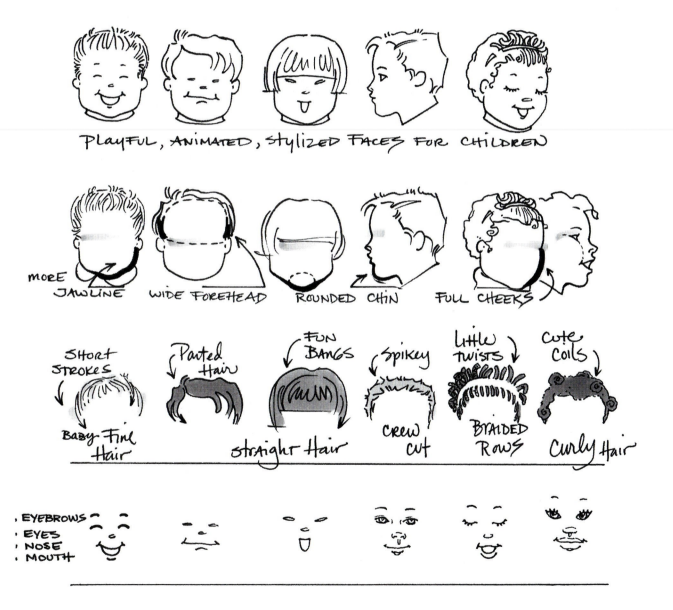

PLAYFUL, ANIMATED, STYLIZED FACES FOR CHILDREN

MORE JAWLINE WIDE FOREHEAD ROUNDED CHIN FULL CHEEKS

SHORT STROKES Parted Hair FUN BANGS Spikey Little TWISTS Cute Coils
Baby-Fine Hair straight Hair CREW CUT BRAIDED Rows Curly Hair

· EYEBROWS
· EYES
· NOSE
· MOUTH

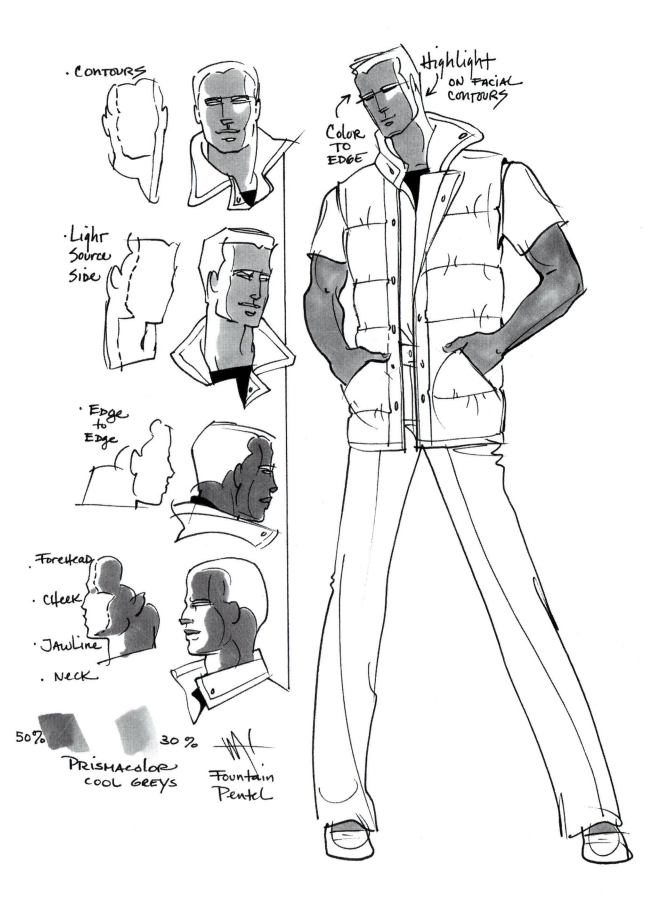

· CONTOURS

Highlight ON FACIAL CONTOURS

Color TO EDGE

· Light Source Side

· Edge to Edge

· Forehead

· Cheek

· Jawline

· Neck

50% 30%

PRISMACOLOR COOL GREYS

Fountain Pentel

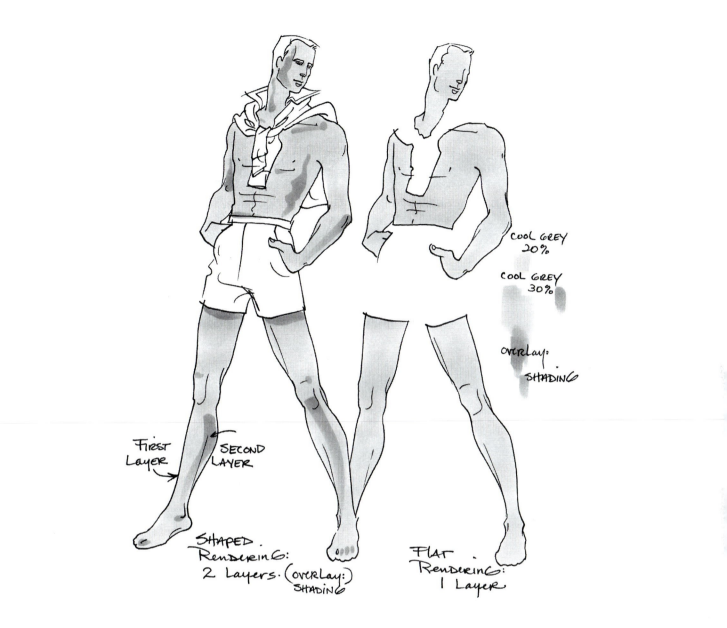

COOL GREY
20%

COOL GREY
30%

OVERLAY:
SHADING

FIRST
LAYER

SECOND
LAYER

SHAPED.
RENDERING:
2 LAYERS. (OVERLAY:)
SHADING

FLAT
RENDERING:
1 LAYER

BODY CONTOURS

The body has many contours to utilize in line and in color. For color, you can work with anatomy, pulling your color around the musculature of the face or any part of the body. There is no set pattern for this contouring or shaping for color on the figure. How and where you render the flesh tone is based on stylistic choices. A few of my choices are illustrated on these pages. These should be easy to imitate and practice.

You can render the face using any part

that has planes. For instance, the temples are the side planes of the forehead. You can color into the planes or use them for highlighting.

Another way to highlight is to use those same planes for shading. Shading is usually done in the same area as a highlight but it catches shadows instead of light. Shading helps to shape the body. It is usually a second layer of rendering sometimes referred to as an overlay of coloring.

Rendering for croquis, the quick designer concept of sketching, creates a long, lean figure interpretation, a clothes hanger of sorts. A designer sketches both the clothes and the figure as conceptual. Your drawing and your rendering should reflect that message. The current trend in fashion is to draw an elongated, incredibly stylized

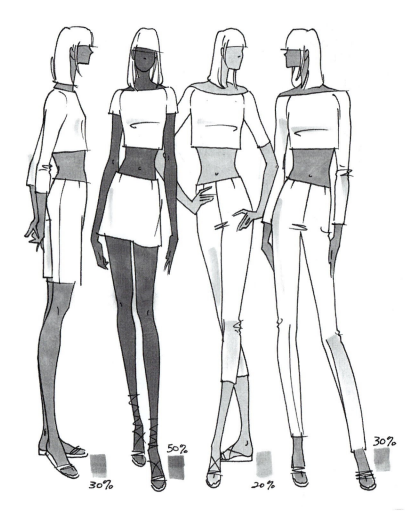

figure. It is only a fashion statement; it may change or not. It is a trend in drawing style that suspends the natural female contours into an idealized, unrealistic proportion. It is a fabulous fashion lie in the fantasy of design. It is wonderfully young and frivolous in this format and is not an assault on the true nature of our bodies. This croquis figure and its flat monotone flesh tone is a shorthand—an abbreviation of the natural form drawn for speed, not for portrait accuracy or human reality. The figure is always open to interpretation in fashion design because the real focus is on the clothes.

Rendering fashion flesh tone, especially for croquis-type figures such as these, means coloring in as quickly as possible since croquis are done in multiples, devoid of too much posing, and only rarely get extra flesh tone shading if there is any time left over.

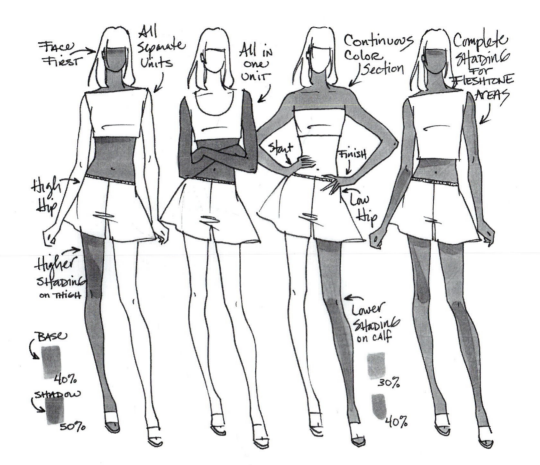

When rendering the flesh tone part of your sketch, start with the head. If you make a mistake on the head, you will probably have to redo the figure, so don't save that part for last.

Look for places where parts of the body intersect. In this drawing, one flesh tone overlaps another as the arms cross over the midriff. These overlapping areas can be one solid block of coloring instead of three (two arms and the midriff). Color them as one unit.

When you are rendering sleeveless design, start at the bottom of one hand, run up that arm, over the chest, and down into the other arm back to the bottom of the other hand—a real round trip! If you don't do it this way you are bound to end up with a streak by one arm or the other if you start at the chest for a sleeveless top.

Body shading on croquis can be done with a minimum of time and fuss. Just emphasize the layers of clothing near the flesh tone first. That gives your garment the focus it needs. If there is any time or energy left over, shade the high-hip thigh and the low-hip calf to help the figure's stance. The arms can be shaded to emphasize their bareness.

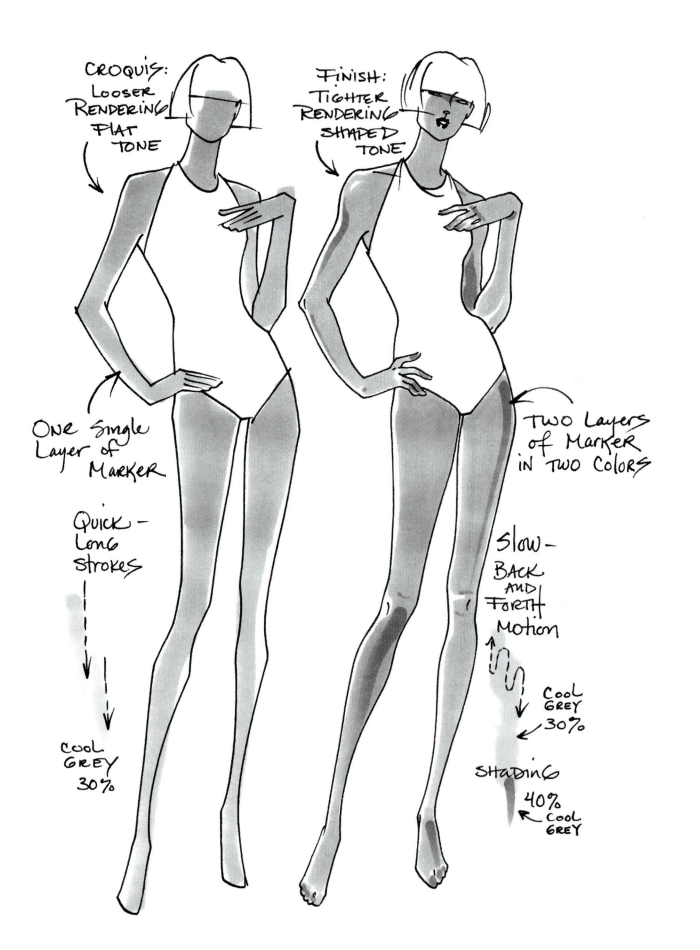

CROQUIS:
LOOSER
RENDERING
FLAT
TONE

FINISH:
TIGHTER
RENDERING
SHAPED
TONE

One Single
Layer of
Marker

Two Layers
of Marker
in Two Colors

Quick –
Long
Strokes

Slow –
BACK
AND
FORTH
Motion

Cool
GREY
30%

Cool
GREY
30%

SHADING
40%
COOL
GREY

29

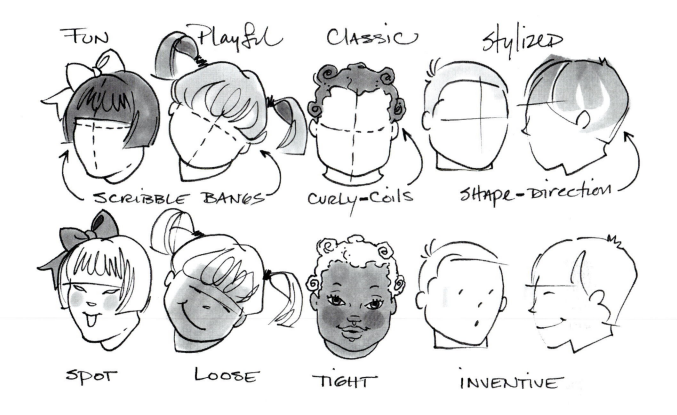

FUN — SCRIBBLE BANGS — SPOT

Playful — LOOSE

CLASSIC — CURLY-COILS — TIGHT

STYLIZED — SHAPE-DIRECTION — INVENTIVE

As was discussed earlier in this chapter, watercolor painting requires more preparation time than working with markers. The success of your watercoloring depends largely on your attention to details. These details begin with how you set up. To set up lay out your palette, paint, cloth, brushes, and water cup to one side, your drawing hand side. Work on a tilted surface or hold your pad up at an angle. Working on an angle will help you to paint evenly and allow the paint to dry evenly. Working flat in tiny areas often leads to color streaking or "pooling"; the paint then dries in uneven splotches. In this instance, your fashion objective for watercolor is to create a solid, flat area of a single color. To mix a solid color wash, gently add water to the gouache or pot. Mix it in your palette or tile until the ratio of water to pigment looks to be somewhere in between too watery and too thick and sticky. You want a smooth consistency that is well blended. Mixing it too quickly or roughly will create tiny air bubbles that interfere with applying flat color.

PAINTING

Each of you will develop your own individual painting style. This style is often based on whether you write with your left or right hand. However, writing is done flat with your hand often covering or resting on and across the page, and painting is done on an angle with your hand raised over the paper so as not to smear the surface as you glide your brush across the page. To paint an entire area in one solid, flat wash you must learn to gauge the amount of

paint—the volume of color—on your brush. Otherwise, the painted color will be streaked. Learn to work with a really wet brush. Start at the top of the figure and drag the wash down over the surface, back and forth over the shape until it reaches the bottom. Remember to keep your hands off the page as much as possible. Touching the paper's surface affects how well it receives the paint.

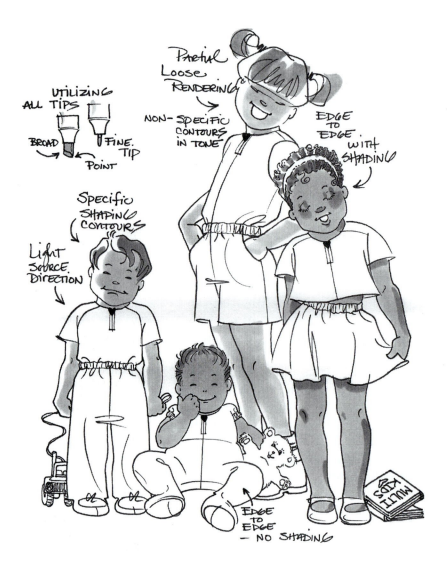

Sketching children's wear can be much more interpretive and more playful than drawing adults if you move into stylistic figures. Children's wear kids can be wonderfully full bodied and much more naturalistic in proportions. Kids in fashion can be less idealized even though, for design purposes, they are used to show off the clothes. Kids fall into four basic categories according to garment sizes: preteen or young adult, child, toddler, and infant. An infant is usually shown seated.

To practice drawing kids and their features, which can be more or less exaggerated than those on adult faces, explore how stylized or realistic you can get in your sketching. Work on the features of the face and then try to find a complementary drawing style for the hair. Remember that infants and toddlers can be sketched with less hair (finer) than older kids. Also keep in mind how large a child's head can be in proportion to his or her body. It is the reverse of drawing heads on adults. And while adults get long necks, kids get almost no necks at all.

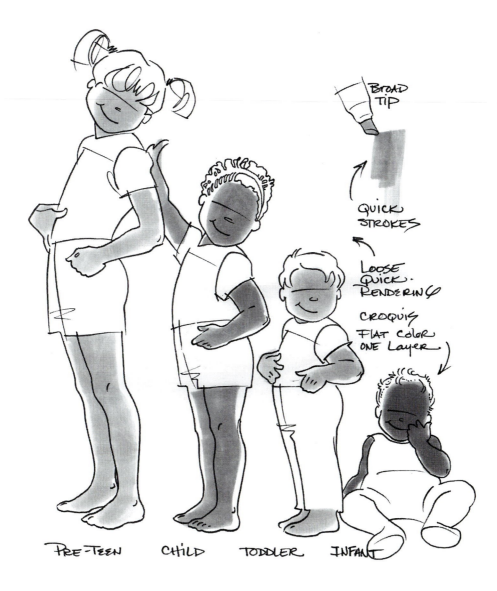

PRE-TEEN CHILD TODDLER INFANT

FASHION HEADS AND HAIR

Sketching and rendering for fashion heads and hair is more concerned with trends and style than technique. Trends involve hair color and styling. Style refers to your drawing style, whether it be realistic or inventive; thus the drawing is stylized. If you are drawing realistically then you might want more realism in the features of the face and hair style. A stylized, inventive drawing needs less realism in the features and hair. These are choices; one is as good as the other.

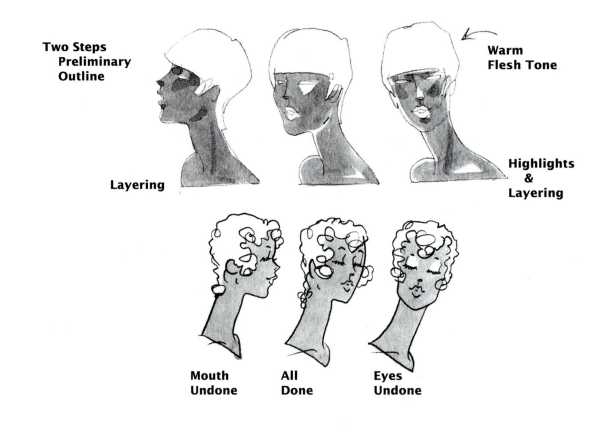

Two Steps Preliminary Outline

Layering

Warm Flesh Tone

Highlights & Layering

Mouth Undone

All Done

Eyes Undone

Set up a range of heads, first for style, then for rendering. Keep the heads' position simple. Draw your favorite view of the head: full front, three-quarter turned, or profile.

Next you should try all three views: full front, three-quarter turned, and profile. Draw the same hair style on all of the positions on the head. Again, for fashion, keep the hair style simple.

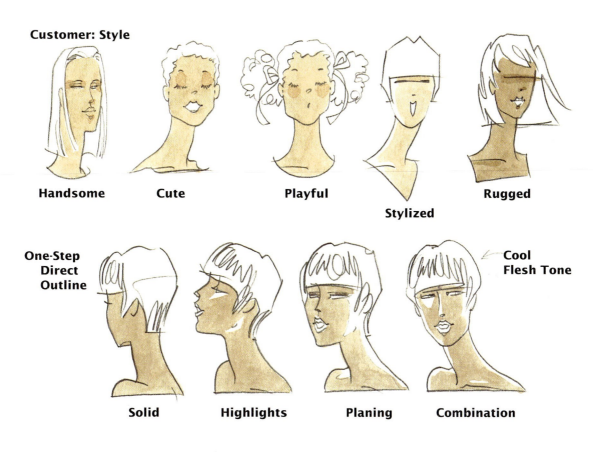

Customer: Style

Handsome **Cute** **Playful** **Rugged**

Stylized

One-Step Direct Outline **Cool Flesh Tone**

Solid **Highlights** **Planing** **Combination**

Within the limits of my own talent, I have tried to create both realistic and stylistic fashion heads. It is important to explore your own range. What more are you capable of that you haven't tried to draw yet? How cute, how sophisticated, how sporty or elegant can you make your sketches? Fashion faces are done to complement the clothing design. Hair is rendered so it does not clash with the garments. Attitude is far more important than personality. The head that you draw is not an individual but expresses the type of person who wears the garment.

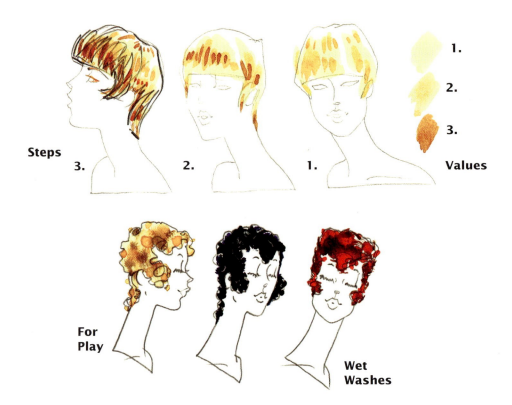

Steps

3.

2.

1.

Values

1.

2.

3.

For Play

Wet Washes

Hair color rendering for style is closely related to the manner in which you rendered the flesh tone on the face. Loose flesh tone coloring needs loose hair style rendering for balance in the technique, and vice versa for tight rendering.

Practice mixing colors for hair as well as for flesh tones. Flesh tone in paint is often a mix of red, yellow ochre, and brown with as much or more water in the mix, so that it is as thin a wash as you can get that will paint smoothly on the paper.

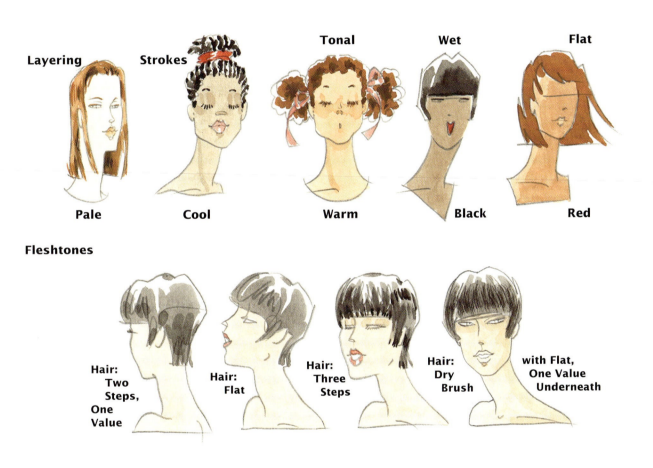

Model drawing—that is, drawing from a person rather than from a photograph—is the best way to practice figure work, particularly posing and proportions. If you are drawing a live model, it is also a great opportunity to practice rendering flesh tone. With multiple figures to paint, you get a real chance to explore highlight and shadow and facial planes. As loose as a gesture, quick sketch can keep your painting technique loose as well. Go for chance; "mistakes" as well as "perfects" are great lessons in your own performance level.

I did these drawings from the model in groups of two-minute poses, sketching as quickly as I could. I used a Prismacolor Verithin Black pencil for line and mixed a large batch of flesh tone from the Grumbacher symphonic set on their palette using a #8 Winsor Newton Brush (middle price range).

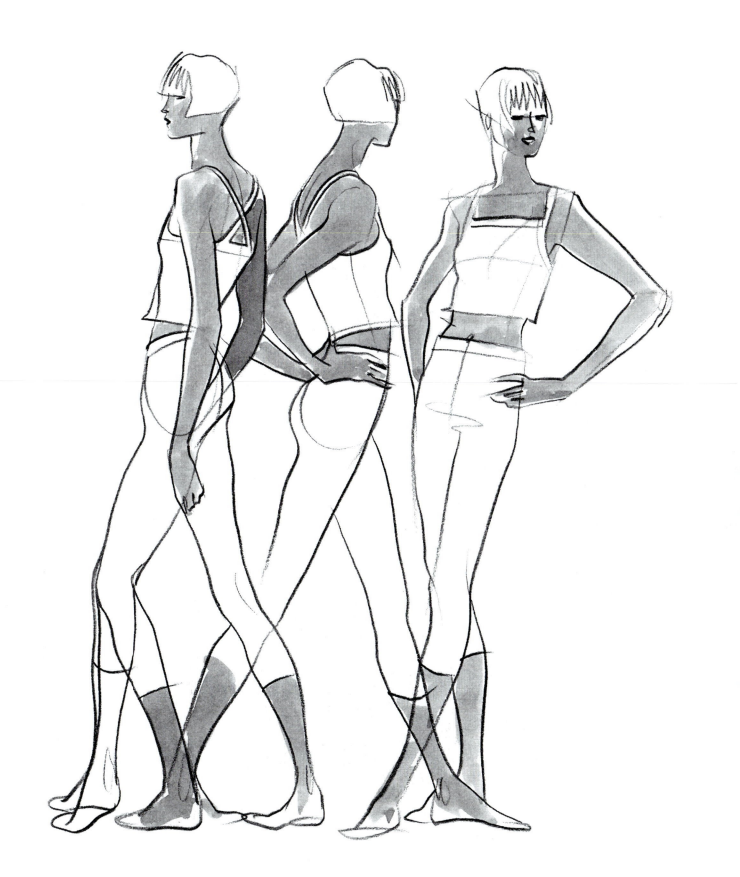

SUPPLIES

Marker paper pad: Bleed proof, 11 × 14

 Markers: Flesh tone range:

 Light beige, tan, sand;

 browns—wood tones

 Hair colors:*

 Beige and brown (overlapping flesh tones' palette)

 Wood-tone reds

 Yellow and ochre, burnt orange

 Black, navy blue

 Colored pencils in tones related to the markers

 Pens: Fine point, bleed proof

Water color paper: Hot press, vellum finish, approximately 11 × 14

 Paints: Flesh tone range in mixes

 Yellow ochre, red, browns of all types

 Pencil: Your choice for outlining

 Two water cups, palette, towel wipe

 Brushes: #1 and # 7

 *Repeat paints for hair color

ASSIGNMENT

Refer back to page 26. Set page up (according to marker or paint process) as shown. Work on exploring flesh tones with colors for heads. Label each color in order of use; do a solid, flat wash layer first, then use the shading wash color second. After you complete three rows of four heads, start another page to practice flesh tones on the figure. Repeat a simple pose twice. Render both figures, again experimenting with your media. One figure should get shading and the other figure should not so you can compare the results.

CHAPTER 4

SOLID-COLOR FABRICS

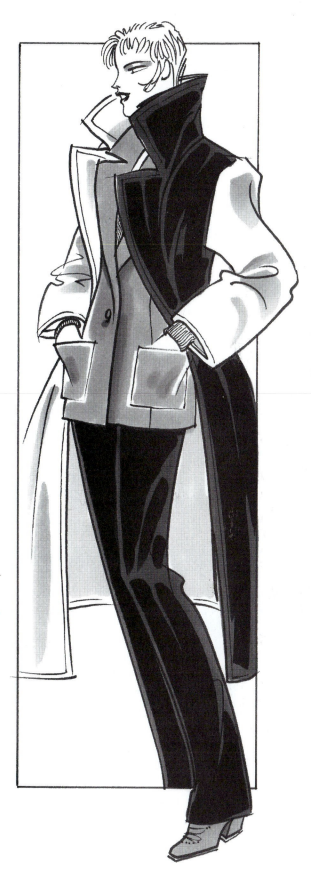

Rendering solid colors is often more intimidating than rendering a print. Applying solid color that is supposed to look flat looks easy until you try it. Once the marker or paint hits the paper your task is to render that color as smoothly as possible so that it resembles a print or a texture. Flat, solid color on a page cannot appear to be streaked or uneven. You are more critical of the coloring process because its flaws are so obvious. This chapter will help you to discover simple methods to achieve a smooth, flat color on your sketch. Once you have learned these simplified rendering techniques you'll keep practicing and gain more confidence using solid colors. Remember, half of the trick to better rendering lies in the magic of good supplies: paper, markers, or paint. Review Chapter 1 and keep in mind that it is best to back your talent with worthy equipment to complete your drawing.

MARKER SHADING

1. This is an example of solid color flat rendering with all of the interior lines filled in to direct the shading.

2. The shading is filled in according to the folds that drape into and out of the knot.

3. The placement of the knot in the fabric establishes the direction for the shadows.

4. To create the sense of direction for your shadows, you have to render in and out or up and down from the point of the knot in the garment.

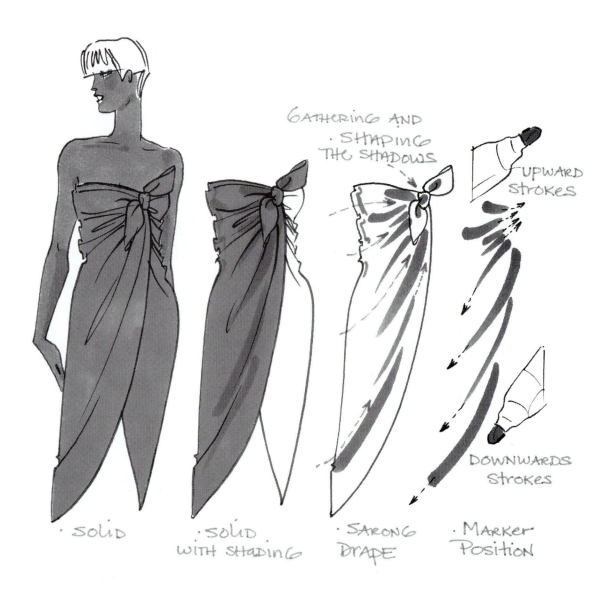

GATHERING AND
· SHAPING
THE SHADOWS

·UPWARD
Strokes

DOWNWARDS
Strokes

· SOLID

·SOLID
WITH SHADING

· SARONG
DRAPE

· MARKER
POSITION

SOLID COLOR RENDERING

Fabrics of a single color are often called solids by the fashion industry. A solid fabric has no print, pattern, or surface treatments. The coloring technique for a solid (color) fabric is called flat rendering. In a fashion design illustration, one garment can have many solid colors. For all of its construction details, that garment is still considered a solid with flat rendering on it. The flat rendering technique can be done without shading or any tonal variations on its coloring method.

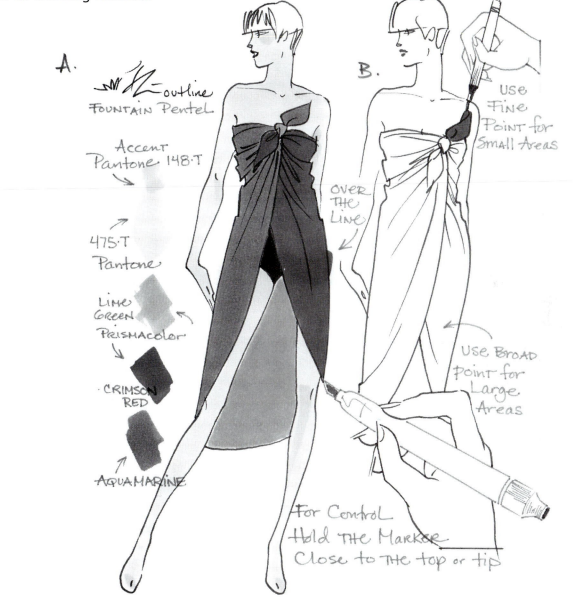

A. outline
FOUNTAIN Pentel

Accent
Pantone 148·T

475·T
Pantone

Lime
Green
Prismacolor

CRIMSON
RED

AQUAMARINE

B.

USE
Fine
Point for
Small Areas

OVER
THE
LINE

USE Broad
Point for
Large
Areas

For Control
Hold THE Marker
Close to THE top or tip

A. For this illustration, the garment has been rendered flat. The flesh tone has been rendered with a bit of shading to contrast with the solid, flat coloring.

B. This example helps you to see the individual shapes that were rendered in the flat technique for solid fabrics.

MARKER TECHNIQUES

After you establish the rationale for shading—its light source and design motives—you need to practice the essentials of marker rendering in one or two layers. This page illustrates at least three methods to practice. As in all rendering, these methods can be separate or combined according to elements in your sketch or the habits of your style of drawing.

A. Apply your marker in the direction of the drape. If the drape moves sideways, so should your marker strokes. This kind of coloring implies motion by moving the color through the angles of the design shapes.

B. Fill in the whole shape by starting in the middle where it is the widest and the least complicated. Color in left and right over the center, filling slowly into the more intricate edges.

C. Combine the methods of A and B to color an entire shape one section at a time. These sections can be divided by design shapes or figure units. This example uses separate design shapes for rendering.

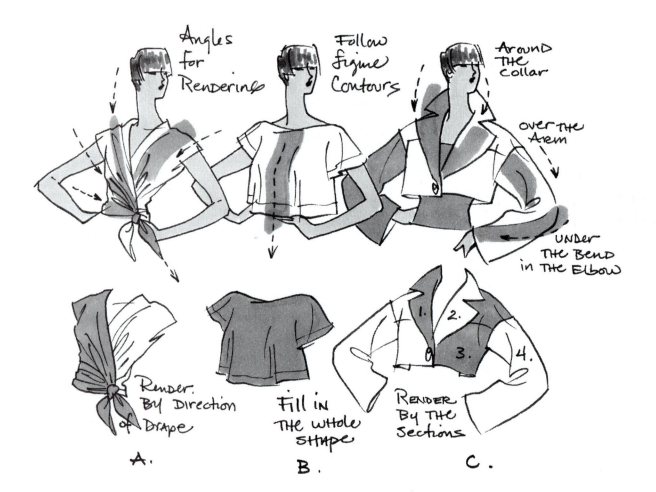

48

Shading is a flexible process. It adapts to all design situations with or without a light source. Shadows are rendered to enhance the fashion features in a garment, to reflect the posing, and to create a sense of dimension in your sketch. All three of the examples on this page have fit and flare shapes. Each one has been shaded to add depth to the fabric according to that specific shape.

The Tops: (1) Draped/fitted, (2) Loose/cling, (3) Loose/boxy, no cling. Each top has been shaded to the visible bustline or to the fabric covering it up as in the jacket.

The Bottoms: (1) Flare/loose, (2) Cling/soft pleating, (3) Narrow/crisp pant leg. All of the bottoms use shadow to show the relationship of the hipline to the knee or the knee to the ankle. Notice that the shading is based on fabric and posing without a specific light source.

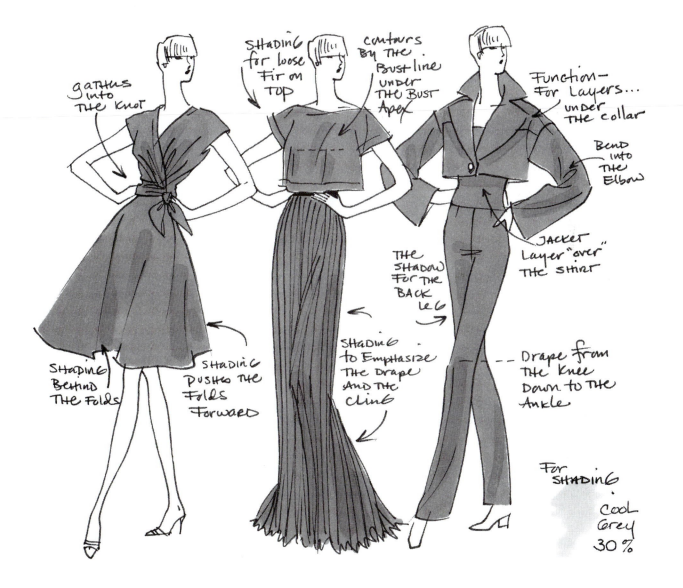

MARKER STAGES IN RENDERING

These pages represent the marker stages as well as the sections in a garment that need special attention in rendering.

The flat (rendering without shading) rendered sections of this three piece top have been divided into color units. Each unit—the vest, the shirt, and the turtleneck underneath—has its own color value to reinforce its shape and layer in relationship to the other two layers.

The shading has been done to illustrate two types of shadow. One type accentuates the body curves that form contours under the fabric worn on the figure. The other is strictly a function of the layers or gravity of the drape. Drape is for folds in shadows. Layers are for any section of clothing overlapping another. Gravity is where the shadows of the drape or layer take on direction.

When you isolate these stages in rendering, it helps you to understand the premise behind shading and its visual impact. It takes planning for it to look so loose and natural. Compare each separate stage with the completed example and you will understand the process as a whole.

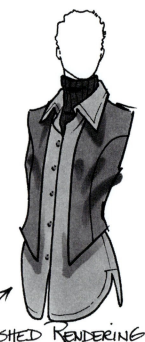

FINISHED RENDERING
WITH LINE

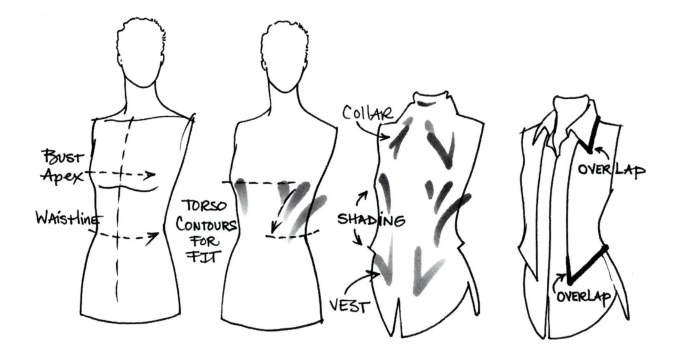

BUST APEX

WAISTLINE

TORSO CONTOURS FOR FIT

COLLAR

SHADING

VEST

OVERLAP

OVERLAP

50

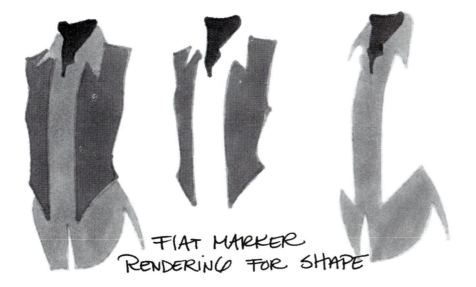

FLAT MARKER
RENDERING FOR SHAPE

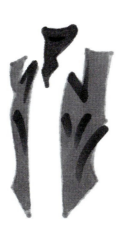

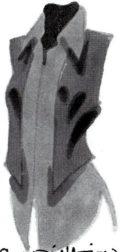

SHAPES
AND SHADOWS

TURTLENECK
AND VEST

SHIRT
ONLY

COMBINATION
WITHOUT LINE

SHADING

As stated previously, shading for garments falls into two categories: one for fabric folds and the other for body contours (the shape inside the fabrics). Spring or warm-weather fabrics that fit loosely combine the shading categories. For this type of garment, as illustrated here, the folds drape around the bust and just after the hips in random sequence. The shading must appear to be just as random so it looks unstructured and accidental, which gives your rendering a natural, spontaneous look. In other words, to make it look easy you have to really work hard at it.

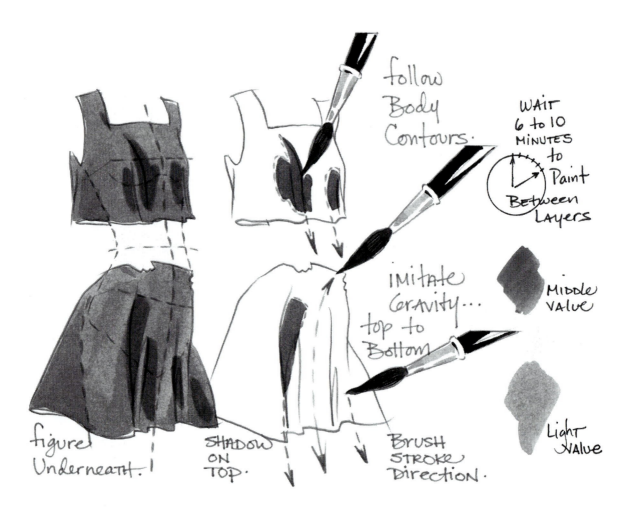

follow Body Contours.

WAIT 6 to 10 MINUTES to Paint Between Layers

iMitate Gravity... top to Bottom

MIDDLE VALUE

Light Value

figure Underneath.

SHADOW ON TOP.

Brush STROKE Direction.

To practice rendering shadows, define the figure (posed or not posed) underneath/inside of the garment. You can work on top of a solid, flat color with the shading as a second layer or you can just practice shading by itself.

Work on the random size and placement for your shading. Shadows will fall with gravity but your brush can swing in any direction, up or down, to create the shapes. Remember to leave drying time if you are working in color layers.

LIGHT SOURCE

A light source can come from a multitude of specific directions. For fashion design illustration, it is easiest to work with one light source at a time. For our purposes, that light source is from the left or right side above the figure. These two directions simplify the shaded or highlighted areas for your sketch. Shading is a darker area underneath or behind a fold or garment contour. Highlighting is a lighter area on top of or in front of a fold or garment contour.

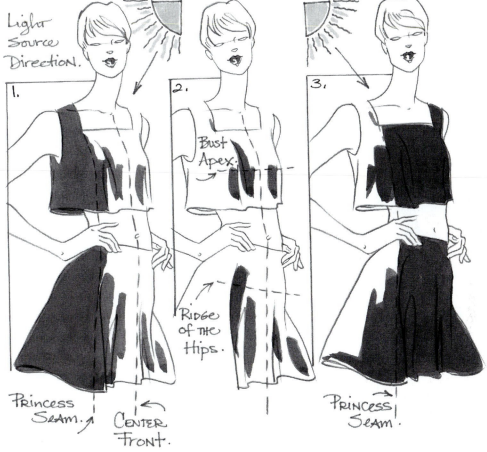

1. This demonstrates the total area for shading for this light source direction. As the figure turns to the direction of the light source, the far side behind the princess seam falls into a solid shadow.

2. This is an example of partial shading using the same light source direction as in example 1. There are times when it isn't necessary to use the solid shading areas. For partial shading, use the natural contours around the bust apex and after the ridge of the hips. Both areas bring folds into loose fabric.

3. The opposite-side light source used in this version sheds light onto the area just before the princess seam. At all times, the color is staggered or stepped to imitate folds or to suggest the existence of color against light.

SHADING FOR FASHION DESIGN

Fashion design broadens the range of the light source to include the scope of garment construction. This type of shading is done to enhance a silhouette, to display its design focus, its function.

You have learned how to render a first layer of a solid single color. The first layer fills in all of the color on the garment regardless of construction. The second shading layer picks up the darker color specifically to emphasize the construction.

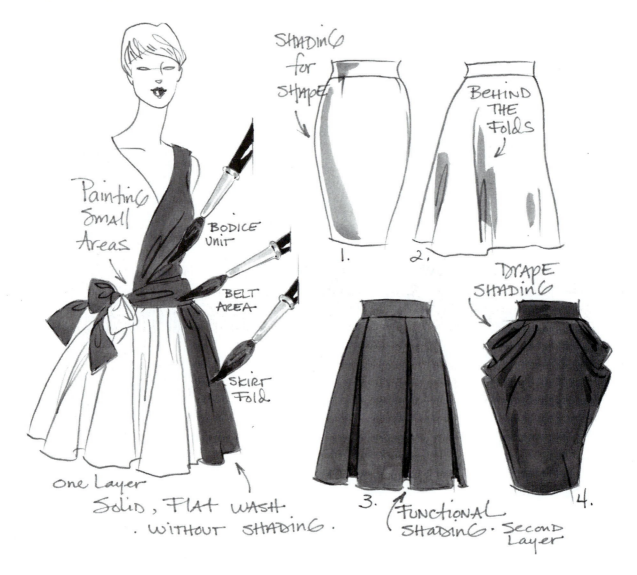

Here are four examples of shading.

1. Contour body shaping shadows for a fitted skirt.
2. Shading dipping in between the folds in an A-line skirt.
3. Functional shading that slips behind each pleat in a box-pleat skirt.
4. Shading that plays up the drape underneath the cowl-draped skirt.

Shading, as a process, has many solutions. These solutions are all based on individual taste, style, and fashion silhouette in regard to shape, posing, or fabric type. This page illustrates some of that variety between a fashion shape and posing in a classic sense.

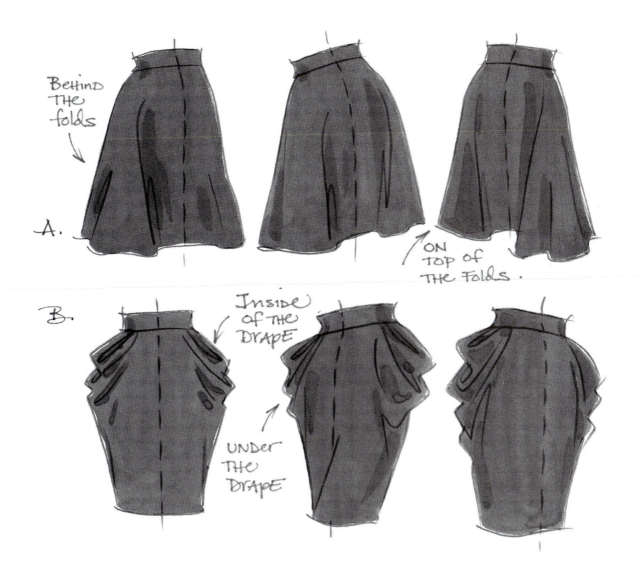

Behind the folds

A.

ON TOP of THE Folds.

B.

Inside of THE DRApE

UNDer THE DRApE

A. This example uses an A-line skirt. With each pose the placement of the shadows changes with the nuance of folds falling after the hip line. The shading dips down toward the hem, falling away from the waistband where there is no design detail.

B. This example demonstrates a few of the options in shading a cowl-draped skirt. This time the shading is directly related to the waistband where there is a lot of design detail. Here the shadows collapse into and underneath the drape out toward the hip line. There is little detailing by the hem in this shape so the shading fades away at the bottom.

55

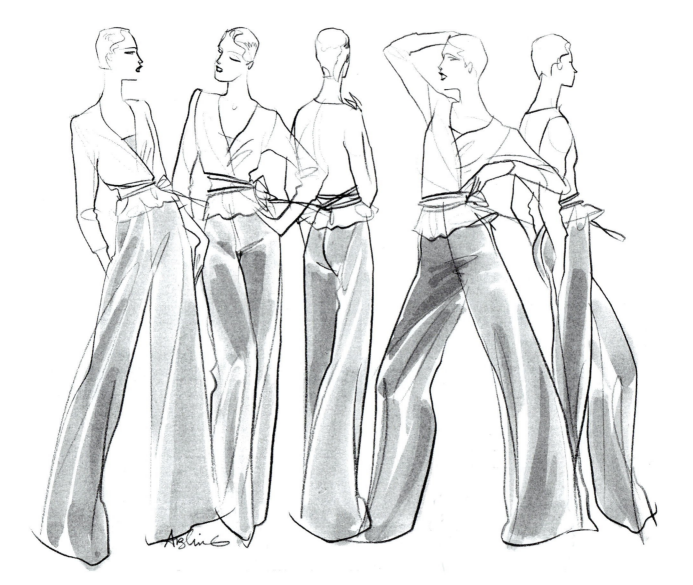

Practice Is the Key!

Practice is the key to mastering any choice of media. Doing something over and over again unlocks your talent. It opens up the door to your imagination. Practice trains your hand, your eyes, and your mind. You learn mastery and that control gives you the confidence you need to render, to create line quality, and to promote your own drawing style. More will be done very well on purpose and less will be done partially well by accident. These sketches are mine.

They were sketched from the model in a series of five-minute poses. I put the paint on after I finished drawing, which gave me a chance to practice painting the top and the pants in a variety of positions. Both sets of sketches are examples of constant practice, doing something again and again until you know it works every time. (Well, maybe not every time, but getting close is a start.)

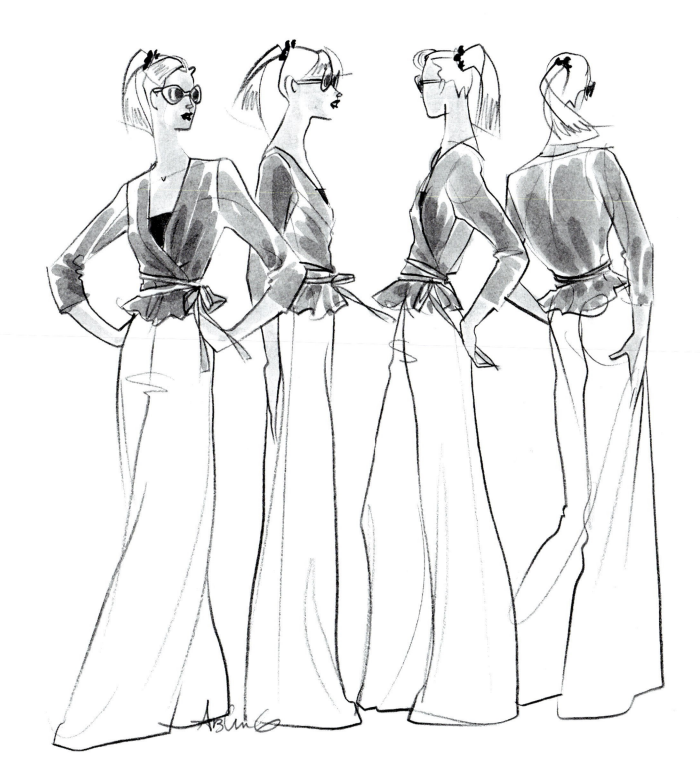

MARKER SOLIDS

Set up a practice page for yourself. Work with a dressed figure or just the garment. Repeat the silhouette four times on the page so that you can observe your own technique and results.

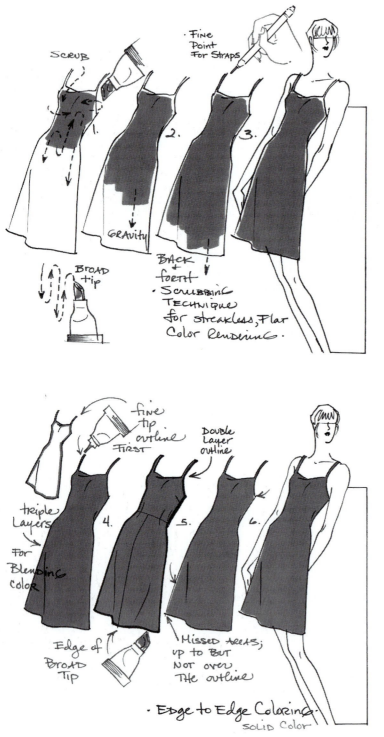

1. Try out the wide tip of your marker. Start at the top of your garment and scrub the color back and forth over itself to quickly blend the color strokes into a solid mass.

2. Pull the scrubbed color down the silhouette toward the hem or bottom of the garment.

3. The scrubbing motion will keep the color wet enough to create a streakless rendering in the time it takes to fill that shape. Use the finer tip of your marker to fill in the narrow sections of your garment.

4. The finer tip of your marker can be used to outline a shape before you color it in. With this technique the outline color has more time to dry and could appear darker than the middle. To color match the outline edge try a few layers of color in the middle.

5. After the coloring process, you can go back in with the pen line to pull out design detail or to emphasize the outline contour.

6. Marker rendering nibs cannot always maneuver in tight corners, so some parts may be harder to color in than others. It always looks better to render away from, rather than overlapping, the outline contour.

MARKER SHADING

Creative shadows on a sketch imitate the reality of a light source. The shading on this page used a light source to establish where the shadows fell. Shadows fall on the opposite side from the direction of the light. Color choices for your shadows are a deeper value of the solid color or a darker tone of grey.

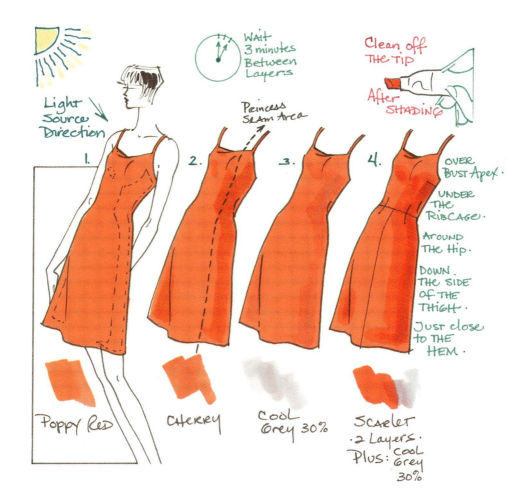

1. Plan to follow the forms of figure and fabric so the shading will not look arbitrary or disturb the illusion of shape.

2. Let your shadows move around the princess seam and under the bustline to suggest the contours of the body. Drop a shadow off of the high hip into the fold of the dress near the hemline.

3. For different marker colors, allow two to three minutes of drying time between each application of the colors.

4. When all of the colors have dried you can go back into the sketch and fill in the information for design.

MARKER METHODS

Rendering methods include more than solid colors and basic shading techniques. Rendering methods involve the surface coloration and treatments for a variety of solid-color fibers, weaves, and knits. The examples on both of these pages display some of these varieties. The fashions in these examples show a few methods for simplified rendering.

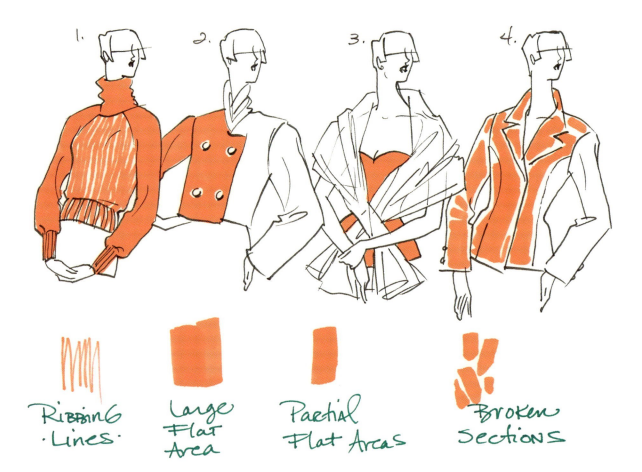

Ribbing Lines.

Large Flat Area

Partial Flat Areas

Broken Sections

1. Knits can be rendered in a first color layer of lines that represent knit ribbing.

2. Some fabrics start with a flat, base color on which to build the next layer.

3. When one type of fabric overlaps another you have to separate the color into the appropriate spaces.

4. Certain fabrics have a sheen to them. You can render that sheen by breaking up your base color in sections. These broken sections of color will appear to be catching light; the sheen will be illustrated by highlighting random sections.

These pages serve as an introduction to the more complex fabrics that will be covered in later chapters. They are an introduction to the combined use of colored pencil techniques and the marker methods of rendering.

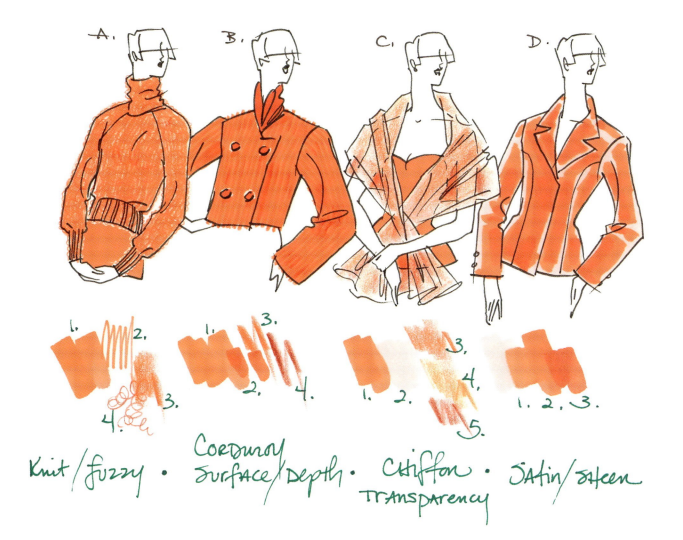

Knit / fuzzy • Corduroy Surface / Depth • Chiffon / Transparency • Satin / sheen

A. Corkscrew lines done in colored pencil over the marker ribbing will resemble the look of a curly yarn bouclé sweater knit with a fuzzy edge.

B. Lay the foundation for the nap or pile of the wide wales of the corduroy which are created by dragging colored pencil in multiple rows over the base color.

C. One of the colored-pencil techniques used to render transparent fabrics is to imitate the change in tones of a solid-color chiffon or organza in random layers.

D. To create a sheen for a fabric, you can use analogous or monochromatic colors to suggest the shine on the fabric. The related colors will still resemble a solid single color when rendered correctly.

COMPLEX SOLID RENDERING

The rendering solutions for wash on these pages are not exclusive to a specific type of fabric. These solutions are open ended answers to the problem of making fabrics look different from each other in a fashion sketch. For instance, you will need to decide how to paint a glossy taffeta and a smooth velvet when both fabrics are shown together on a page, and you need to show that contrast of surface interest even though their coloring may match. The examples on these pages simplify the process by utilizing one shape and contrasting rendering techniques.

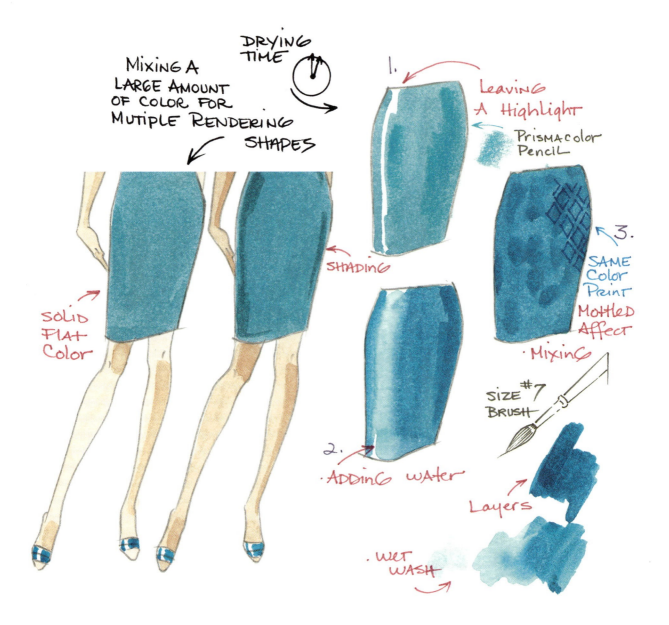

MIXING A LARGE AMOUNT OF COLOR FOR MUTIPLE RENDERING SHAPES

DRYING TIME

1.

Leaving A Highlight

Prismacolor Pencil

SHADING

3.

SAME Color Print

MOTTLED AFFECT

· Mixing

SIZE #7 BRUSH

SOLID FLAT Color

2.

· ADDING WATER

Layers

· WET WASH

There are about six versions of complex, solid rendering techniques for you to master:

1 & 2. A silky charmeuse or any soft-sheen fabric.

3. A printed jacquard or a faux suede (without print).

4. Ribbing on a knit surface.

5. Dry brush technique for a gauze or mushroom pleating.

6 & 7. Velvety, fuzzy nap looks.

8. High shine for a taffeta or a faux leather.

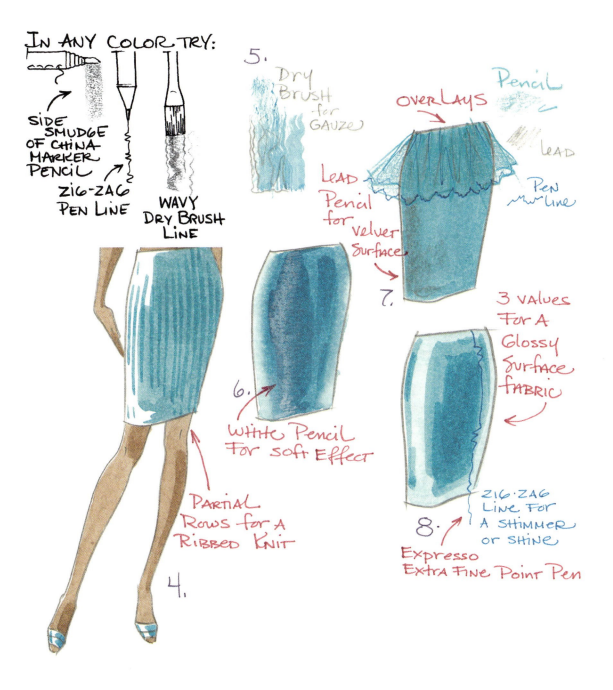

IN ANY COLOR TRY:

SIDE SMUDGE OF CHINA MARKER PENCIL

ZIG-ZAG PEN LINE

WAVY DRY BRUSH LINE

5. Dry Brush for GAUZE

OVERLAYS

Pencil

LEAD

Pen Line

LEAD Pencil for velvet Surface

7.

3 VALUES For A Glossy Surface FABRIC

6. White Pencil For Soft Effect

PARTIAL ROWS for A RIBBED KNIT

4.

8. ZIG-ZAG Line For A SHIMMER or SHINE

Expresso Extra Fine Point Pen

WATERCOLOR TECHNIQUES

This is a simple shape to practice. It was painted in a solid, flat wash. To paint an area of this size, estimate how much wash to mix to cover the area in two layers. It may take only one layer but it is wise to prepare for the option of a second layer in case the first one looks or dries unevenly. For this shape, paint the smallest area at the neck, because small shapes at the top of the figure are the easiest to fill. Begin at the top of your shape. Make sure the brush is wet enough, meaning that the brush is saturated with the paint. With a wet brush, you can paint some shapes, in total, without having to return to the palette for a refill. The more times that you return to the palette, however well mixed the color is, the more likely it is that your painting will be streaked. Practice will guarantee better results and more control over your media.

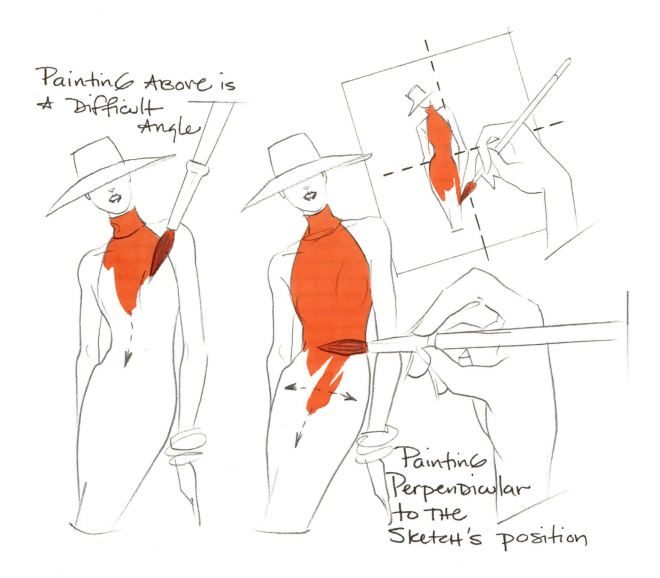

Painting Above is A Difficult Angle

Painting Perpendicular to The Sketch's position

This sequence of figures illustrates, in stages, the coloring techniques of painting from the top to the bottom of a garment. To practice this technique, work with your paper leaning against (and supported on) a tilted surface such as your pad or your desk. Gravity will help drag the wet paint down on the page, with your brush strokes, to create an even wash. As you paint, your brush strokes should utilize the tip or one quarter of your brush's edge. This will give you a light touch so that the paint in your brush gradually releases as you apply pressure on the tip where it touches the paper. Practice this method on one full shape. Set up any number of shapes to rehearse the flat-wash painting method.

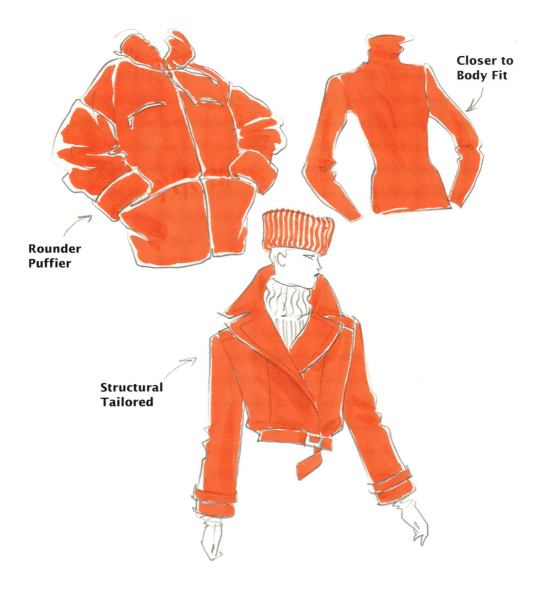

Closer to Body Fit

Rounder Puffier

Structural Tailored

Painting a whole garment can be intimidating. You worry about colors streaking and other mistakes. Painting section by section within a garment cuts down on mistakes. It divides the coloring process and requires smaller amounts of paint on your brush at a time. This method does demand more specific line definition within your sketch before you start to paint.

Another way to control painting problems is to hold off on line and specific definition until after you have painted the whole garment shape. You delay putting in all the interior lines until after the paint for the larger shape has dried. With this method you need more paint on the brush. A wetter brush covers a larger area with fewer sections in broader strokes.

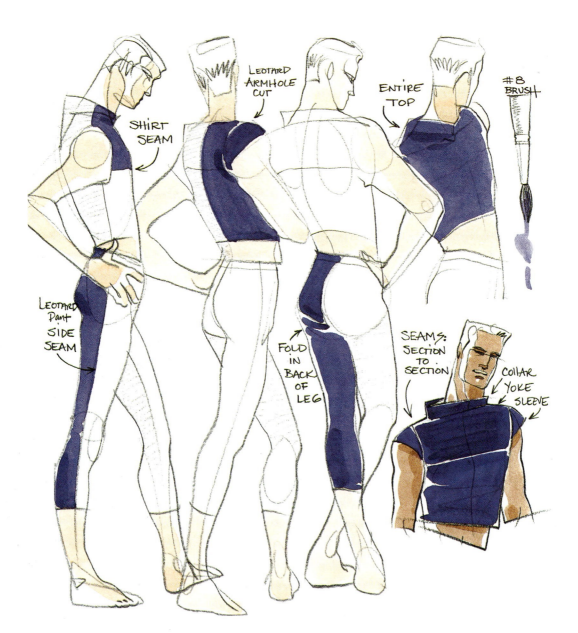

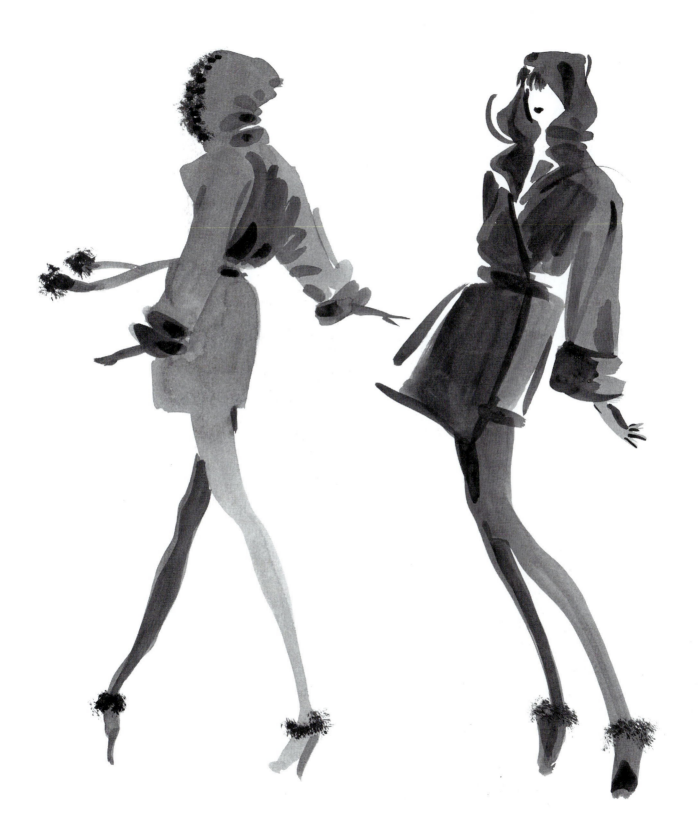

SUPPLIES

Marker paper pad: Bleed proof, 11 × 14

 Markers: Broad-tip and fine-tip

 Colors: Any related or analogous colors. One for fabric color match. One for related color or grey for shading.

 Flesh tone markers: See Chapter 3

 Pens: Fine-point

Watercolor paper: Hot press, vellum finish, approximately 11 × 14

 Gouache or watercolor pans or dots

 Palette, water cups, towel wipe

 Colors: Any related or analogous colors. One color for fabric color match. One related color for shading mix. Black for shading into color mix.

 Flesh tone mix: See Chapter 3

 Pencils: Your choice for outlining

 Brushes: #7 and #1

ASSIGNMENT

Refer back to page 55. Using this page as a reference, sketch three rows of three different types of skirts on your pad or paper that you can then render in a solid color. The rows of skirts should be rendered in a solid, flat color. For this exercise, make all nine of the skirts the same color. Then on the second and third rows practice shading. On the second row, try a darker version the same color as your shadow. For the third row, you can use grey or mix another color in to see how that looks. Practice pages like these should be done over and over until you teach yourself where the shading looks best and which shadow color is going to work.

CHAPTER 5

WHITE FABRICS

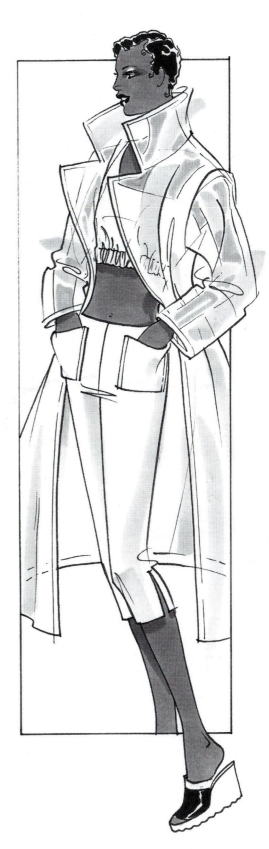

This chapter teaches you rendering techniques for white fabrics on a white paper background. All white garments must have some indication of shading to give your sketch depth, volume, and movement. This shading will add dimension to enhance your drawing of a white fabric, especially if it is next to a color fabric. Without shading, a white fabric garment looks unfinished and lacks visual pizzazz. With a few strokes of the brush or marker you can change your sketch from blank to blissful.

Another benefit to this chapter's work is that the shading technique you learn for white fabrics is the same technique you will need for all of the other fabrics. It is the illusion of shading or in its reverse, highlighting, that makes a drawing "readable." Readable means that it communicates in fashion: the fit, the drape, and the shape of a fabric in a garment. Not every drawing style requires shading or highlights but you need to learn the technique for future reference. The skills you learn in this chapter will augment other rendering techniques learned in later chapters.

FORMAL WHITE CLOTHES

Beyond the summer casual ones, all white fabrics are used for formal evening wear and wedding party clothes. These special occasion fabrics of white, off white, and pale, misty, color-tinted whites are a real challenge to render on a white piece of paper. (That is why whites are often illustrated on a colored paper for a contrast in background.) Some of the gossamer fabrics such as chiffon, organza, and tulle, to name only a few, add transparency to your marker or point rendering techniques. These pages demonstrate a sampling of rendering solutions for transparent and solid coloring for these dressed up fabrics.

Chiffon and other transparent fabrics often have a fine mesh weave that can easily be rendered as a texture with your pencil. The pencil can imitate the delicate surface look to the fabric in contrast to another type of fabric in the same outfit that is more matte or glossy.

You may come across many white on white prints, jacquard patterns, and textures in your fashion fabrications. The rendering solutions have to be subtle. Work as lightly as possible in your paints or markers using the palest tints possible. Think blue tints or grey for cold whites and tender beige for warm whites when working in color shadows.

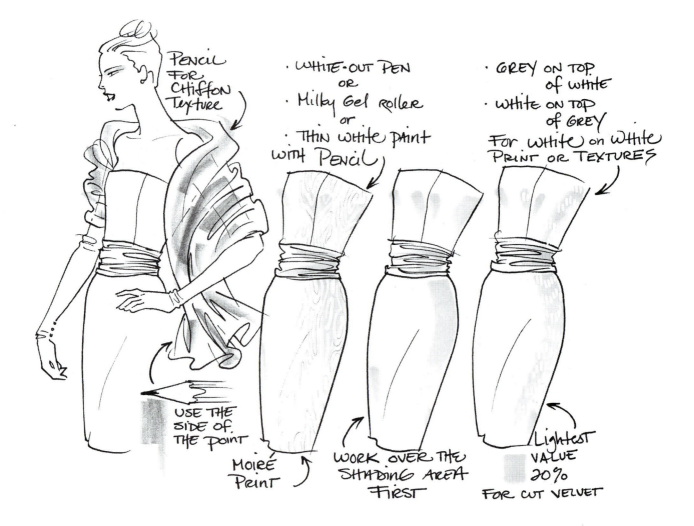

PENCIL FOR CHIFFON TEXTURE

USE THE SIDE OF THE POINT

MOIRÉ PRINT

• WHITE-OUT PEN
OR
• MILKY GEL ROLLER
OR
• THIN WHITE PAINT WITH PENCIL

WORK OVER THE SHADING AREA FIRST

• GREY ON TOP OF WHITE
• WHITE ON TOP OF GREY
FOR WHITE ON WHITE PRINT OR TEXTURES

LIGHTEST VALUE 20% FOR CUT VELVET

SHADING ON WHITE/PALE FABRICS

Shading is the major method of giving white fabrics some depth or dimension on the page. Any fabric type, matte or shiny, needs shadows to define a garment's fit, drape, or design detail for fashion illustration. For the fit, shading on clothing emphasizes the contours of the body. For drape, the shading picks up fabric folds or gathers. For design detail, which includes fit and drape, shading signals direction, overlap, or layers—to mention only a few elements on any given outfit.

Shading for white or pale-tint fabrics needs to be subtle. It has to be the lightest value possible without disappearing com-

pletely. In this example, shading on a dress is used to emphasize body contours.

This is an example of two-tone flesh tone rendering that makes the shawl appear to be a transparent, chiffon fabric. The flesh tone underneath the folds of this fabric has a peek-a-boo look as the flesh tone appears and then disappears behind the wrap.

Another rendering solution for a darker transparent fabric is to use a single-tone flesh tone color that contrasts with your fabric's color. It still retains that peek-a-boo effect as long as you break up your flesh tone color areas.

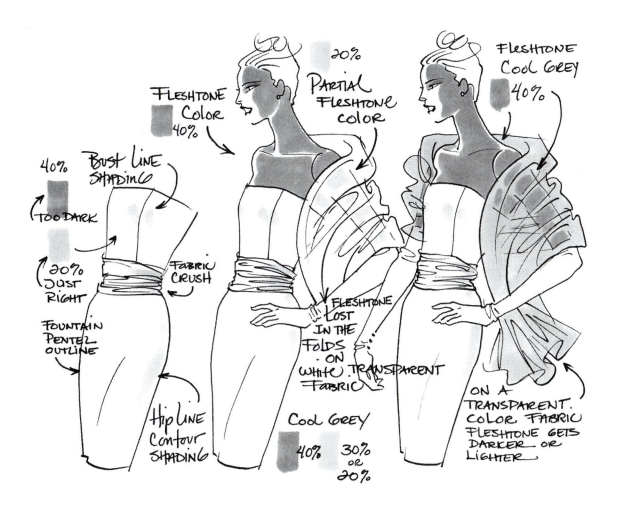

Two-Tone Shading

To completely understand and integrate a rendering technique into your repertoire, you need to practice it in as many options as possible. In this manner you will have a deeper comprehension of why each technique is performed the way it is.

On the previous page you saw a single-tone shading for a matte white fabric in chiffon. Here is an example of a glossier shawl in an opaque fabric. To do this you can use double or two-tone shading to imply a glossier look.

This is what one-step shading looks like on an opaque shawl of colored fabric. The shading on the shawl is done darker in contrast to the lighter shading on the white of the dress to signal the differences in fabric types.

Notice that the shading technique for fabric that wraps around is to incorporate that wraparound in the direction of the color. Your shaded areas should curve and bend with the fabric in the direction of its drape and folds.

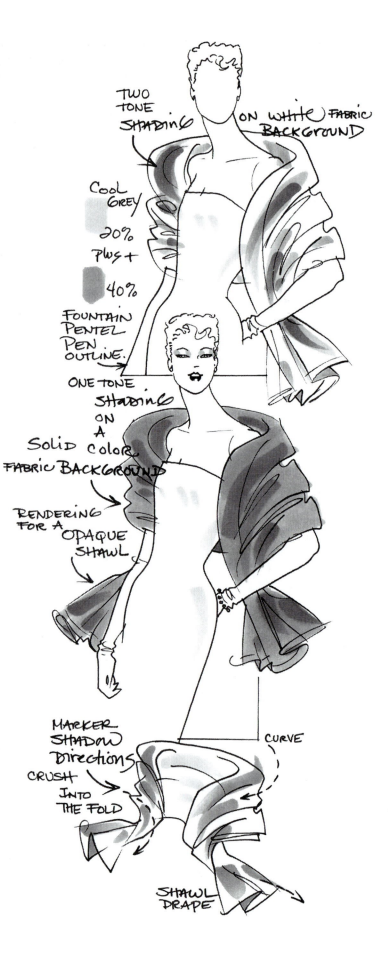

TWO TONE SHADING ON WHITE FABRIC BACKGROUND

CooL GREY 20% PLUS + 40%

FOUNTAIN PENTEL PEN OUTLINE.

ONE TONE SHADING ON A Solid Color FABRIC BACKGROUND

RENDERING FOR A OPAQUE SHAWL

MARKER SHADOW Directions

CRUSH INTO THE FOLD

CURVE

SHAWL DRAPE

These are more variations on the same theme: rendering techniques for white and transparent fabrics mixed with shading techniques for both, adding in a dash of solid color rendering for the differences between them. There will be a full chapter on the more complex rendering techniques for glamour fabrics later on in this book. Meanwhile, get out your color markers and translate these black and white illustrations into your version of them in full color, matching their color contrast value to the grey scale on this page.

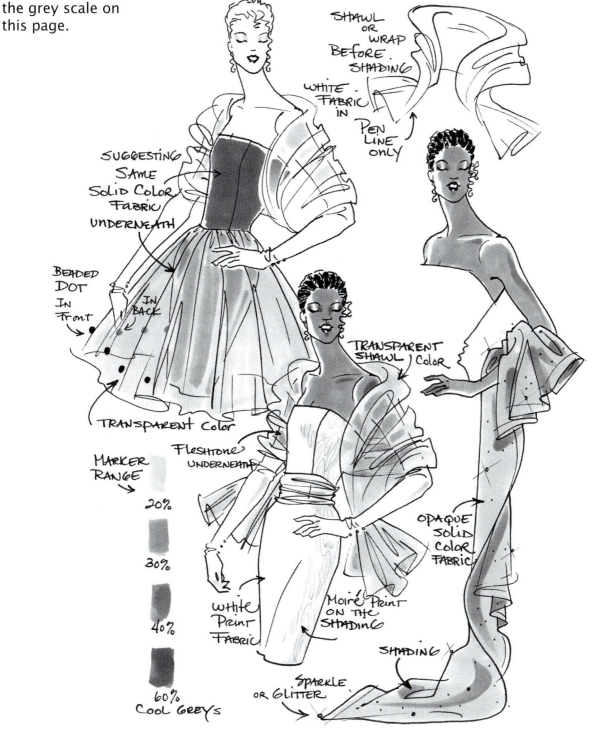

SHAWL OR WRAP BEFORE SHADING

WHITE FABRIC IN PEN LINE ONLY

SUGGESTING SAME SOLID COLOR FABRIC UNDERNEATH

BEADED DOT IN FRONT

IN BACK

TRANSPARENT Color

TRANSPARENT SHAWL Color

MARKER RANGE →
20%
30%
40%
60% Cool Greys

Fleshtone UNDERNEATH

White Print Fabric

Moiré Print ON THE SHADING

OPAQUE SOLID COLOR FABRIC

SHADING

SPARKLE OR GLITTER

ONE BRUSH Fill for All 6 areas of FLESHTONE

Same Mix - Double Layer for Shading

Paint FleshTone Peeping Through the open weave print
Pencil

Subtle Shading on White Fabrics

Palette mix

#7 Brush

White Tempera or White Pen

China or Marker Gouache White

These sketches were done in a 2B pencil on single sheets (versus a pad) of watercolor paper, medium weight and medium tooth (surface). They demonstrate the same premise for transparent and opaque fabrics that you saw rendered in marker on the previous pages. As you can see, the peek-a-boo effect between layers of fabric and flesh tone can be done in either paint or marker rendering techniques. The look is the same and so is the process. The difference lies in drying time between layers. Paint needs more time to dry, but you have more options to use for illustrating prints on white fabrics.

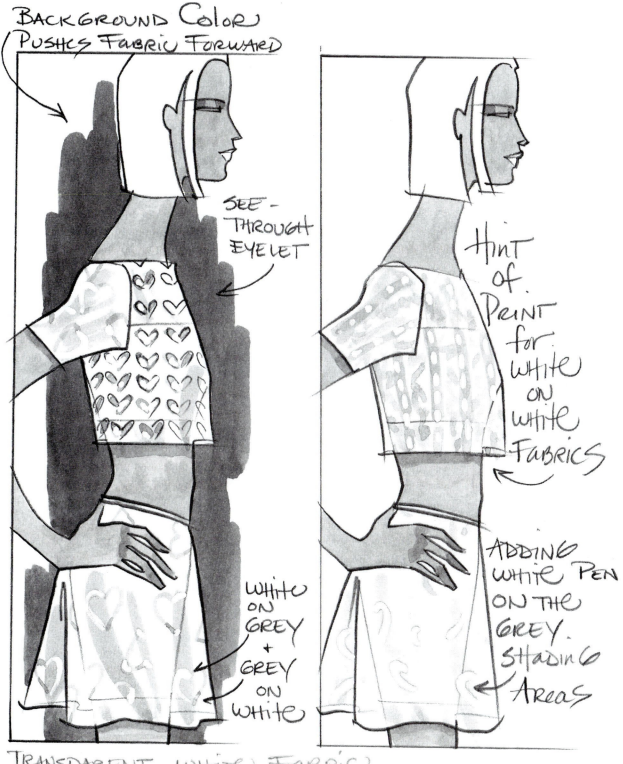

BACKGROUND COLOR PUSHES FABRIC FORWARD

SEE-THROUGH EYELET

WHITE ON GREY + GREY ON WHITE

TRANSPARENT WHITE FABRIC

HINT OF PRINT FOR WHITE ON WHITE FABRICS

ADDING WHITE PEN ON THE GREY. SHADING AREAS

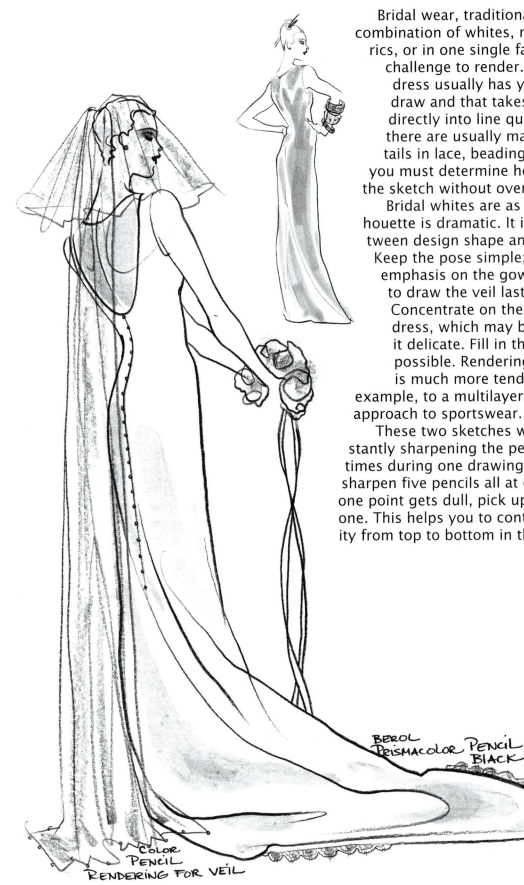

Bridal wear, traditionally done in any combination of whites, mixing white fabrics, or in one single fabric is always a challenge to render. First, a wedding dress usually has yards of fabric to draw and that takes you, in a sketch, directly into line quality. Second, there are usually many exquisite details in lace, beading, or appliqué that you must determine how much to put in the sketch without overdoing it.

Bridal whites are as subtle as the silhouette is dramatic. It is a balance between design shape and fabric nuance. Keep the pose simple; put all of the emphasis on the gown. You may want to draw the veil last in your sketch. Concentrate on the rendering for the dress, which may be minimal to keep it delicate. Fill in the veil as lightly as possible. Rendering for bridal wear is much more tender in contrast, for example, to a multilayered, more gutsy approach to sportswear.

These two sketches were done by constantly sharpening the pencil, at least five times during one drawing. Or you can sharpen five pencils all at once; as soon as one point gets dull, pick up the next sharper one. This helps you to control your line quality from top to bottom in the sketch.

BEROL PRISMACOLOR PENCIL BLACK

COLOR PENCIL RENDERING FOR VEIL

76

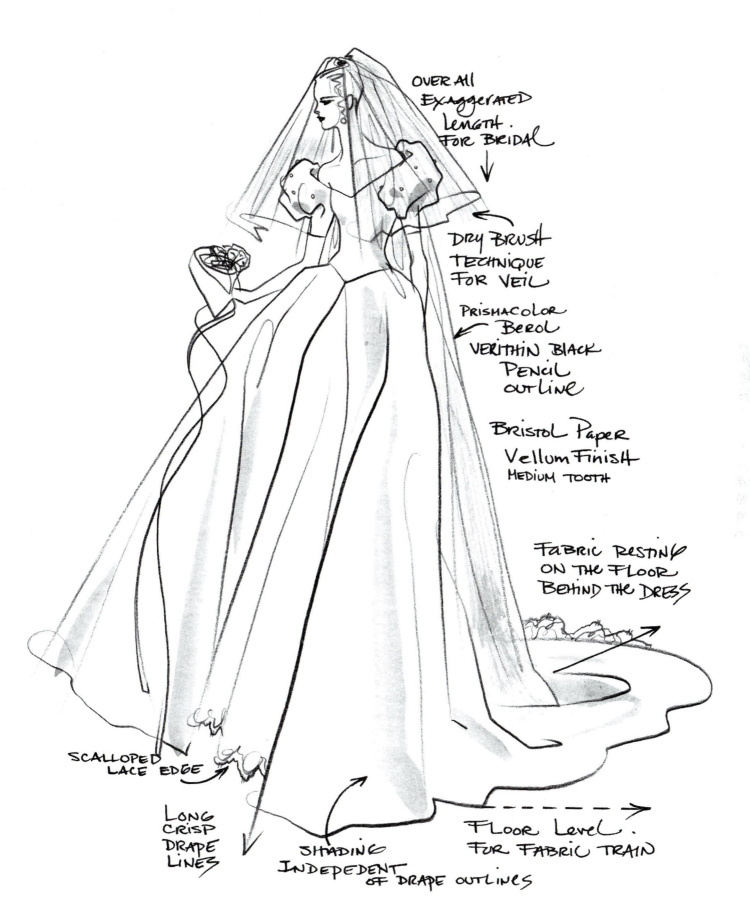

OVERALL
EXAGGERATED
LENGTH.
FOR BRIDAL

DRY BRUSH
TECHNIQUE
FOR VEIL

PRISMACOLOR
BEROL
VERITHIN BLACK
PENCIL
OUTLINE

Bristol Paper
Vellum Finish
MEDIUM TOOTH

FABRIC RESTING
ON THE FLOOR
BEHIND THE DRESS

SCALLOPED
LACE EDGE

LONG
CRISP
DRAPE
LINES

SHADING
INDEPEDENT
OF DRAPE OUTLINES

FLOOR LEVEL.
FOR FABRIC TRAIN

SUPPLIES

Marker paper pad: Bleed proof, 11 × 14

 Markers: Get the palest of pales in colors, 10%, 20%, etc. in greys

 Flesh tones/hair: See Chapter 3

 Pens: Bleed-proof, fine-point

 Gel pens and white china marker pencil

 Colored pencils: White

 White paint tempera and gouache

Watercolor paper: Hot press, vellum finish, approximately 11 × 14

 Gouache, watercolor, or tempera

- Mix to the lightest possible tints
- Mix black to a watery grey (transparent)
- Mix black and white for a (opaque) grey

 Pencil: Your choice for outlining

 Palette, water cup, and towel wipe

 Flesh tone/hair: See Chapter 3

 Brushes: #1 and #7

ASSIGNMENT

Refer to pages 70 and 71 in this chapter as the simplest place to start practicing for white fabric rendering. Move on to the other shapes as you progress into more calculated results. Put three simple figures together on a page. Render each one differently from the other. Test your skills against the limits of the media. Which methods work the best for you? What was the quickest technique to execute on the page? If you have samples, swatches to render for specific results, adapt any of the techniques in this chapter to achieve the look of your swatches or invent new methods utilizing the skills gleaned from the book's examples. Remember to label every step and to note every supply that you used next to each fabric you have rendered.

CHAPTER 6

SIMPLE PRINTS

Simple print fabrics help you learn the basics of rendering before you delve into more intricate patterns, such as paisley or plaid, that have a complex structure and a multicolored intricate design. These easy prints start with stripes—tiny pin stripes to bigger awning stripes. Also included are checks—thick buffalo checks to the long, thin windowpane checks— and the simple checkerboard of average size. This chapter works with the gingham pattern, a familiar kitchen print that is also popular in children's wear fabrics. It, too, comes in a variety of sizes. What these prints have in common, in this chapter, is that they are all on a white background fabric. Their simplicity lies in their one-color print, which makes it easier to practice, in marker or paint, rendering the shadow and then the print in two or three steps on a garment for fashion. You can practice with other easy prints, such as polka dots or an uncomplicated floral, to build up your confidence in rendering and to develop the skills to handle more challenging fabrics.

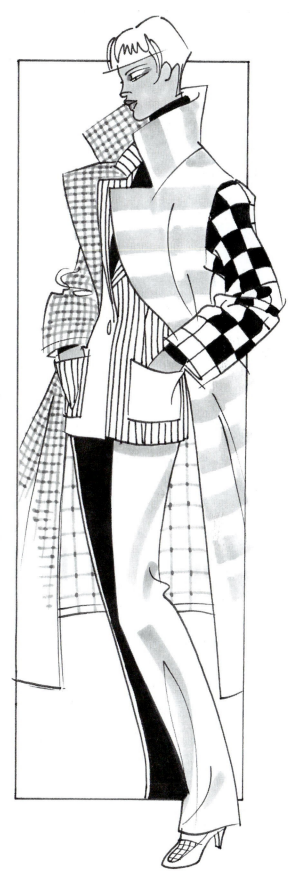

RENDERING STRIPES

Stripes can be vertical, horizontal, or diagonal. To begin, use a medium-size stripe in a summer weight fabric. Remember, the first step is to put in a bit of shading before starting to render the print. Stripes, like most prints, are affected by the direction of the fabric in the garment construction. These examples should help you practice these directions.

Horizontal and vertical stripes on a plain-front garment (shorts in this example) can curve a bit around the hipline area near the waistband seam. The horizontal stripes start to imitate the folds in the curve of the hemline at the bottom of any garment. The vertical stripes, starting at center front by the waistband seam, move out toward the outline contour at the hip where they are drawn off the edge.

Gathered fabric tends to crush the stripes on any fabric weight into multiple folds at the seam in the waistband. Horizontal folds get lost in these gathers, falling in front of or behind the fabric's crush lines in your sketch. Vertical stripes, as they reach the hem, must mimic the hemline's curve as they respond to the flow of drape in a garment. Horizontal stripes just ride those folds in a straight line on center front and then curve left or right over the corresponding hipline direction of the garment.

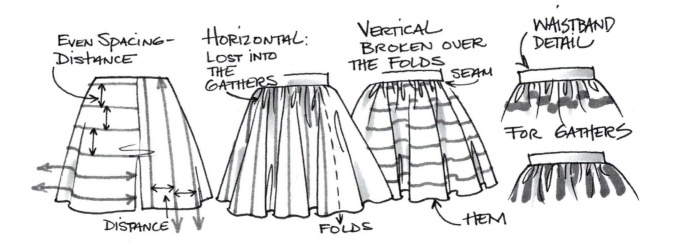

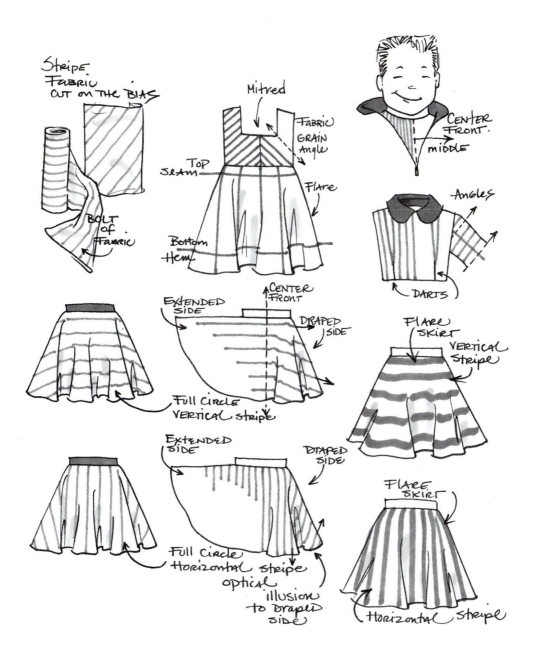

Stripes on the straight grain or on the bias (angled sideways to create a slanted stripe) always fall according to construction within a garment. Seams and darts can affect a stripe's direction. Volume in the fabric can alter, in an optical illusion, the direction of the stripes. The easiest way to render stripes is to start in the middle of a garment or closest to the construction detail that affects the stripe's position.

RENDERING GINGHAM

Gingham rendering involves putting a vertical and horizontal stripe together on one garment. Rendering stripes in both directions takes more planning; you must allow for the angles of the collar, the bodice, and the sleeve, as shown in the illustration. Even the cuff at the end of a sleeve follows its own path as you render your gingham fabric.

The first step in rendering a print on a white background fabric is to put in the shading. The next step is to plan out the middle or central cross of the gingham print on each construction shape on the garment you have drawn. When that plan is fixed, continue rendering the gingham, carefully focusing on the spacing of each row against the other.

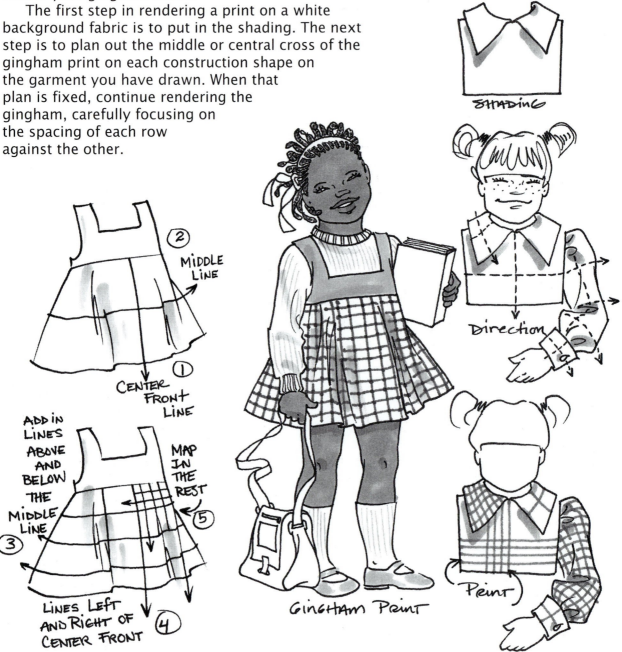

SHADING

MIDDLE LINE

② ①

CENTER FRONT LINE

ADD IN LINES ABOVE AND BELOW THE MIDDLE LINE

③

MAP IN THE REST ⑤

LINES LEFT AND RIGHT OF CENTER FRONT ④

Direction

Print

GINGHAM PRINT

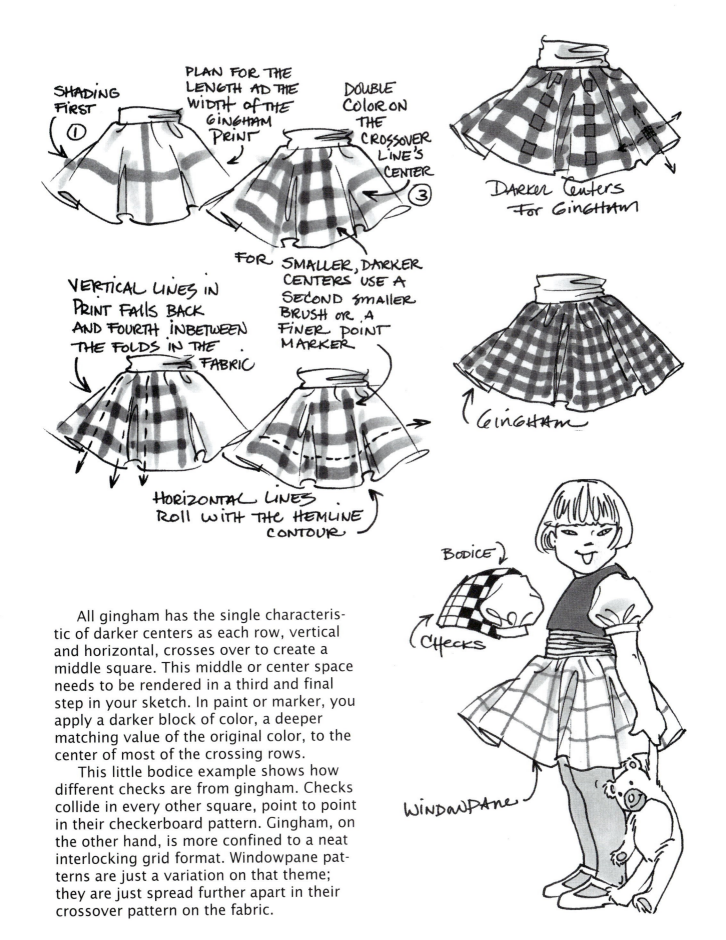

SHADING FIRST ①

PLAN FOR THE LENGTH AD THE WIDTH OF THE GINGHAM PRINT

DOUBLE COLOR ON THE CROSSOVER LINE'S CENTER ③

FOR SMALLER, DARKER CENTERS USE A SECOND SMALLER BRUSH OR A FINER POINT MARKER

DARKER CENTERS FOR GINGHAM

VERTICAL LINES IN PRINT FAILS BACK AND FOURTH INBETWEEN THE FOLDS IN THE FABRIC

HORIZONTAL LINES ROll WITH THE HEMLINE CONTOUR

GINGHAM

BODICE

CHECKS

WINDOWPANE

All gingham has the single characteristic of darker centers as each row, vertical and horizontal, crosses over to create a middle square. This middle or center space needs to be rendered in a third and final step in your sketch. In paint or marker, you apply a darker block of color, a deeper matching value of the original color, to the center of most of the crossing rows.

This little bodice example shows how different checks are from gingham. Checks collide in every other square, point to point in their checkerboard pattern. Gingham, on the other hand, is more confined to a neat interlocking grid format. Windowpane patterns are just a variation on that theme; they are just spread further apart in their crossover pattern on the fabric.

CUT AND DRAPE

These pages illustrate how garment construction—the cut and drape of the fabric—affect your rendering process. Garment design decisions factor into the rendering because that is where the placement for the direction of the stripes begins. For instance, the blouse has a collar with bias-cut fabric sewn onto the lapel. The lapel is a folded over straight-grain flap of the same fabric direction as the bodice. As you look at the blouse you see the three stripe directions in the fabric. The same stripe is rendered on the sleeve and the cuff, which have stripe directions of their own. Keep in mind that a bent arm will alter the stripe more than a straight, extended arm.

Polka dots may be random or organized. The skirt on this page illustrates the organized, systematic rendering of these dots that are more equidistant from each other. They can be just as easily mapped out in a grid formation like the check or gingham prints.

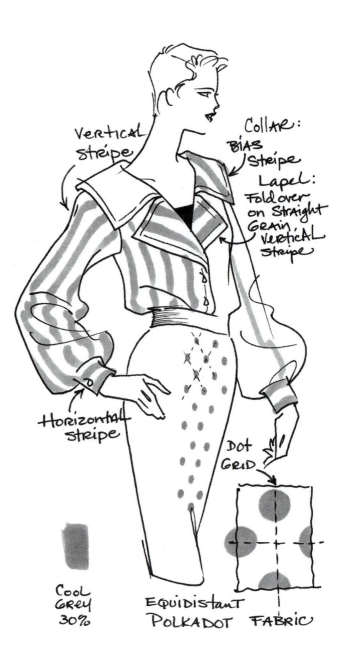

Vertical Stripe

Collar: BIAS Stripe

Lapel: Fold over on Straight Grain vertical stripe

Horizontal stripe

Dot Grid

Cool Grey 30%

EQUIDISTANT POLKADOT FABRIC

84

This page shows more examples of how construction—the cut and tailoring of a garment—can influence your rendering. In the classical approach to sketching, the fabric is drawn and rendered in a direct relationship to the contours in the body. This translates into rendering that reflects those contours, as the examples demonstrate.

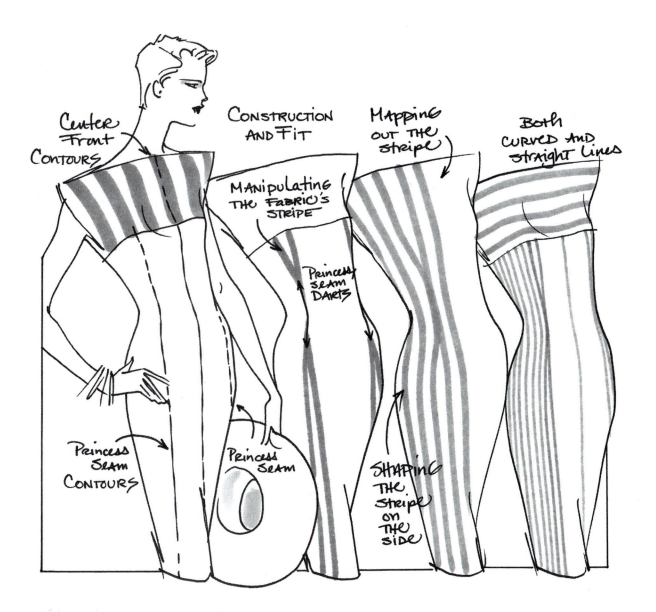

Center
Front
Contours

Construction
and Fit

Mapping
out the
stripe

Both
Curved and
straight lines

Manipulating
the Fabric's
stripe

Princess
Seam
Darts

Princess
Seam
Contours

Princess
Seam

Shaping
the
stripe
on
the
side

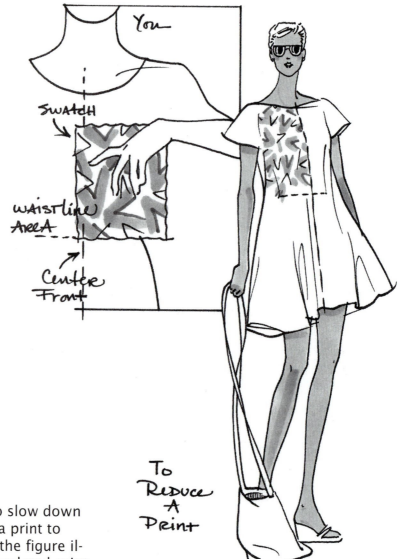

Here is a great place to slow down and learn about reducing a print to match the relative size of the figure illustration. The reduced, rendered print must reflect its actual size in proportion to the garment.

The best way to analyze the size of any fabric is to hold it up to your own body. Place it on center front, hold it toward the front of your body, and stretch it out toward the side seam on your figure (left or right direction, it doesn't matter). Now count the number of stripes or pattern repeats in that swatch or unit of fabric in your hand. This count of stripes or amount of print is roughly the count you want to represent in the matching (same location) area on the figure in your sketch. Keep in mind that some tiny stripes or prints just have to be faked so they do not merge into a solid color when they are reduced.

86

SUPPLIES

Marker paper pad: Bleed-proof, 11 × 14

 Markers: Broad-tip and fine-tip

 Colors: Any related or analogous colors. One for fabric color match. One for related color or grey for shading.

 Flesh tone markers: See Chapter 3

 Pens: Fine-point

Watercolor paper: Hot press, vellum finish, approximately 11 × 14

 Gouache or water color pans or dots

 Palette, water cups, towel wipe

 Colors: Any related or analogous colors. One color for fabric color match. One related color for shading mix. Black for shading into color mix.

 Flesh tone mix: See Chapter 3

 Pencils: Your choice for outlining

 Brushes: #7 and #1

ASSIGNMENT

Set up another page of simple garments, as on page 81, for fabric rendering practice. Leave enough space for three rows of two or three garments across. Drop in a bit of shading since all of the prints in this assignment will be on a white background fabric. With the subtle shading process completed, try out vertical and horizontal wide or thin stripes on the first two rows. Save the third row to practice the gingham fabric, also in at least two sizes of small or large gingham prints.

 For an alternative assignment, reduce a stripe or any other simple print on a white background fabric. (These are far less complicated to render and less time consuming at the start.) Use page 86 as a guide to help you accomplish the reduction. You might render the largest or darkest color last in paint, but it can be first in marker. However, this is not true for every fabric.

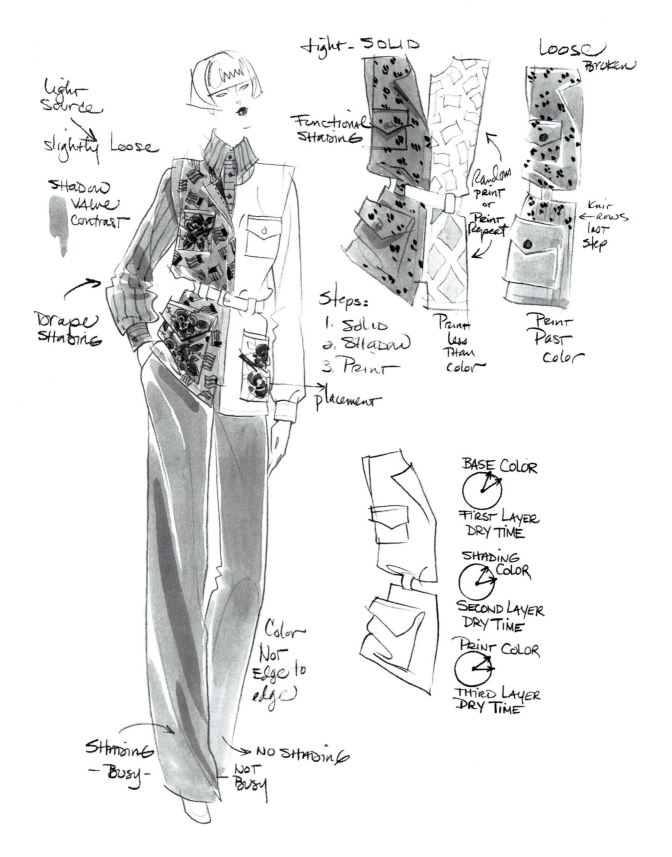

Light
Source

slightly Loose

SHADOW
VALUE
Contrast

Drape
Shading

tight - SOLID

Functional
Shading

Random
print
or
Print
Repeat

Print
Less
Than
Color

LOOSE
Broken

Knit
Rows
Not
Step

Print
Past
Color

Steps:
1. Solid
2. Shadow
3. Print

placement

Color
Not
Edge to
edge

SHADING
- Busy -

NO SHADING
NOT
BUSY

BASE COLOR

FIRST LAYER
DRY TIME

SHADING
COLOR

SECOND LAYER
DRY TIME

PRINT COLOR

THIRD LAYER
DRY TIME

SIMPLE PRINT ON COLOR BACKGROUND

Now that you have practiced one solid color print on a white background fabric, you should move onto the next level: a simple print on a colored background. The coloring technique requires the new first step of a solid, flat color wash. Flat means without shading. Adding shading, which usually involves using a light source direction as you practiced in earlier chapters, is the second step. Shading can be a darker, contrasting version of your original wash's color. Both colors have to dry before you block in your print.

Prints can be random or structured; you're the judge of that. In a repeat pattern you have to map out the print. With a flat color background, you can decide to fill in all or just some of the print once you have reduced it to fit into your sketch. Your print can be rendered more or less than your colored background area. It is all in the style, tight to loose, that you work in for your rendering technique.

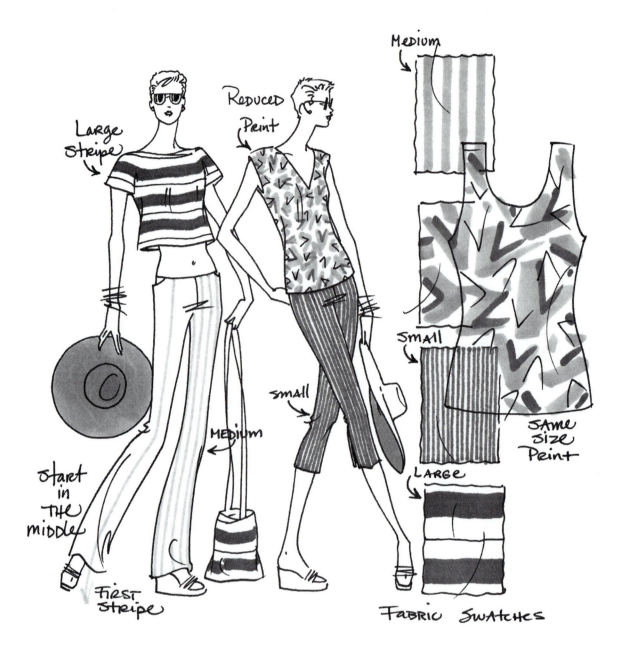

Large Stripe

Reduced Print

Medium

Medium

Small

Same Size Print

Start in the middle

First Stripe

small

Large

Fabric Swatches

The three sizes of stripes and one easy print represent (roughly) life-sized swatches of fabric. These same swatches have been reduced to capture the nature of the stripes and print as interpreted, in my style, for the fashion outfits on this page. This is not a scientific, precise reduction. It is just close enough to give an idea of how these four fabrics would look together. The degree of accuracy is something for you to decide based on the task at hand. Some jobs require more or less precision than others. This is a good pace to start to learn how to reduce a print for fashion design illustrations, because these are the least complicated to practice.

CHAPTER 7

FALL FABRICS

There is an amazing number of heavy (or tropical) weight fabrics in the fall/winter selection in any given design category. In that number are the staples, the classics, that never seem to go out of fashion. This chapter deals with the most commonly used, classic fabrics. There are tweeds, herringbones, and houndstooths that have a set pattern repeat that comes in all sizes. Plaids also come in many varieties with names like glen plaids or tartans. This chapter covers twill weaves such as denim or gabardine and a pile fabric called corduroy. These specific fabrics are staples in your rendering techniques. It is their weight, surface, and volume that requires new drawing or rendering techniques. These fabrics can be thicker and heavier and they may be worn in layers. This adds weight and volume in your fashion sketch. You will need to be generous with your shapes and work on your line quality to stand up to the task of rendering denser patterns and textures. You will end up using and mixing more media—as in blending pencils, markers, or paint—to create the visual surface of these fabrics in your sketches.

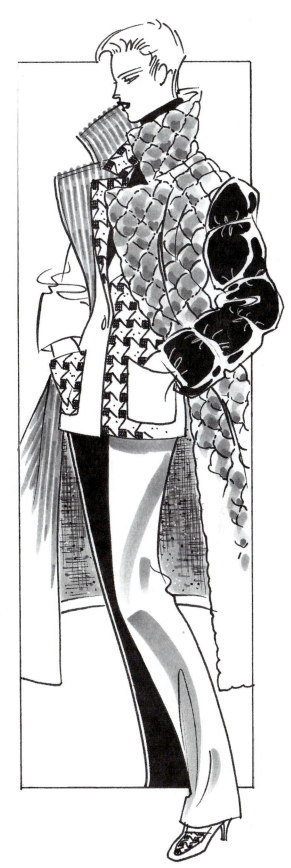

Fall/winter clothing should be drawn with an emphasis on how much thicker, heavier, or layered it might be in contrast to the lighter, thinner, closer-to-the-body garments of spring/summer clothing.

For kids, fall/winter clothing can be greatly exaggerated. But most of that exaggeration holds true for adults, too, since every new layer of clothing has to be drawn with ever increasing volume to accommodate the extra fabric's volume.

WINTER SUMMER

DOUBLING THE SIZE

Beyond THE FORM

CLOSE TO THE BODY

INCREASED VOLUME

SKIMPY SUMMER WEIGHT

A summer lightweight topper or vinyl raincoat is drawn much narrower than a heavyweight deep-winter coat. You illustrate this difference by moving your clothing contours closer or farther away from the body you are dressing in your sketch.

92

Fall/winter clothing can be fuller and higher on the neck. Armholes can be deeper. Fabric covering the arms can be drawn thicker. Fabric across the waistline can be wider. Hems at the cuff of the pants, the sleeves, or the end of a coat should be drawn with broader edge so that they look roomy enough to have another unseen layer beneath them.

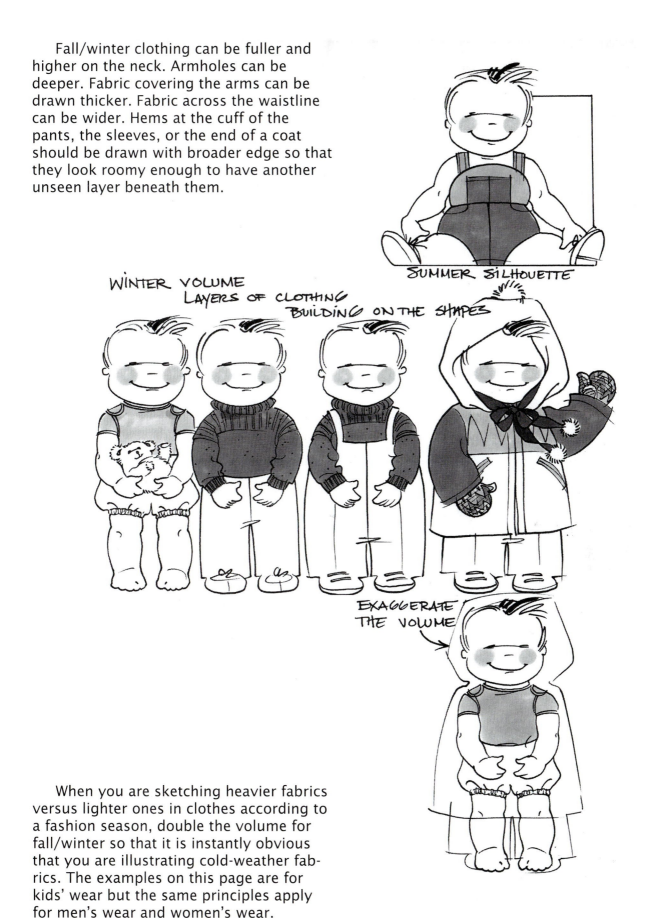

SUMMER SILHOUETTE

WINTER VOLUME
LAYERS OF CLOTHING
BUILDING ON THE SHAPES

EXAGGERATE THE VOLUME

When you are sketching heavier fabrics versus lighter ones in clothes according to a fashion season, double the volume for fall/winter so that it is instantly obvious that you are illustrating cold-weather fabrics. The examples on this page are for kids' wear but the same principles apply for men's wear and women's wear.

RENDERING PANTS

Pants are staples in any fall collection. Rendering for pants starts with a solid background and then a layer of shading to accentuate the pose and drape. Here are a few examples of this type of shading for pants. Pants in almost any design silhouette drape from the hip with a break line near the knee which slips the line down toward the ankle. Make sure the shadow on the left leg looks different than the shadow on the right leg to give the pants a look of spontaneous, unplanned rendering. It's a natural look since shadows are rarely ever even on any shape.

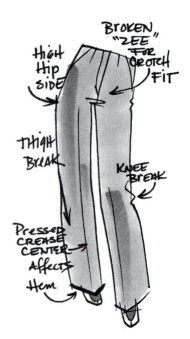

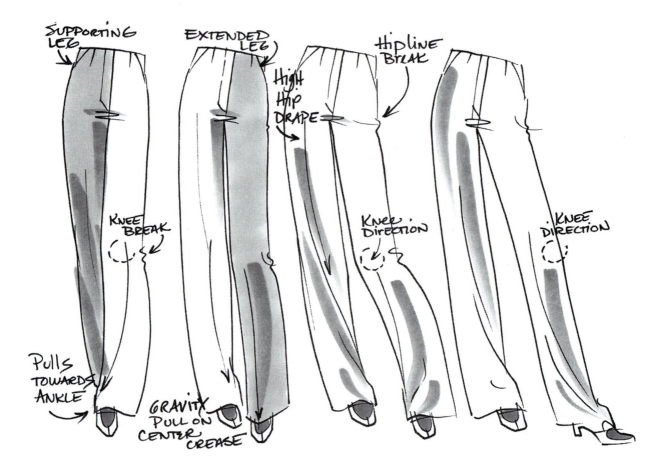

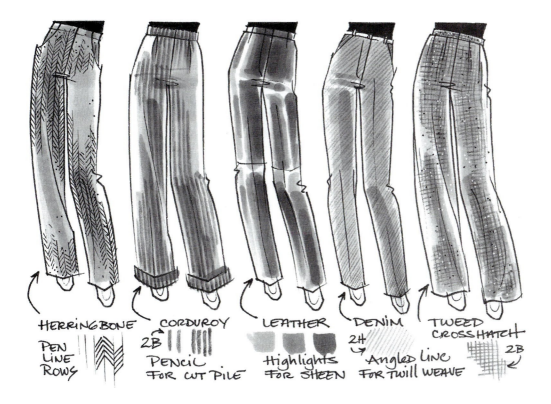

HERRINGBONE — PEN LINE ROWS

CORDUROY — 2B PENCIL FOR CUT PILE

LEATHER — Highlights for sheen

DENIM — 2H Angled line for twill weave

TWEED — CROSSHATCH — 2B

Here are five of the most popular fall fabrics in varying degrees of partial to completed rendering. These fabrics will be covered in depth farther into this chapter. This gives you a chance to practice mixing markers with pencils to create the illusion of surface on your sketch while deciding just how much of that surface to illustrate on your garment. The beauty of partial rendering is that it shows just enough surface without overwhelming the silhouette. Too little rendering would make the same drawing look incomplete. It's a fine lesson to learn: what is too much, too little, or just enough. The answer is usually related to individual style choices. Here are mine.

FABRIC SURFACES

Like prints, textured surfaces are rendered in layers, one step at a time. Your base wash, the first layer, is the foundation color. It can be the lightest value with each additional layer getting darker. Some fabrics need, in their last step, a few strokes of a lighter color just to pick up detail or provide an accent.

You need to practice matte and shiny fabrics, for any season. For fall these fabrics might be a matte leather with a dull, coarse surface or another type of leather with a glossy surface and a high shine to it. Fall fashions often mix fabrics so your rendering will end up being as multilayered as it is multicolored.

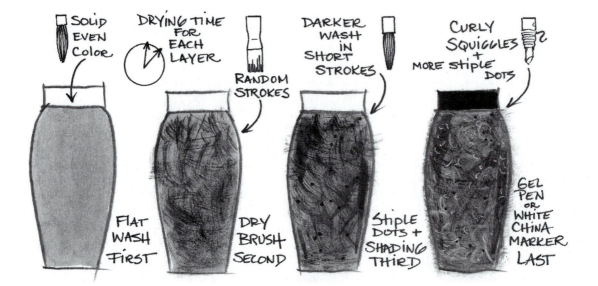

This spread explores some of the different painting techniques: wet wash, dry brush, and multilayered rendering. To practice these techniques you need to repeat a silhouette, the same shape, so you learn to control the paint within an area. These skirt demonstrations illustrate control and experimentation with the process.

For dry brush technique, use just the tip of your brush, flat or rounded. Touch the brush to the paint and dab it (without going near your water) on your towel, wiping away excess paint only. You then dry the brush, tip side, actually skimming the page, in a particular direction. A fuzzy woolen fabric like this shaggy melton gets many directions. The faux fur on the facing page gets a circular motion.

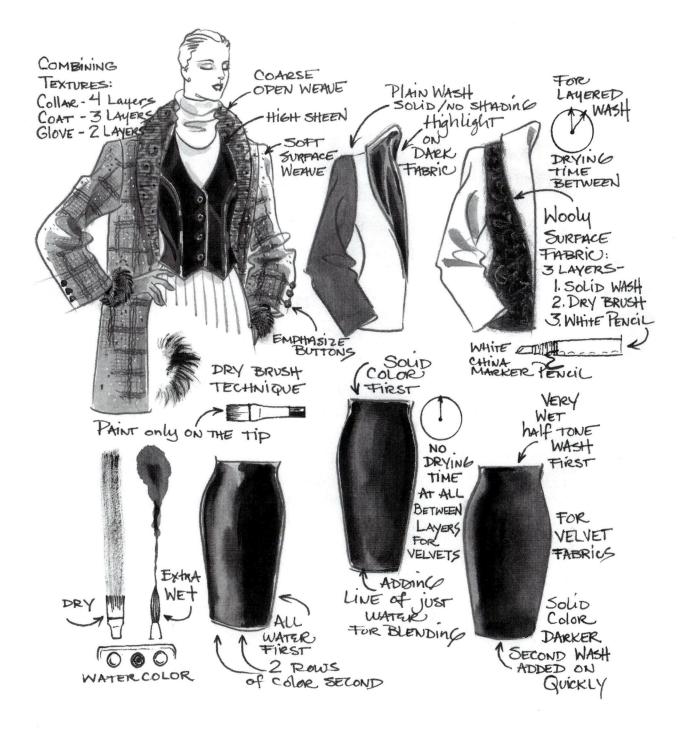

COMBINING TEXTURES:
Collar - 4 Layers
Coat - 3 Layers
Glove - 2 Layers

COARSE OPEN WEAVE

HIGH SHEEN

SOFT SURFACE WEAVE

PLAIN WASH SOLID / NO SHADING

Highlight ON DARK FABRIC

FOR LAYERED WASH

DRYING TIME BETWEEN

Wooly SURFACE FABRIC:
3 LAYERS -
1. SOLID WASH
2. DRY BRUSH
3. WHITE PENCIL

WHITE CHINA MARKER PENCIL

EMPHASIZE BUTTONS

DRY BRUSH TECHNIQUE

PAINT only ON THE TIP

DRY

EXTRA WET

WATERCOLOR

ALL WATER FIRST
2 ROWS of COLOR SECOND

SOLID COLOR FIRST

NO DRYING TIME AT ALL BETWEEN LAYERS FOR VELVETS

ADDING LINE of JUST WATER FOR BLENDING

VERY WET half TONE WASH FIRST

FOR VELVET FABRICS

SOLID COLOR DARKER SECOND WASH ADDED ON QUICKLY

Wet washes can be done in a variety of methods. Here are three to practice. Wet wash has the opposite effect of the dry brush technique. This time you want as much water as possible before you even add your paint. The trick is to prevent it from dripping out of your silhouette. It is a balance between too much or too little and that is what experience will teach you.

Some fabrics shine in the middle; others, such as velvets shine, just a bit, at their outside edge. Paint velvets with a hint of light to represent their sheen and a depth to display their nap. A solid-color velvet seems to reflect shades or tints of its hue. That is why a wet wash, which can render color modulations, is a great technique for rendering velvet.

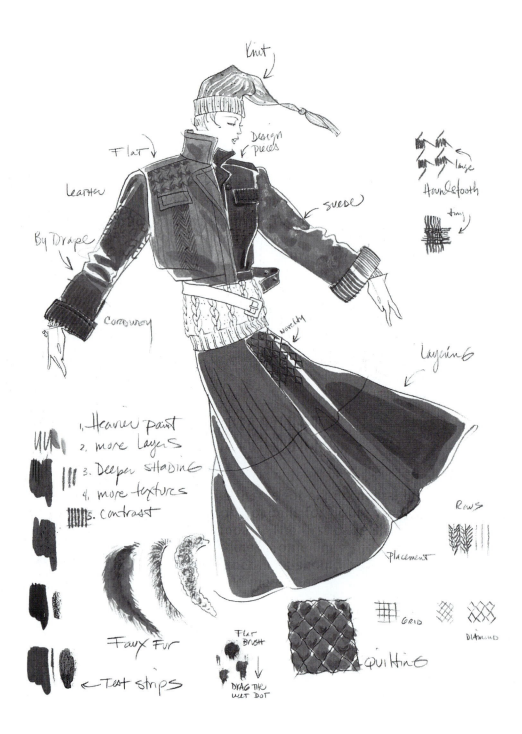

Knit

Flat

Leather

By Drape

Corduroy

Design pieces

suede

Novelty

Layering

Large
Houndstooth
tiny

1. Heavier paint
2. more Layers
3. Deeper shading
4. more textures
5. Contrast

Faux Fur

Test strips

Fur Brush

DRAG THE WET DOT

QUILTING

Placement

Rows

GRID

DIAMOND

Fall fabrics should look thicker, heavier. Try to keep your paint full-bodied-thick without getting pasty or sticky. On your sketch you can paint in big wedges, coloring from seam to seam, leaving a hint of light on the details. You can also paint in the complete shape, edge to edge, using shading to pick up the details. After full-color coverage you can go back into your sketch with your pencil or pen to emphasize the seams, buttons, or other major design elements that got blurred by the heavy wash of color.

98

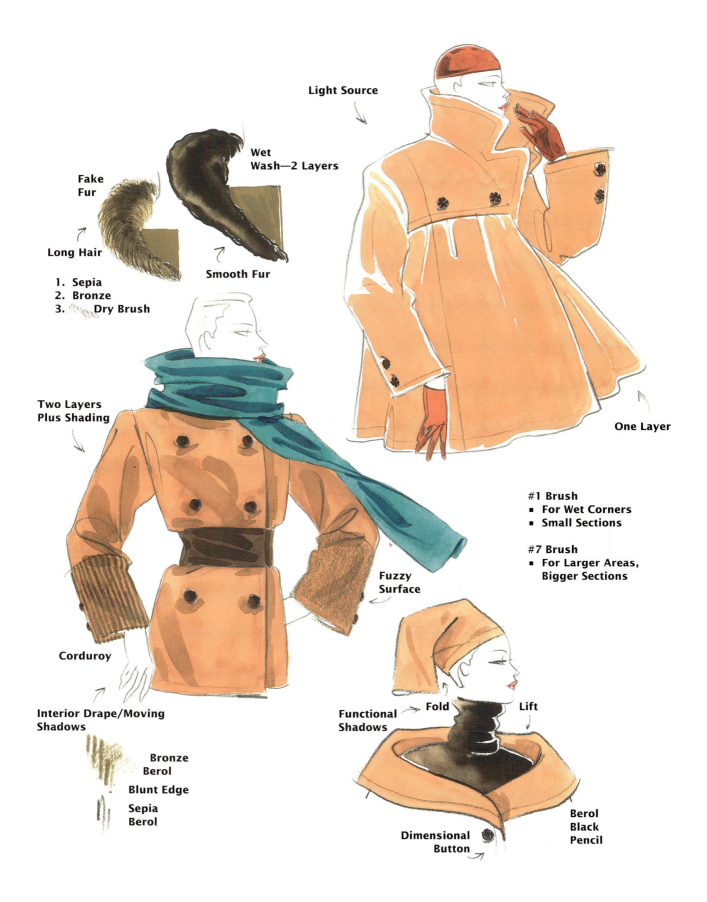

Light Source

Wet
Wash—2 Layers

Fake
Fur

Long Hair

1. Sepia
2. Bronze
3. Dry Brush

Smooth Fur

Two Layers
Plus Shading

One Layer

#1 Brush
- For Wet Corners
- Small Sections

#7 Brush
- For Larger Areas,
 Bigger Sections

Fuzzy
Surface

Corduroy

Interior Drape/Moving
Shadows

Bronze
Berol

Blunt Edge

Sepia
Berol

Functional
Shadows

Fold

Lift

Berol
Black
Pencil

Dimensional
Button

99

MARKER RENDERING FOR FALL FABRICS

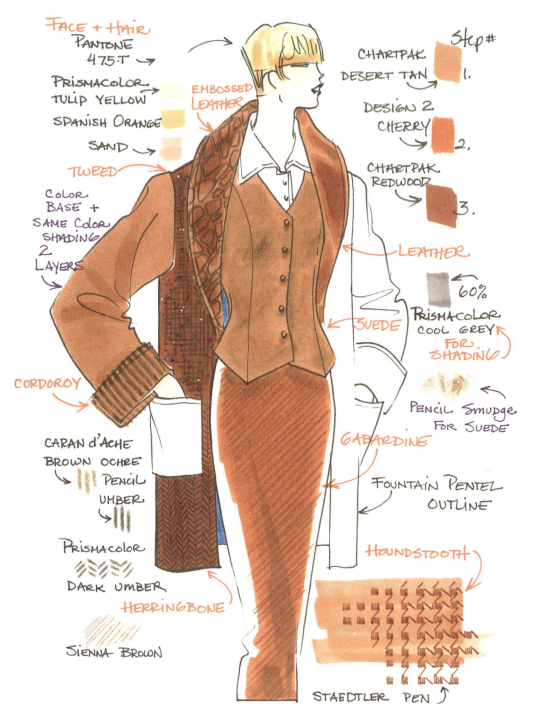

FACE + HAIR
PANTONE
475·T →

PRISMACOLOR
TULIP YELLOW
SPANISH ORANGE
SAND →

EMBOSSED
LEATHER

TWEED →

COLOR
BASE +
SAME COLOR
SHADING
2
LAYERS

CORDOROY

CARAN d'ACHE
BROWN OCHRE
↓ PENCIL
UMBER
↓

PRISMACOLOR
DARK UMBER
HERRINGBONE

SIENNA BROWN

CHARTPAK
DESERT TAN

Step #
1.

DESIGN 2
CHERRY
2.

CHARTPAK
REDWOOD
3.

LEATHER

SUEDE

60%

PRISMACOLOR
COOL GREY
FOR
SHADING

PENCIL SMUDGE
FOR SUEDE

GABARDINE

FOUNTAIN PENTEL
OUTLINE

HOUNDSTOOTH

STAEDTLER PEN ↑

Marker rendering for fall fabrics looks easier than paint but it can involve so many more colors to combine just to reach the one color you need. There are new markers on the market, such as blenders or others that you can mix, blending them into one color at your desk, as you need them. So, depending on your supplies, marker rendering can still involve multiple layers. Get out your pens and pencils to color match and practice the fabrics shown here. Markers will not go over pencil and they can make pen ink run, so always render with pencils or pens last.

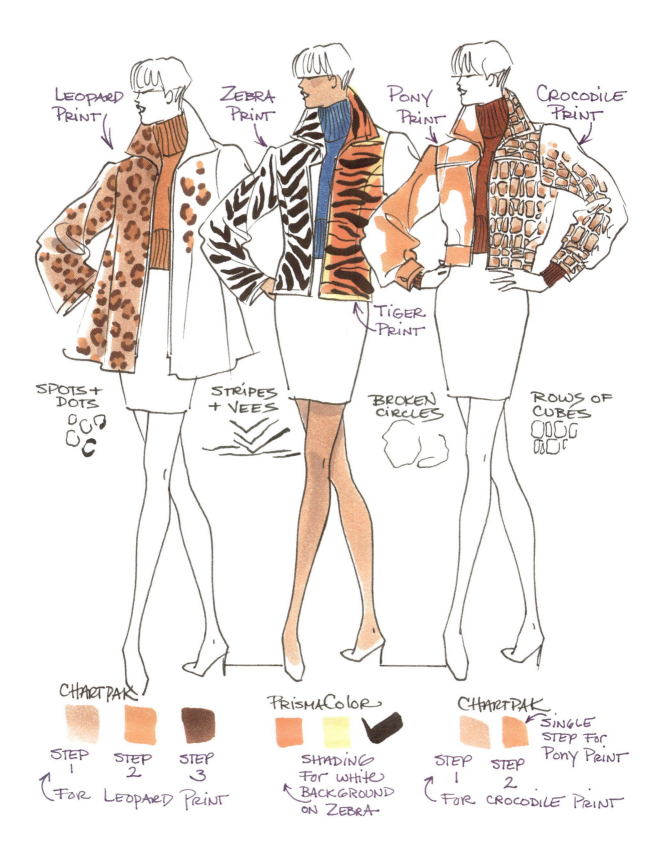

LEOPARD PRINT

ZEBRA PRINT

PONY PRINT

CROCODILE PRINT

TIGER PRINT

SPOTS + DOTS

STRIPES + VEES

BROKEN CIRCLES

ROWS OF CUBES

CHARTPAK

STEP 1 STEP 2 STEP 3

FOR LEOPARD PRINT

PRISMACOLOR

SHADING FOR WHITE BACKGROUND ON ZEBRA

CHARTPAK

SINGLE STEP FOR PONY PRINT

STEP 1 STEP 2

FOR CROCODILE PRINT

RENDERING A PLAID BLAZER

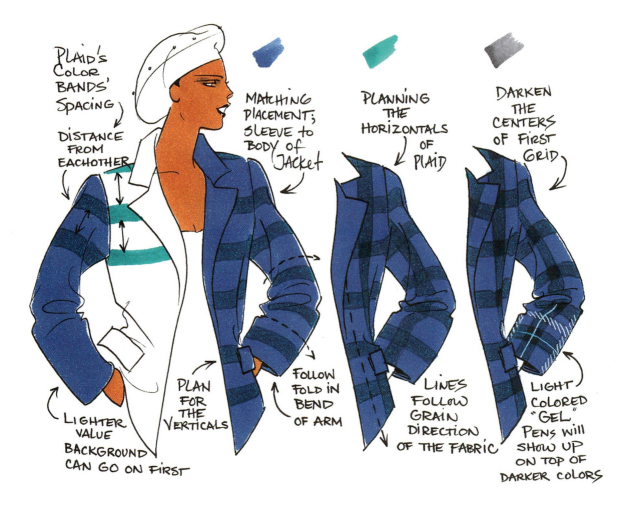

PLAID'S COLOR BANDS' SPACING

DISTANCE FROM EACHOTHER

MATCHING PLACEMENT; SLEEVE to BODY of JACKET

PLANNING THE HORIZONTALS OF PLAID

DARKEN THE CENTERS OF FIRST GRID

LIGHTER VALUE BACKGROUND CAN GO ON FIRST

PLAN FOR THE VERTICALS

FOLLOW FOLD IN BEND OF ARM

LINES FOLLOW GRAIN DIRECTION OF THE FABRIC

LIGHT COLORED "GEL" PENS WILL SHOW UP ON TOP OF DARKER COLORS

Someone is always designing a blazer and one of them is likely to be plaid, so here is one to practice on. It requires the same process as planning your stripe, with a bit of gingham and win- dowpane rendering combined. This time the rendering is going to get so layered that it is optional to put in shading. I left shading out of the steps to show you that rendering can look just as fin- ished without it in this type of pattern. A background color is an- other option based on the number of colors in your plaid fabric. If you need a first layer, background color, always select the lightest one (in large areas) to render first and the darkest one for last so the colors won't run into each other as they dry.

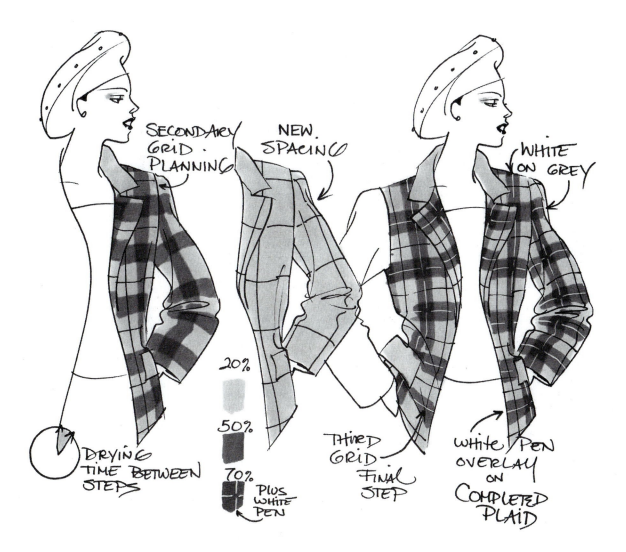

SECONDARY GRID PLANNING

NEW SPACING

WHITE ON GREY

DRYING TIME BETWEEN STEPS

20%

50%

70% PLUS WHITE PEN

THIRD GRID FINAL STEP

WHITE PEN OVERLAY ON COMPLETED PLAID

Render your plaid in stages. Map in your first, widest unit in the pattern as a stripe in one direction across the garment. Lay in the second perpendicular, matching wide stripe across the first, then darken each overlapping center in a third step. In the fourth step, you work on the finer, thinner lines of the plaid pattern across the garment in one direction (over the others) at a time. Each grid needs its own equal spacing as you map it in on the color priority; render lighter colors first, if possible. To complete some plaids, the lightest color, especially in a thinner line, goes on last, unless you have to go back in to make those centers even darker, for contrast.

FIT AND FABRICATION

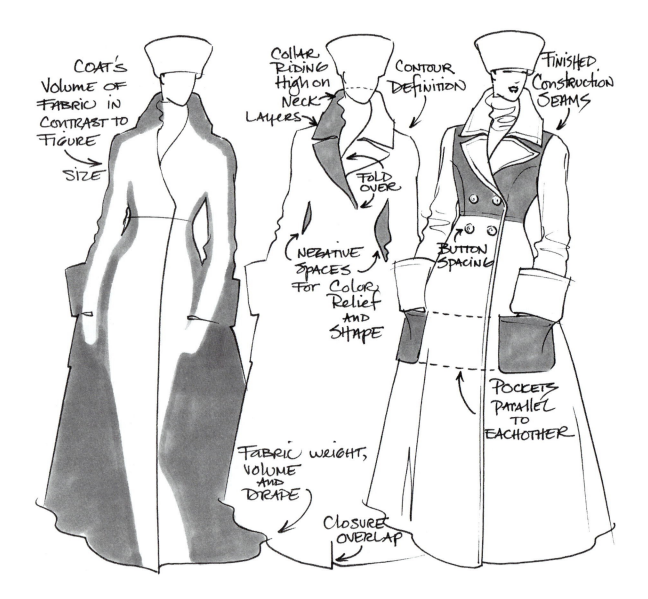

COATS
VOLUME OF
FABRIC IN
CONTRAST TO
FIGURE
SIZE

COLLAR
RIDING
HIGH ON
NECK
LAYERS

CONTOUR
DEFINITION

FINISHED
CONSTRUCTION
SEAMS

FOLD
OVER

NEGATIVE
SPACES
FOR COLOR
RELIEF
AND
SHAPE

BUTTON
SPACING

FABRIC WEIGHT,
VOLUME
AND
DRAPE

POCKETS
PARALLEL
TO
EACHOTHER

CLOSURE
OVERLAP

Sketching coats in fashion design illustration is usually about shape: the cut of the coat—its fit and fabrication. Shape and fabrication overlap in your sketching priorities. The thickness, the bulk, and volume of the fabric in that coat's shape affect how it's going to fit on the body.

Detailing is also crucial. The design point of view is emphasized in the details. Exaggerate, in artistic license, these details. You can overstate the collar, the cuffs, the fit at the waist, or the buttons' size so that the overall silhouette is generously proportioned. This makes a fashion statement in shape before you even get to the rendering process.

104

TRIMS AND NOTIONS

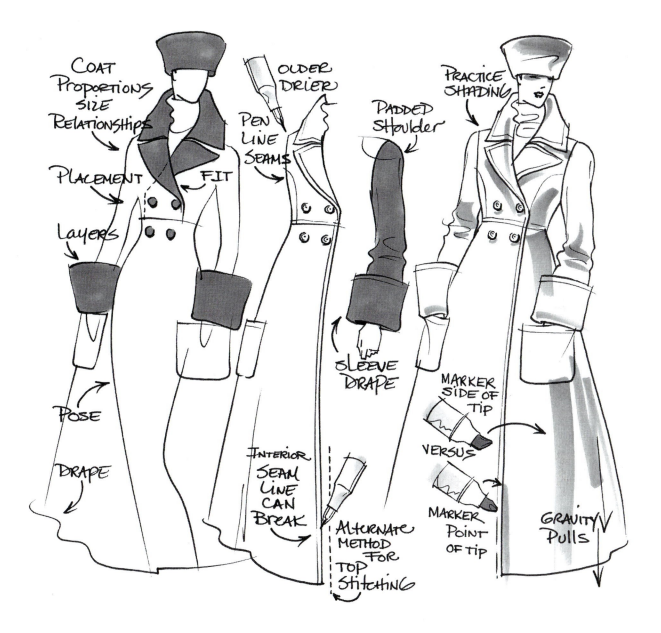

Pay attention to all of the minor details in trims and notions on any design, but especially in winter fabrics because little details can get lost in all of the layers of pattern rendering. Plan their placement carefully. Map out where top stitching or other seaming and construction lines should fall on the figure inside the garment.

Shading on fuller silhouettes such as a coat in a heavy fabric should look thicker, more dramatic, where necessary. Think about the volume and layers of fabric overlapping each other in the garment. Accent the collar as it lifts over the bodice of the coat. Gently bend the sleeve near the elbow to keep its shadow from looking too stiff. Let the line of shadow fall away from the outline, inside your shape, so it looks loose and natural.

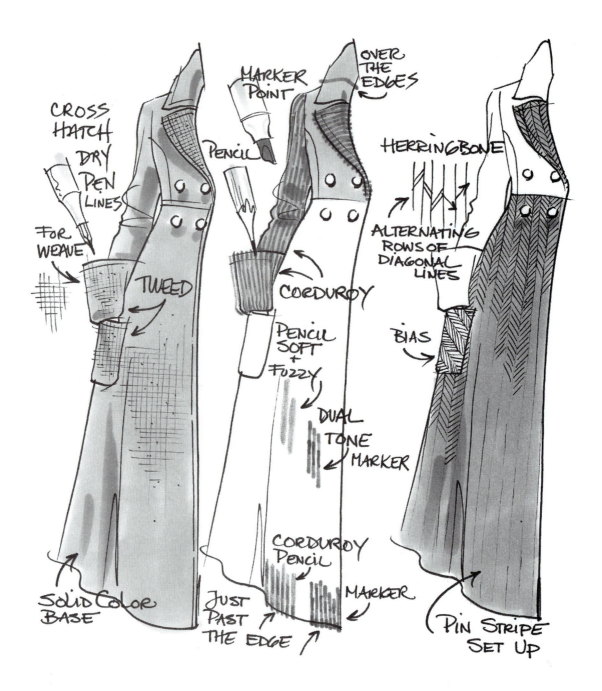

CROSS HATCH DRY PEN LINES

PENCIL

FOR WEAVE

TWEED

SOLID COLOR BASE

MARKER POINT

OVER THE EDGES

HERRINGBONE

ALTERNATING ROWS OF DIAGONAL LINES

CORDUROY

PENCIL SOFT + FUZZY

DUAL TONE MARKER

CORDUROY PENCIL

MARKER

JUST PAST THE EDGE

BIAS

PIN STRIPE SET UP

Tweed. Rendering a tweed usually involves some open-weave cross-hatching lines that can be done in pen or pencil, on top of a solid-color background rendering. Dots or dashes are filled in on top to reflect the fiber stubs of surface interest in a tweed.

Corduroy. Corduroy can be rendered in pencil or marker on top of a solid background color. You want to suggest a depth in the coloring to the rows, called pinwale or wide wale, that looks textured. That textured look can extend past the edges of the garment to add to the illusion of depth.

Herringbone. Herringbone rendering can start off as a lightly filled in pinstripe. You can use a pen or pencil line. Herringbone patterns in any size create chevrons of touching angles, all in continuous rows. These alternating rows of matching diagonal lines also can be done in pen or pencil.

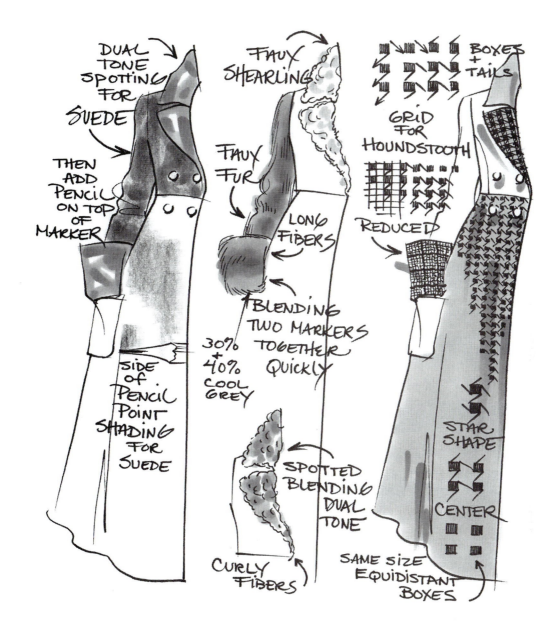

Suede. Suede can be very smudgy in your rendering. Suede can have a rough or smooth surface, but either way there is a bit of a nap that changes color. This creates a multitoned solid color that could get additional pencil rendering to add on the surface look.

Faux Furs. Faux furs have a fibrous edge depending on their particular hair types. Some are curlier than others or have longer or shorter fur-like contours. Your outline is an integral element in your rendering. It has to catch the nature of the fur's edge before you get into its tonal quality.

Houndstooth. Houndstooth has a checkerboard look to it but it really consists of boxes of equal size to equal rows that are painstakingly rendered in the larger sizes of this pattern. The smaller sizes are too tiny to render individually as squares, so they become connected, albeit wavy, lines to capture the nature of the print.

107

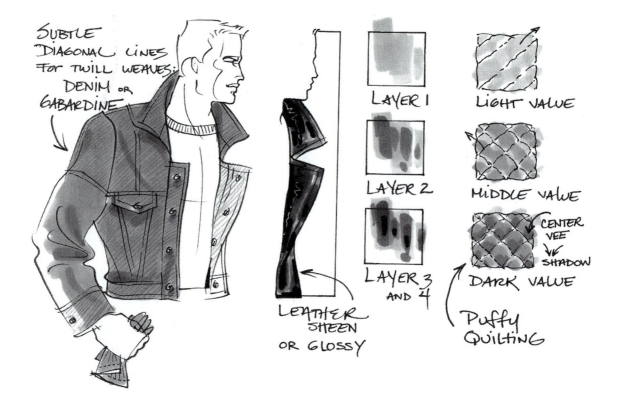

SUBTLE DIAGONAL LINES FOR TWILL WEAVES: DENIM OR GABARDINE

LAYER 1

LAYER 2

LAYER 3 AND 4

LEATHER SHEEN OR GLOSSY

LIGHT VALUE

MIDDLE VALUE

DARK VALUE

CENTER VEE

SHADOW

Puffy Quilting

Some rendering can be in straight, solid strokes of flat coloring. Your goal is often to render flat, nonstreaked color, especially in simple lightweight summer fabrics. Fall fabrics, because of their more developed patterns, are much more forgiving. Flat, solid coloring for fall fabrics is usually streaked on purpose or the streaks don't show because the next two layers of rendering hide them.

Other types of rendering can be in strokes of uneven coloring. For example,

look at the puffy quilting boxes on this page. The color went on in a wavy line of pressure and release on the marker's wedge tip. That created color nuance as each color value went over the next in that same wavy stroke. Light pops through the rendering that appears to raise the surface on the fabric. This technique is a visual trick, just like the flat multilayered sheen on a glossy leather. Both have three layers of color with quite different results.

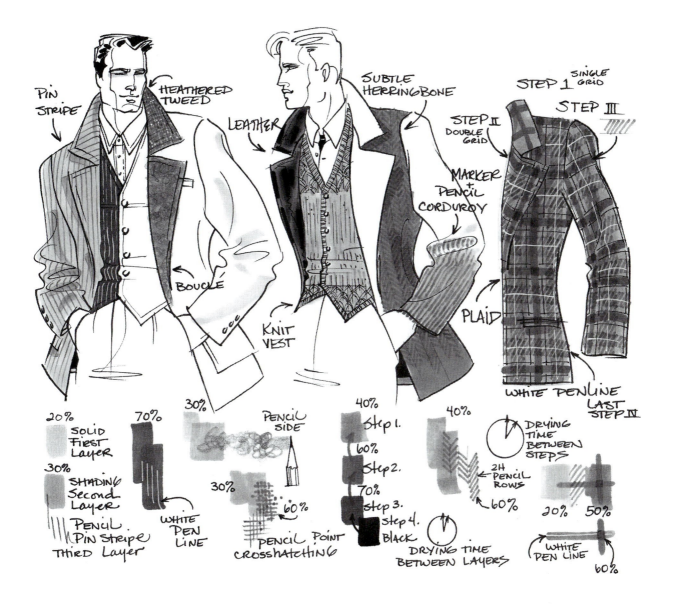

PIN STRIPE
HEATHERED TWEED
LEATHER
BOUCLE
SUBTLE HERRINGBONE
KNIT VEST
STEP 1 SINGLE GRID
STEP III
STEP II DOUBLE GRID
MARKER + PENCIL CORDUROY
PLAID
WHITE PENLINE LAST STEP IV

20% SOLID FIRST LAYER
30% SHADING SECOND LAYER
PENCIL PIN STRIPE THIRD LAYER
70%
WHITE PEN LINE

30%
PENCIL SIDE
30%
60%
PENCIL POINT CROSSHATCHING

40%
Step 1.
60%
Step 2.
70%
Step 3.
Step 4. BLACK
DRYING TIME BETWEEN LAYERS

40%
24 PENCIL ROWS
60%
DRYING TIME BETWEEN STEPS

20% 50%
WHITE PEN LINE
60%

These fabrics all need a solid background color with a deeper shading as their foundation. Then you can begin to develop patterns or textures in mixed media options—pens, pencils, or other markers. A reminder: markers of different brands may have a slight chemical reaction to each other if you use them together.

Also, they can react differently on a variety of papers; changing colors or bleeding (running) at the edge. Always keep a test (same paper) page to experiment on before you work on your good sketch. Always clean off the tip of your markers if they went over something darker. (Rub off their tips on your test sheet.)

SUPPLIES

Marker paper pad: Bleed-proof, 11 × 14

 Markers: Color-matched to specific fall fabrics, or use some of the browns you chose for rendering hair

 Flesh tone/hair: See Chapter 3

 Keep hair black, red, or blonde to differentiate it from the fabric browns.

 Colored pencils: In coordinating colors

 Pens: Bleed-proof, fine-point

Watercolor pad or paper: Hot press, vellum finish, approximately 11 × 14

 Paints: Colors related to specific fall fabrics (to be mixed) or use some of the colors used in flesh tone and hair coloring

 Pencil: Your choice for outlining

 Palette, water cups, and towel wipe

 Flesh tone/hair (see Chapter 3) will be in lighter values in contrast to the fabric's deeper colors

 Brushes: #1 and # 7

ASSIGNMENT

Sketch out a few jackets, as on pages 102 and 103. Get a solid background color on all of them. Add shading with an intensity appropriate to how many layers of rendering will go on top of it, or skip shading altogether. Shading can, with difficulty, be put on top of your finished fabric. Practice dissecting the textures or patterns in this chapter, one layer at a time. Do not discard mistakes. Label them as reference on what process not to repeat. You can learn from your rendering success, just keep lots of notes and practice the same techniques until you perfect the results.

CHAPTER 8

KNITS

There are always sketching and rendering problems to solve for knitwear fashions because there are different categories of knits. The distinctions between these categories— interlock, machine knits, and hand knits—are constantly blurring as the technical aspects evolve. Interlock or jersey is the name for tee-shirt fabric. The cut-and-sew blanket knits are similar to hand-knit sweaters, but they are by machine instead of by hand. Finer gauge (rachel) rib knits can be as smooth as jersey knits, while machine and hand knits can have rib-knit rows of texture. Knits are incredibly fun to draw. The challenge lies in their range of textures, patterns, and surface interest. This chapter introduces you to the simplest sketching and rendering techniques for knitwear fashions. In the fashion industry, knits are often drawn with cloth, so you can take the skills learned in this chapter and combine them with what you practiced in other chapters. You will be able to create intricately illustrated fashion design sketches. From now on, when you look at or imagine a knit for a sweater, you will be free to invent new sketching solutions.

Moving into knitwear rendering territory gives you a chance to explore the drawing solutions for a variety of novelty stitches, trims, and notions that you might find in other categories but which are easiest to practice here. So much comes into play for sweater design that you want to determine which ones, such as top stitching or yarn treatments, need to be mapped out in detail. Here are a few examples of options in line drawing solutions. For instance, notice that the lines used for embroidery or crochet could be interchangeable; both involve decoration and its direction of print. The same type of line used for rib casing is all about distance or proximity. Take a look at the lines used to express fringe versus those used for the knit rows: One is uneven while the other is very even. Knit rows in line are an abbreviation of the knit and purl seed stitches. Crochet, which is more of a loop than a stitch, is often still drawn as a line in a fashion sketch.

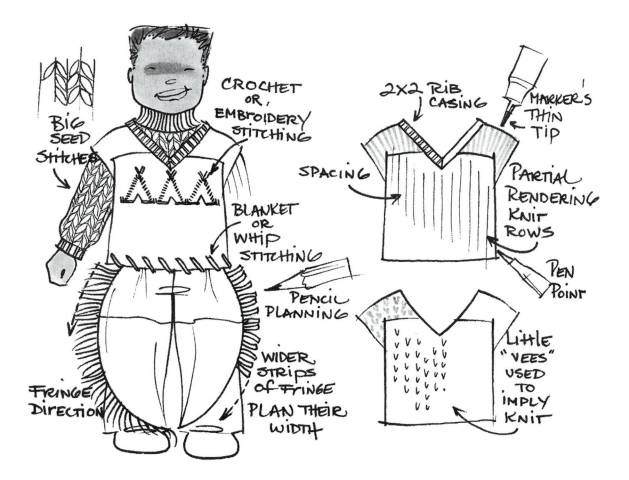

Intarsia knits are usually bold prints with stop and start yarns. This means the print probably doesn't repeat. Jacquard prints do repeat. The repeat in a jacquard can be smaller, creating rows of its print. On the other hand, a print may have been painted or screened onto a knit or a woven. Also, illustrated on this page is an example of a reduction in stitches often seen in the armhole of certain types of sweaters. As demonstrated here, many rendering options within these drawing techniques will produce similar results for knitwear sketches.

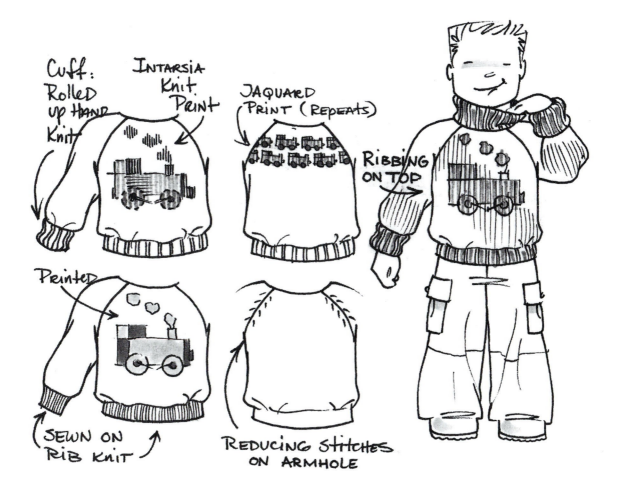

RENDERING A BASIC CABLE

There are quite a few ways to sketch a basic cable. Here are a few more examples to add to the ones on the preceding page. Again, you want to follow the length of the cable's direction on the sweater as it either interlocks over itself in a chain or slips into the center of each link of its shape or weaves back and forth in a braided formation.

Follow each of these cable sketches and you will see that sketching each shape, one at a time, makes it easier to define the whole pattern no matter how complex the design gets. Definition is in the detail that you draw for yourself. The last step is to fill in the knit direction on top of the cable.

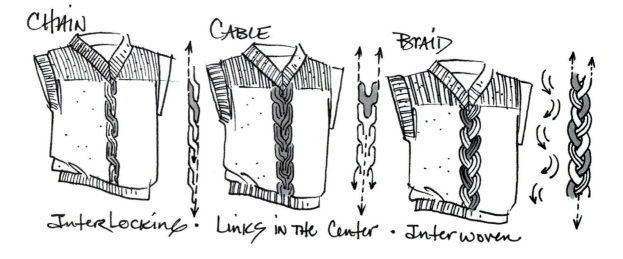

CHAIN CABLE BRAID

Interlocking · Links in The Center · Interwoven

The rendering on the facing page introduces more novelty stitches and yarn variety. This time you can add colored pencil to your marker and pen line techniques. Rendering past the contour shape gives depth to the yarn's fiber content. Rendering shadows underneath the popcorn stitch suggests column or dimension. Appliqué is something sewn onto your knit, and pointelee stitches are openings in the knit. Another technique for knit rows is to create little vees to imply surface interest.

Colored pencil adds another quality to rendering for knits when combined with marker (or watercolor). It gives a sense of yarn beyond flat color. It raises the surface and fools the eye in an illustration to imply the tactile fuzzes that many sweaters have. For these rendering techniques, practice using the pencil on its side versus on its point to get to the softer coloring direction.

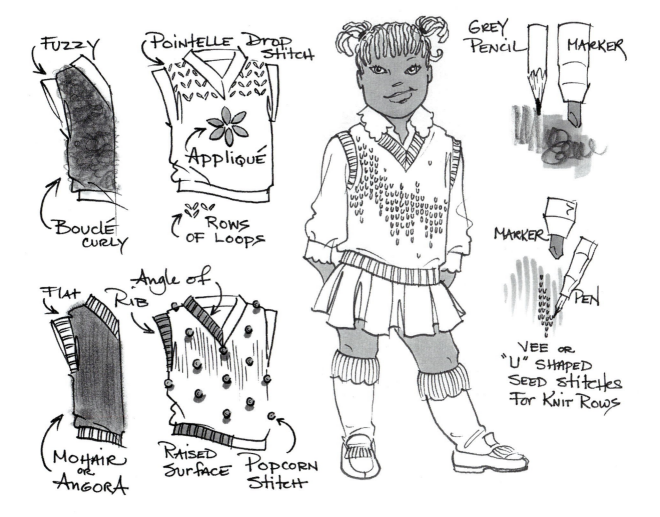

FUZZY

POINTELLE Drop Stitch

APPLIQUÉ

Bouclé CURLY

ROWS OF LOOPS

Angle of RIB

FLAT

MOHAIR OR ANGORA

RAISED Surface

POPCORN Stitch

GREY PENCIL MARKER

MARKER PEN

VEE OR "U" SHAPED SEED Stitches For KNIT ROWS

RENDERING THE EDGE OF A KNIT

The edge of a knit refers to the areas where it is finished off—at the end of the stitches. This edge is usually at the cuff, hem, collar, or button placket. Finish treatments are more likely to be done to hand knits than to the cut and sew machine knits, but then there are so many finishing possibilities for knitwear. This page illustrates the most common treatment, the rib casing. Rib casing is drawn in a more rigid, segmented manner than softer looking edges such as crochet or an untreated knit edge that rolls over itself in a curling manner. Rigid lines are often more controlled in your sketching, while softer lines can be more subtle.

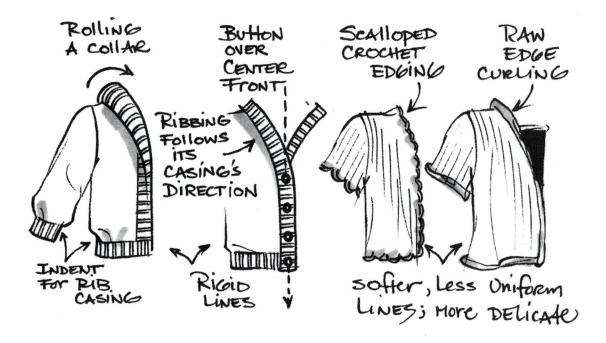

ROLLING A COLLAR

INDENT FOR RIB CASING

BUTTON OVER CENTER FRONT

RIBBING FOLLOWS ITS CASING'S DIRECTION

RIGID LINES

SCALLOPED CROCHET EDGING

RAW EDGE CURLING

SOFTER, LESS UNIFORM LINES; MORE DELICATE

116

This page divides knitwear rendering into two methods. The quickest method is in flat color. The other method, which is more involved, uses color strokes that look more dimensional. It is not that one method looks better; it is about options. Many different methods can be used to render fabrics so that someone else can see what you intended in your sketch.

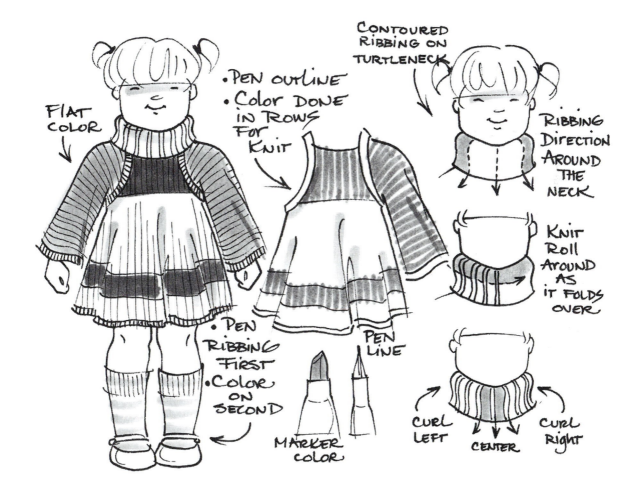

FLAT COLOR

• PEN OUTLINE
• COLOR DONE IN ROWS FOR KNIT

• PEN RIBBING FIRST
• COLOR ON SECOND

MARKER COLOR

PEN LINE

CONTOURED RIBBING ON TURTLENECK

RIBBING DIRECTION AROUND THE NECK

KNIT ROLL AROUND AS IT FOLDS OVER

CURL LEFT CENTER CURL RIGHT

RENDERING KNITS IN GOUACHE

These are practice pages for knit rendering in gouache. Yarn types, textures, and patterns have been isolated so that you can find rendering solutions and test the paper's reaction to paint and brush size. Your goal is to teach yourself about your ability to control your media and then to learn which techniques work best for you.

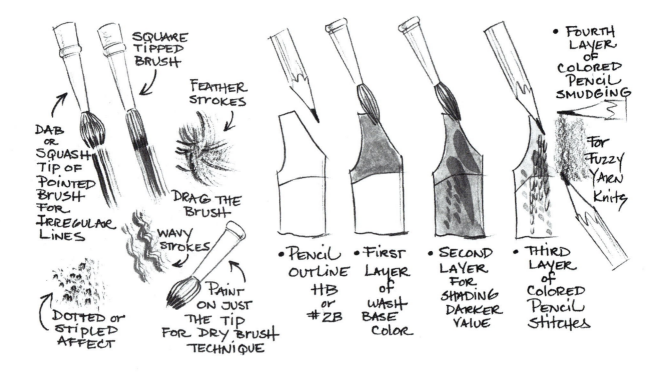

The illustrations on the facing page were done on medium-weight watercolor paper. Large areas were painted with a #8 brush. Finer, smaller areas were done in a #1 brush. Gouache was mixed in equal proportions of water to pigment. Some of the surface (fuzzy) texture was done with a soft lead-colored pencil. All of the outlines were done in a 2B pencil. Two things to remember about practice pages: Always label your demonstrations of technique solutions and leave enough space for a test strip for color reference because paint can dry lighter.

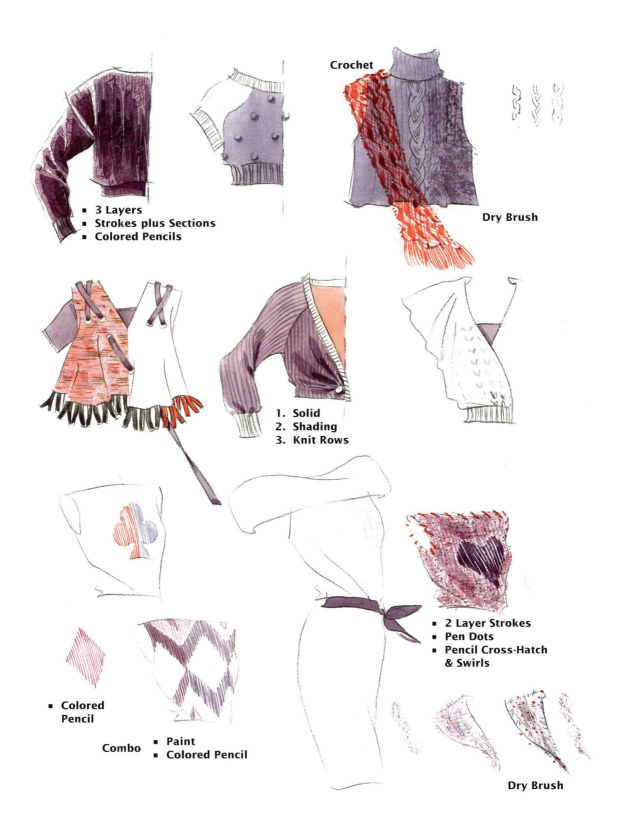

- 3 Layers
- Strokes plus Sections
- Colored Pencils

Crochet

Dry Brush

1. Solid
2. Shading
3. Knit Rows

- Colored
 Pencil

Combo
 - Paint
 - Colored Pencil

- 2 Layer Strokes
- Pen Dots
- Pencil Cross-Hatch
 & Swirls

Dry Brush

119

Many simple knits require a strong, flat wash—the solid-color background—as the first step in a successful fashion rendering. As you learned in earlier chapters, the next step is to add in areas of shading to create dimension and suggest the fit or drape of the

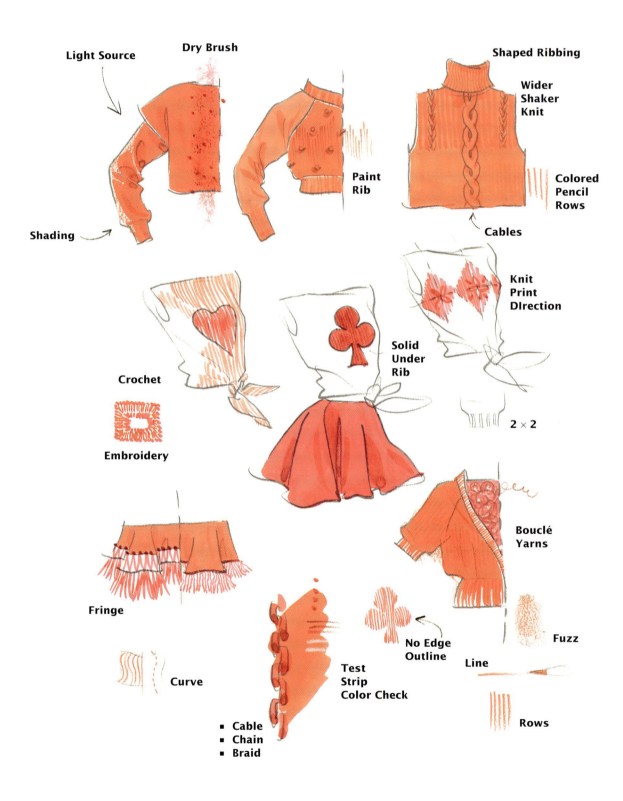

Light Source

Dry Brush

Shaped Ribbing

Wider
Shaker
Knit

Paint
Rib

Colored
Pencil
Rows

Shading

Cables

Knit
Print
DIrection

Crochet

Solid
Under
Rib

Embroidery

2 × 2

Bouclé
Yarns

Fringe

No Edge
Outline

Fuzz

Curve

Line

Test
Strip
Color Check

Rows

- Cable
- Chain
- Braid

fabric. Adding simple knit rows can be the basis for the patterns in the knit stitches or just a top-layer texture. Get out your colored pencils, too. They can add a great deal of visual interest and save you time in sketching knits.

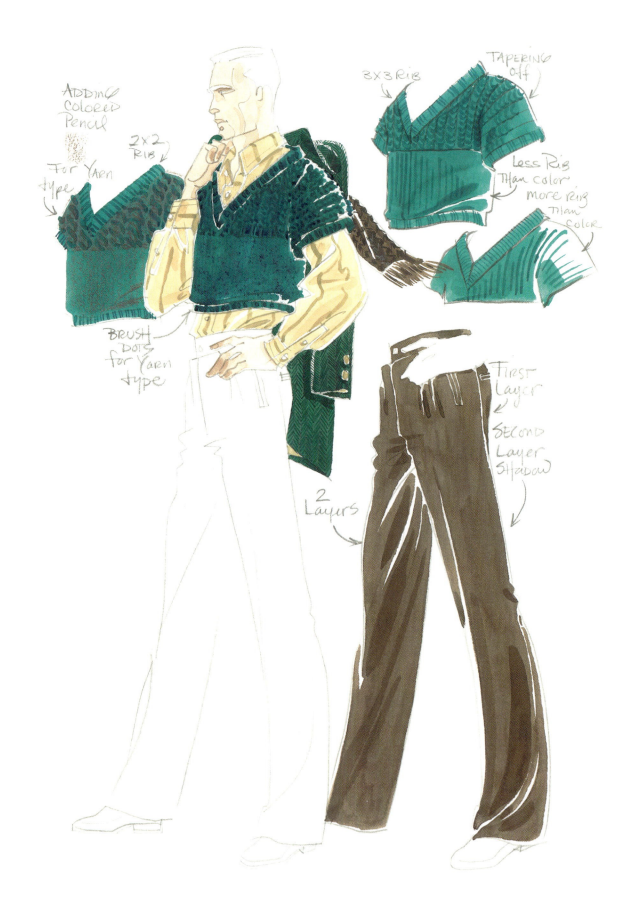

ADDING
COLORED
Pencil

FOR Yarn
type

2×2
RIB

3×3 RIB

TAPERING
off

Less RIB
THan color
more RIB
THan
color

BRUSH
Dots
for Yarn
type

FIRST
Layer

SECOND
Layer
SHadow

2
Layers

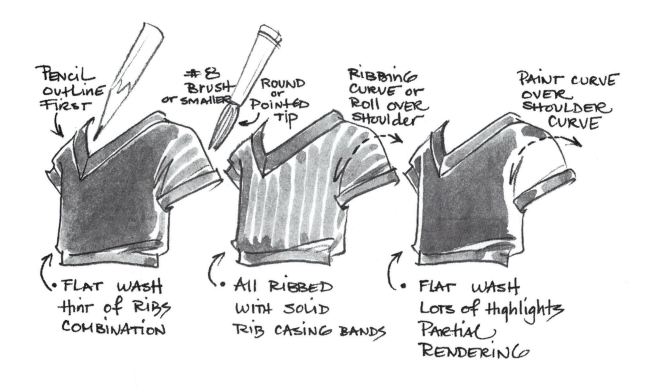

PENCIL
OUTLINE
FIRST

#8
BRUSH
or SMALLER

ROUND
or
POINTED
TIP

RIBBING
CURVE or
ROLL OVER
SHOULDER

PAINT CURVE
OVER
SHOULDER
CURVE

• FLAT WASH
thin of RIBS
COMBINATION

• All RiBBED
WITH SOLID
RiB CASING BANDS

• FLAT WASH
LotS of Highlights
PartiaL
RENDERING

These are examples of mixing smooth and textured fabrics within one outfit. The nontextured, smooth wovens are rendered in contrast to the surface interest: ribs, stitches, or yarn qualities in the knits. The contrast is developed through the layers in the rendering steps.

The first rendering step for all of these examples was a flat base, solid wash. This flat coloring method establishes a base from which the rest of the rendering steps will follow. The base can be fully or partially rendered, which will influence the subsequent layers of shading and texture in the surface interest. The most successful rendering job begins with a strong base that defines the shape and fit of the garment.

A garment can be drawn as a flat, a croquis, an illustration, or a mood sketch. The flat is a diagram with specific detailing. A croquis is a designer's creative statement. An illustration poses, while showing who would wear this garment. A mood sketch is about attitude; it shows how someone's going to feel in this garment—sexy, prim, or active versus sedate.

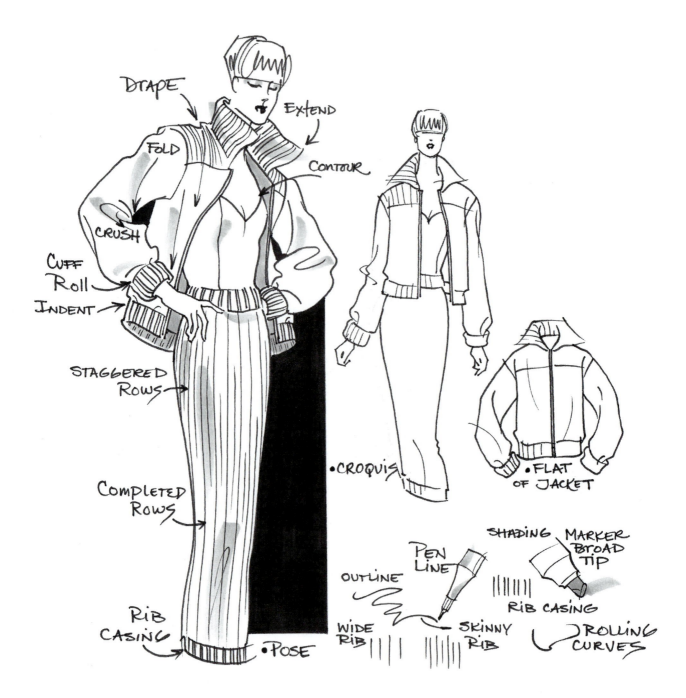

DRAPE

EXTEND

FOLD

CONTOUR

CRUSH

CUFF ROLL

INDENT

STAGGERED ROWS

COMPLETED ROWS

RIB CASING

•POSE

•CROQUIS•

•FLAT OF JACKET

OUTLINE

PEN LINE

SHADING

MARKER BROAD TIP

RIB CASING

WIDE RIB

SKINNY RIB

ROLLING CURVES

The knit outfit has been rendered in both marker and paint to illustrate, within one style, the similarities and the differences in technique. Brushes have more flexibility than a marker's hard edge. Still, the areas of emphasis for shading and detail need to fall on the same form and areas of fit on this outfit. Marker colors come ready to use, while paint's subtleties must be mixed. Marker colors don't always match your fabric, while paint always can. These are the conflicts and decisions that you will be facing as you learn more about the rendering process.

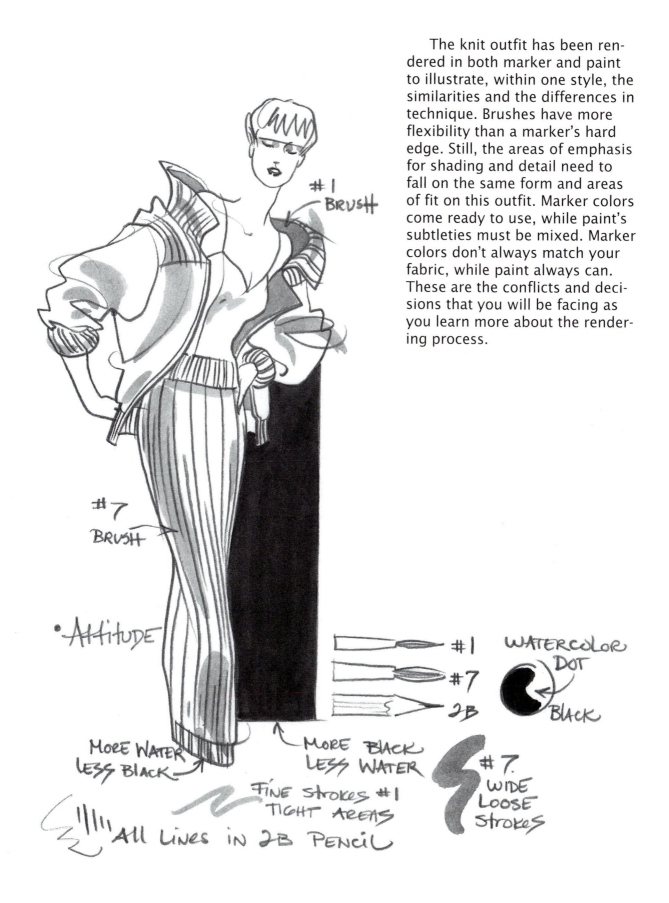

#1 BRUSH

#7 BRUSH

•Attitude

#1

#7

2B

WATERCOLOR DOT

BLACK

MORE WATER LESS BLACK

MORE BLACK LESS WATER

FINE STROKES #1 TIGHT AREAS

#7 WIDE LOOSE STROKES

ALL LINES IN 2B PENCIL

1×1
RIBBING

MIDDLE
AreA
For
PATTERN

1×1
RiBBING

PLANNING
THE
GRID

MAP IN
SECONDARY
GRID

CONNECT
THE
SHAPES
BY COLOR

Step by step, this is how to analyze and draw an argyle pattern. Most argyle patterns are a series of superimposed diamond shapes of varying sizes. To analyze the pattern, begin by locating the largest diamond in the print.

To map out the largest or main diamond, start in the middle or center of your garment. It's here that you draw in your first diagonal lines. As you cross these lines over each other, you will establish the size and number of the largest

diamonds in the argyle pattern. Continue your diagonal crossing lines over your original cross in equal spacing to establish that first grid in a series of three. Since your grid covers the whole garment it will probably collapse into many folds in the sketched garment as it does in real life, when worn on the figure.

With the first grid completed, draw a second, smaller grid over it. This secondary grid, done in the same steps as the first one, can be done in a dotted line that will be easier to see over the solid line in your grid. Then add a strong block of color by filing in the center row of diamonds in this grid to help the argyle pattern take on shape and structure.

126

ANALYZING AND DRAWING AN ARGYLE PATTERN

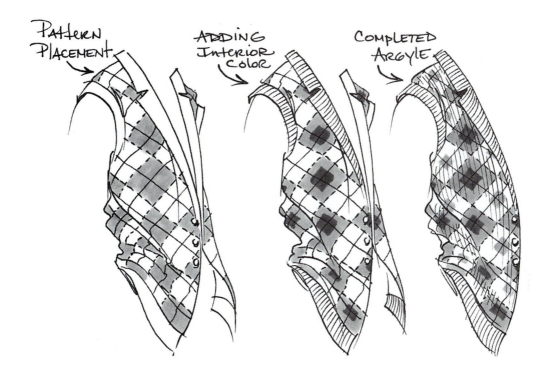

Fill in the rest of these middle-sized diamond shapes. Here, again, the dotted line will help you to follow the shapes back and forth over the pattern placement on the garment. Each of the colored diamonds will touch the next one point to point on all four sides. The print in this step resembles a sort of checkerboard pattern turned on its side.

The last diamond shape, the smallest one in this version of an argyle pattern, is also going to be the darkest grey of white, black, and grey. With these four values of greys, white and black can easily translate into four colors or more. All you have to do is place the fourth color directly in the center of the crossing black lines in the middle of the colored diamond to complete this pattern.

A final step for most knits, including this argyle, is to add the lines on top of the pattern that indicate knit rows on a sweater and to draw in the rib casing's knit pattern on this garment's collar, armhole, and hem. In contrast to the colored diamonds, notice that another minidiamond was introduced in this final stage to the white diamond shape for additional print development.

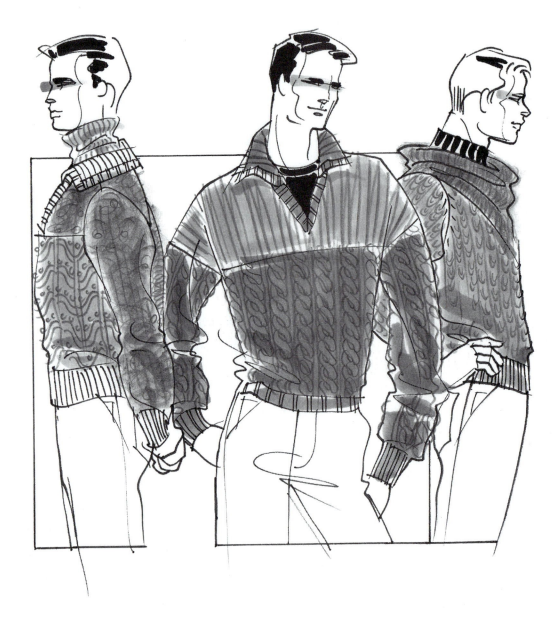

Hand knitting is another art form with its own vernacular. For illustration purposes, you do not need an in-depth grasp of all of the stitches as long as you can imitate their look in a sketch. Many sweaters mix these stitches. The patterns combine surface and texture that you have to decode in a drawing and usually in a limited time frame. What you want are simple, quick solutions for your rendering techniques. Here are a few that have been decoded. They have been rendered in pen,

pencil, and marker. Pen line definition as the outline came first. Marker in the background coloring came second. The final step was in pencil for most of the knitted detail. Pencil is done in two phases. The first is to establish the width, length, and position of the knit rows. The second phase is to imitate the actual knit pattern in those rows. A final step would be to add soft fuzzy rendering, if there is a nap in the yarn, on top of all of the other rendering.

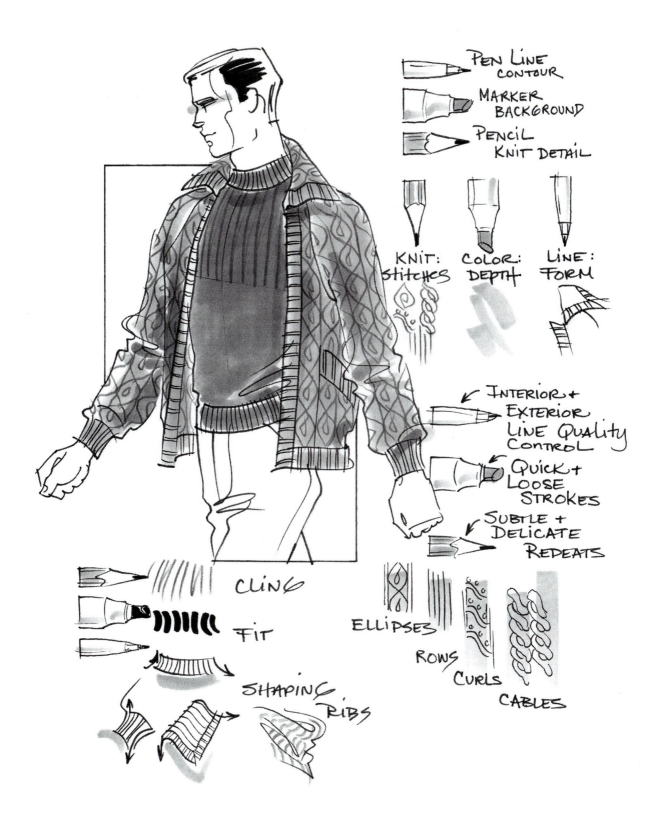

PEN LINE
CONTOUR

MARKER
BACKGROUND

PENCIL
KNIT DETAIL

KNIT:
STITCHES

COLOR:
DEPTH

LINE:
FORM

INTERIOR +
EXTERIOR
LINE QUALITY
CONTROL

QUICK +
LOOSE
STROKES

SUBTLE +
DELICATE
REPEATS

CLING

FIT

SHAPING
RIBS

ELLIPSES

ROWS
CURLS

CABLES

129

SUPPLIES

Marker paper pad: Bleed-proof, 11 × 14

 Markers: Color matches to specific fabrics or work in chapter-related colors often in sets of three analogous colors such as blue, blue-green, and blue-violet. All of equal intensity. It is your choice and budget.

 Colored pencils: White plus others selected to coordinate with your marker range.

 Pens: One fine-point for outlining. Others in colors to match your fabrication.

Watercolor paper: Hot-press, vellum finish, approximately 11 × 14

 Paint: Color matches to specific fabrics or work in chapter-related colors often in sets of three analogous colors such as blue, blue-green, and blue-violet. All of equal intensity. It is your choice and budget.

 Colored pencils: White plus others selected to coordinate with your paint range.

 Palette, water cup, towel wipe

 Pencil: Your choice for outlining

 Brushes: #1 and #7

ASSIGNMENTS

Rendering for knits should be progressive. Start out with the basics working on simple shapes. Design a classic turtleneck sweater. Sketch it three times in a row in a total of three rows. This will give you a stack of nine sweaters to practice rendering on. Get a solid color on all nine of them. Shading should go on the second and third row of sweaters. See how the first row looks, in comparison, without shading. For your first row of knits practice rows of ribs in variations of all-over to partial rendering. On the second row, experiment with novelty stitches or surface interest for a knit. The third row is a good place to practice an argyle pattern for knits. As always, label your process and supplies as you go along. Keep these notes as reference for your progress. Remember, the point of a page like this is to play around with your media options within the rendering techniques as covered in these chapters.

CHAPTER 9

GLAMOUR FABRICS

Glamour fabrics are a walk on the wild side. The shine, gleam, and glitter are visually inviting. The attraction for glamour fabrics in either casual or dressy garments is the drama in the cloth. Some of the fabrics in this category are fragile, translucent; others are exquisitely fluid and some are boldly crisp to the touch. Between the lace, the beading, and the sequins there can be a hint of sparkle or all-out shimmer. Fashion trends often layer these fabrics in one silhouette, creating some of the most intricate rendering problems. This chapter approaches the glamour fabrics in segments, one type of fabric at a time. This way you can identify and adapt the rendering techniques to fit your fashion reference. These fabrics are often used in combinations, but that level of complex coloring can be frustrating at the beginning. After you have learned these separate rendering methods you should explore as many fabric combinations and treatments as you can imagine.

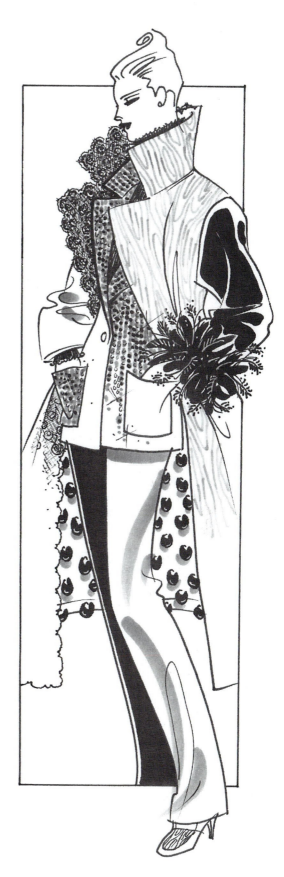

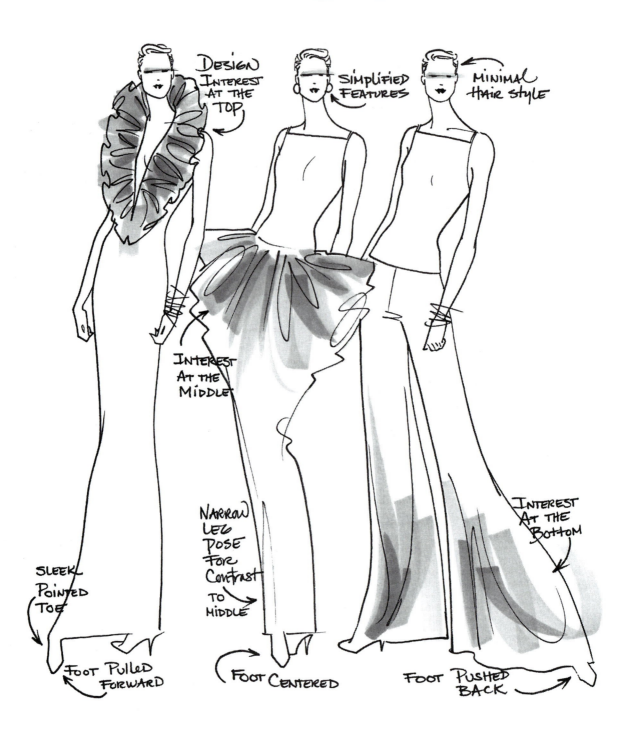

DESIGN INTEREST AT THE TOP

SIMPLIFIED FEATURES

MINIMAL HAIR STYLE

INTEREST AT THE MIDDLE

INTEREST AT THE BOTTOM

SLEEK POINTED TOE

NARROW LEG POSE FOR CONTRAST TO MIDDLE

FOOT PULLED FORWARD

FOOT CENTERED

FOOT PUSHED BACK

Special occasion clothing often has a design feature, interesting shape, or detailing that needs attention-getting focus. You can bring that focus into view with overstatement, exaggerating the fashion story. These six examples, all in the same torso position, show how you can add focus to the garment.

Notice how the same pose can shift just enough through the legs to enhance the design story in each outfit. The shading—a background color—was added to keep your attention on a certain area of each garment, which shows how rendering can be exaggerated for detail.

132

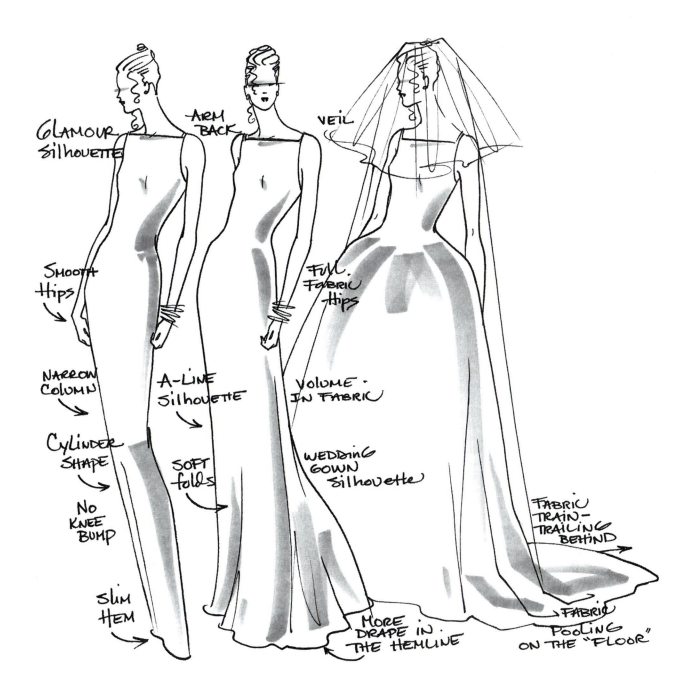

GLAMOUR Silhouette

ARM BACK

VEIL

SMOOTH HIPS

FULL FABRIC HIPS

NARROW COLUMN

A-LINE SILHOUETTE

VOLUME IN FABRIC

CYLINDER SHAPE

SOFT FOLDS

WEDDING GOWN SILHOUETTE

NO KNEE BUMP

FABRIC TRAIN - TRAILING BEHIND

SLIM HEM

MORE DRAPE IN THE HEMLINE

FABRIC POOLING ON THE "FLOOR"

This type of pose is commonly used for evening wear fashion. It's an S-curve pose, with the shoulders back and the hips forward. This pose mimics the stance of models on the runway at a fashion show.

In the fashion industry, the garment sketch rules the body. Never pick a pose that contradicts or interferes with the design message: shape, fit, or features in the clothing. This is often the opposite of what you see in fashion magazines, so it's up to you to decide what is best for your own drawing.

133

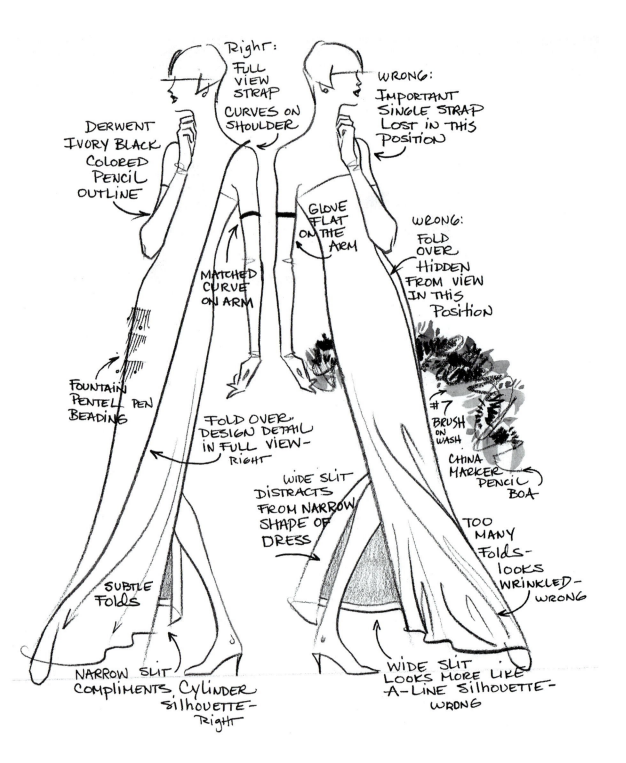

Right:
FULL VIEW STRAP
CURVES ON SHOULDER

WRONG:
IMPORTANT SINGLE STRAP LOST IN THIS POSITION

DERWENT IVORY BLACK COLORED PENCIL OUTLINE

GLOVE FLAT ON THE ARM

MATCHED CURVE ON ARM

WRONG:
FOLD OVER HIDDEN FROM VIEW IN THIS POSITION

FOUNTAIN PENTEL PEN BEADING

FOLD OVER DESIGN DETAIL IN FULL VIEW—RIGHT

#7 BRUSH ON WASH

CHINA MARKER PENCIL BOA

WIDE SLIT DISTRACTS FROM NARROW SHAPE OF DRESS

TOO MANY FOLDS—LOOKS WRINKLED—WRONG

SUBTLE FOLDS

NARROW SLIT COMPLIMENTS CYLINDER SILHOUETTE—Right

WIDE SLIT LOOKS MORE LIKE A-LINE SILHOUETTE—WRONG

This dress design features bare shoulders and one strap. It is a narrow dress cut with a side wrap (foldover) with bugle beading. The accessories—long, tight opera gloves and a long boa—are in keeping with the narrow dress silhouette. All of these elements create a fashion message. It's your job to get that message across clearly in your sketch.

In the right position, this pose can deliver the fashion message as shown on this page. The same pose flopped over is in the wrong position to illustrate the design elements in this garment. A strong sketch is more than line quality and rendering, posing and figure proportions. It also maximizes the garment's visual impact and illustrates the design detail correctly.

134

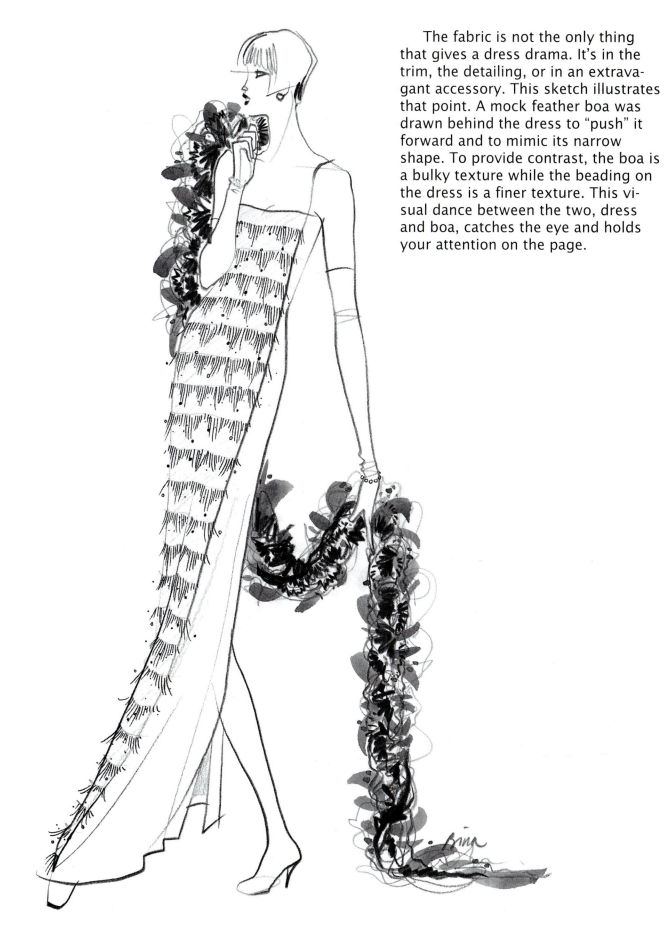

The fabric is not the only thing that gives a dress drama. It's in the trim, the detailing, or in an extravagant accessory. This sketch illustrates that point. A mock feather boa was drawn behind the dress to "push" it forward and to mimic its narrow shape. To provide contrast, the boa is a bulky texture while the beading on the dress is a finer texture. This visual dance between the two, dress and boa, catches the eye and holds your attention on the page.

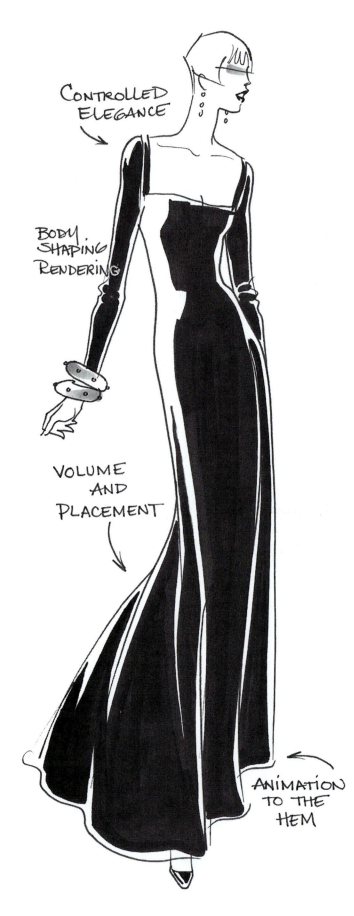

CONTROLLED ELEGANCE

BODY SHAPING RENDERING

VOLUME AND PLACEMENT

ANIMATION TO THE HEM

GLAMOUR POSES

There is an elegance to posing the figure for special occasion clothing, a flair for the dramatic. A statement of glamour comes through in an instant in your sketch. Here are some drawing tips.

1. Look for the negative spaces within a pose. They lie between the arms and the torso and by the legs. The pose's positive space is taken up by the actual figure and the clothing. A successful fashion pose uses the negative spaces to bring attention to the positive shape of the body in the garment.

2. Think of the total silhouette of the garment you want to draw. What is its shape, its fit? How can you exaggerate its design story? Which pose would do the most for this outfit? For fashion, the pose has to bring out the dress, not vice versa.

3. Volume and placement have to come into focus in your sketch. Drawing a gown means emphasizing its cut: narrow or full, long or asymmetrical. It is very important to animate the hem on a gown—to get it to flow, drift, or drape across the imaginary floor on your paper. To do this weave your line over and under the edges of the hemline.

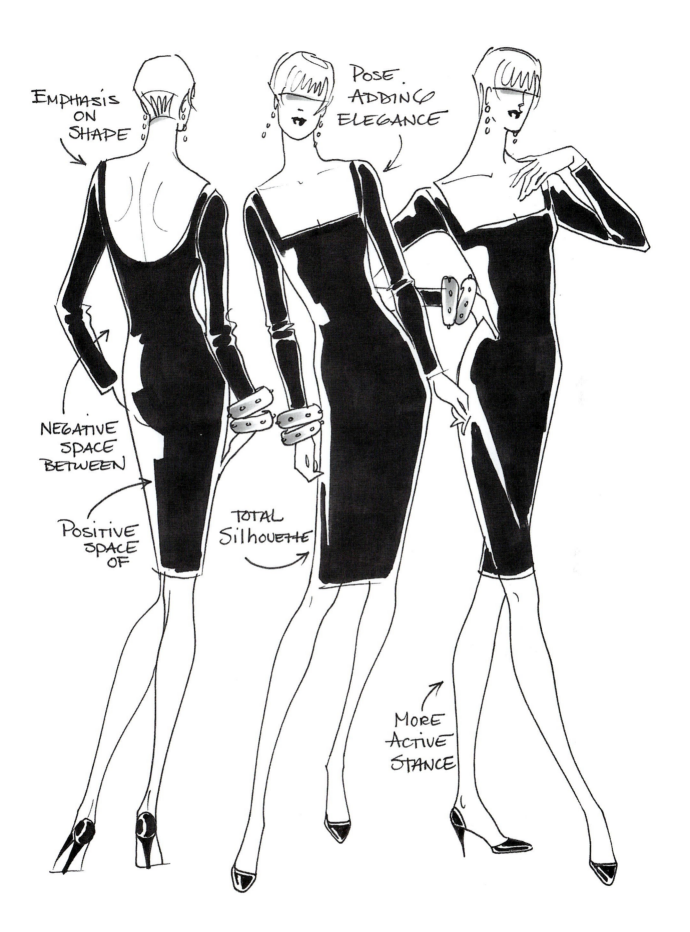

EMPHASIS ON SHAPE

POSE. ADDING ELEGANCE

NEGATIVE SPACE BETWEEN

POSITIVE SPACE OF

TOTAL Silhouette

MORE ACTIVE STANCE

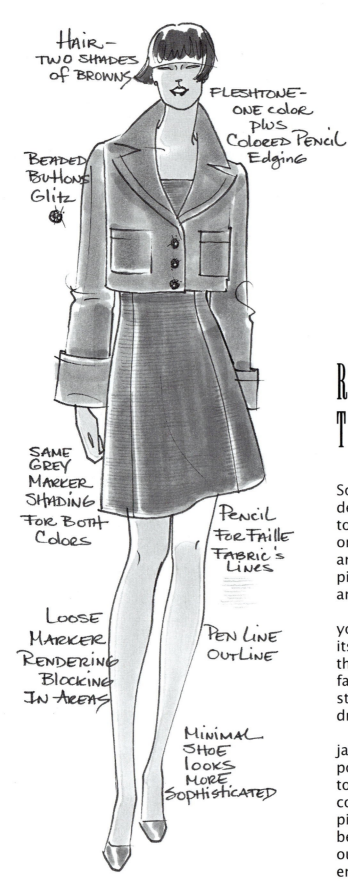

HAIR—
TWO SHADES
OF BROWNS

FLESHTONE—
ONE COLOR
PLUS
COLORED PENCIL
Edging

BEADED
BUTTONS
Glitz

SAME
GREY
MARKER
SHADING
FOR BOTH
Colors

Pencil
FOR FAILLE
FABRIC'S
LINES

LOOSE
MARKER
RENDERING
BLOCKING
IN AREAS

PEN LINE
OUTLINE

MINIMAL
SHOE
looks
MORE
SOPHISTICATED

RENDERING A TWO-PIECE GARMENT

Sooner or later you will be asked to render a two-piece garment. The challenge is to incorporate all of the design detail on one figure (two figures is the easy answer). The solution is to open up one piece to see the other on one figure. Here are some alternative solutions.

These examples examine just how far you can go with the jacket without losing its all-important design shape. In real life, the jacket would collapse into a blur of fabric. In your fashion sketch, the jacket stays true to shape and form even as it drapes.

The dress is an A-line shape. The jacket is short and boxy; it has a cuff, a pocket, and novelty buttons that all need to show up in a designer's sketch. To complicate matters, the dress has an empire cut and a short sleeve. All of that can be shown in different views of the same outfit, but with the same all-important emphasis on details.

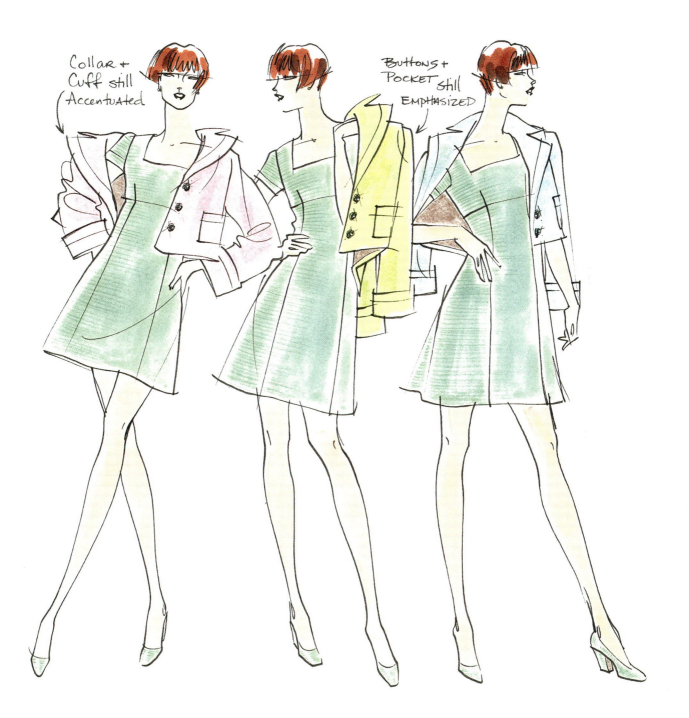

Collar +
Cuff still
Accentuated

Buttons +
Pocket still
Emphasized

139

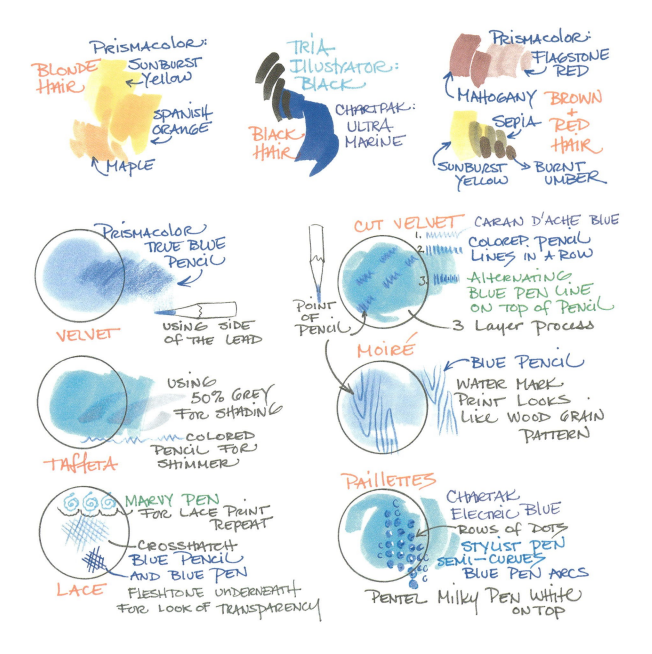

Rendering techniques are not written in stone. There is always another method, a new alternative to someone else's style. That takes you beyond step-by-step instructions. You just have to explore your own best guess, testing your media and papers as you go.

Here is a mix of fabrics done in quick, simple methods. Most of your on-the-job rendering will require more speed than perfection. So blend time and accuracy with freedom of expression. This way you will learn faster and be less critical of your own shortcuts. Rendering shortcuts are good, but practice perfection after you've learned the basics.

140

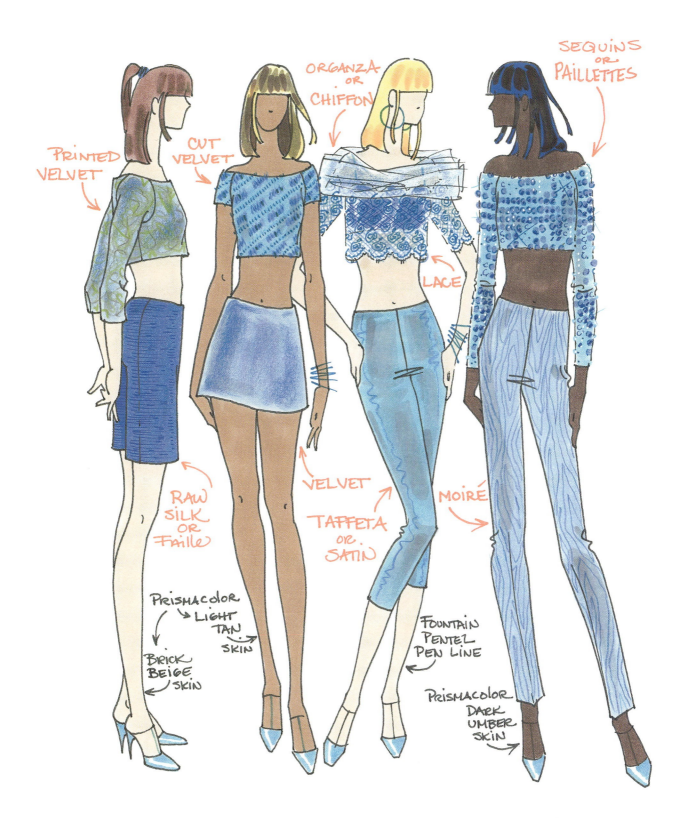

PRINTED VELVET

CUT VELVET

ORGANZA OR CHIFFON

SEQUINS OR PAILLETTES

LACE

RAW SILK OR Faille

VELVET

TAFFETA OR SATIN

MOIRÉ

PRISMACOLOR LIGHT TAN SKIN

BRICK BEIGE SKIN

FOUNTAIN PENTEL PEN LINE

PRISMACOLOR DARK UMBER SKIN

141

RENDERING PANTS

For pants in a profile view (pose), you have to accent the back to keep the garment from resembling a skirt. This accent is applied by deepening the color on the back leg or adding shading on it, which helps to separate the legs. Start on your background color first. Work your marker in a circular or scrubbing motion over the coloring to keep it smooth and to prevent streaking. For a faille, raw silk, or any fabric with a prominent weave line, you can indicate its raised surface in pen or pencil.

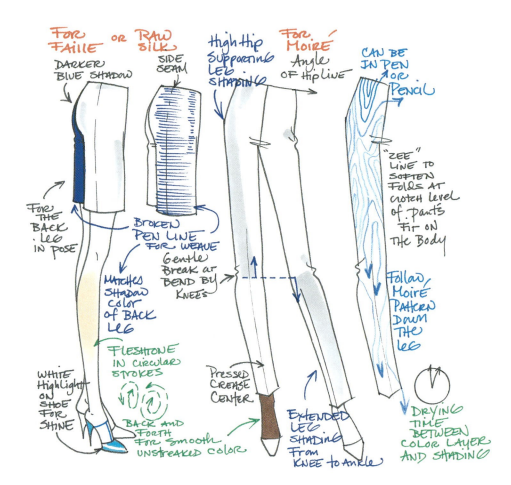

Front-view pants, in a high-hip pose, get a solid background color, one leg at a time. When that color dries you can splash on the shadow, starting at the high-hip side in one stroke to the inside of the knee. On the other leg, run the shadow from the inside of the knee down to the outside of the far ankle area at the hemline. This variety and distance in your shading adds to the motion in the pose.

When the background color and the shading are dry, you can add your pattern; in this case the watermark of a moiré fabric. This pattern runs in wavy lines that imitate a wood grain, with some concentric looping lines that stretch out unevenly in a nonmatching pattern from leg to leg.

Fill in your background color in units, seam to seam sections, or all at once. To prevent streaking, color smaller sections in marker or paint. With a marker, work quickly, scrubbing back and forth to blend the color into its section. Color up to but not over the edge. Use your fine point for corners. Remember, brand new, very wet markers can run or bleed at the edge, so start in the center of the top of the garment section and work your way down. Do the edges last with the outline slightly less than touching the line.

Let your background color set in marker or dry in paint before you add shading or, in this case, fabric characteristics. For taffeta, that characteristic is a shimmer that catches the light. Render the sheen

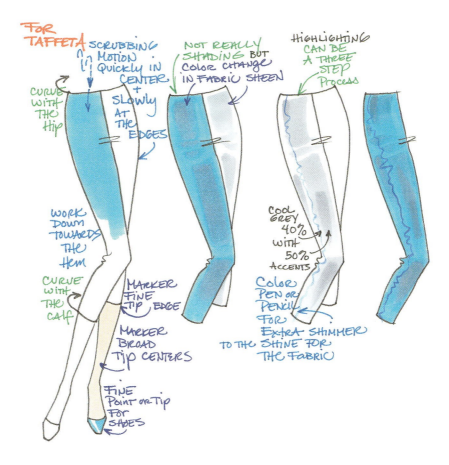

inside the garment away from the edge, breaking it up so it does not look like a solid stripe. Let it bend with the pose so it looks animated and spontaneous. Use the wide, flat part of your marker or brush for the sheen over the top of the thigh and the calf. Change to a smaller fine-point tip of the marker or pointed part of the brush for sheen on the side of the thigh and calf. These uneven, smaller glossy areas of sheen on the fabric have a random look. The last step is to render the shimmer line in pen or pencil for added visual interest.

143

Special occasion clothes are often made with diverse fabrics in matching colors. The trick is to divide fabrics of the same color into different surfaces through different rendering techniques. You can render matte versus shiny or smooth versus textured: taffeta or satin are shiny and charmeuse is matte. The differences in fiber and weave must be illustrated through your coloring methods.

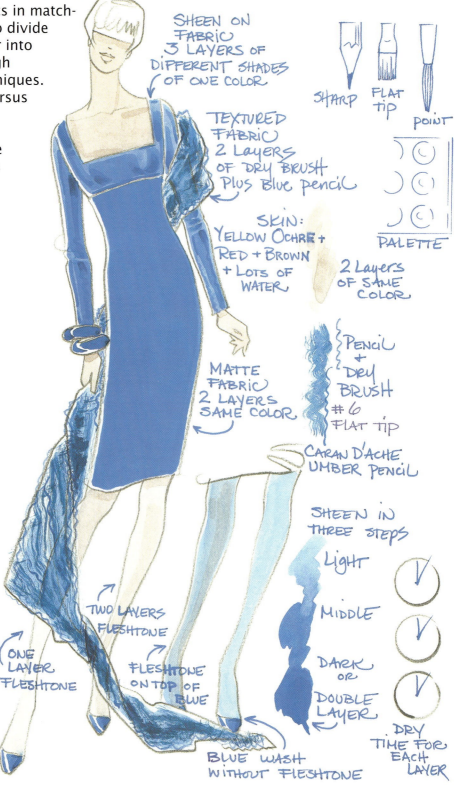

SHEEN ON FABRIC 3 LAYERS OF DIFFERENT SHADES OF ONE COLOR

SHARP FLAT TIP POINT

TEXTURED FABRIC 2 LAYERS OF DRY BRUSH PLUS BLUE PENCIL

PALETTE

SKIN: YELLOW OCHRE + RED + BROWN + LOTS OF WATER

2 LAYERS OF SAME COLOR

MATTE FABRIC 2 LAYERS SAME COLOR

PENCIL + DRY BRUSH #6 FLAT TIP

CARAN D'ACHE UMBER PENCIL

SHEEN IN THREE STEPS

LIGHT

MIDDLE

DARK OR DOUBLE LAYER

TWO LAYERS FLESHTONE

ONE LAYER FLESHTONE

FLESHTONE ON TOP OF BLUE

BLUE WASH WITHOUT FLESHTONE

DRY TIME FOR EACH LAYER

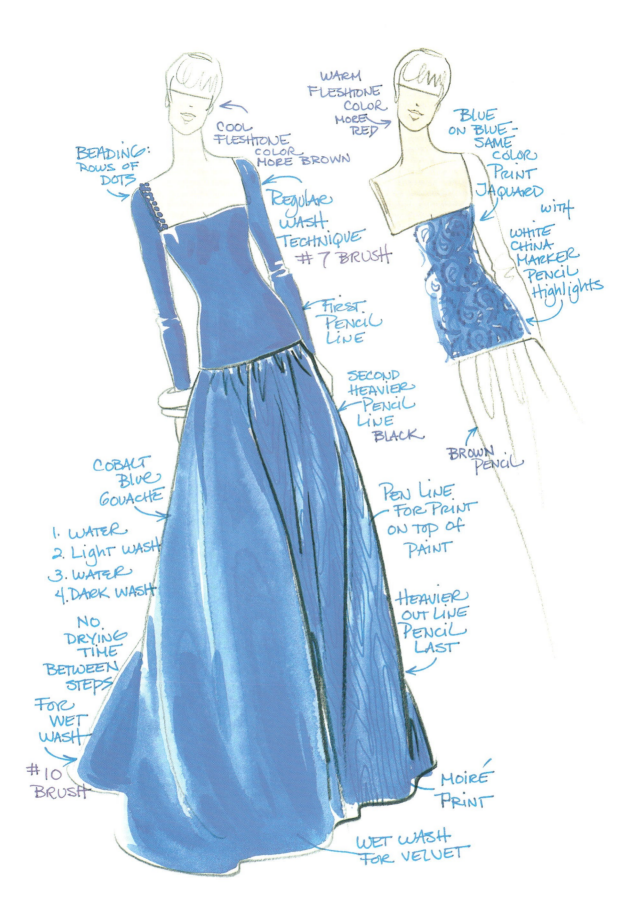

WARM
FLESHTONE
COLOR
MORE
RED

BLUE
ON BLUE—
SAME
COLOR
PRINT
JAQUARD

COOL
FLESHTONE
COLOR
MORE BROWN

WITH
WHITE
CHINA
MARKER
PENCIL
Highlights

BEADING:
ROWS OF
DOTS

Regular
WASH
TECHNIQUE
#7 BRUSH

First
PENCIL
LINE

SECOND
HEAVIER
PENCIL
LINE
BLACK

BROWN
PENCIL

COBALT
BLUE
GOUACHE

Pen Line
FOR PRINT
ON TOP OF
PAINT

1. WATER
2. Light WASH
3. WATER
4. DARK WASH

HEAVIER
OUT LINE
PENCIL
LAST

NO
DRYING
TIME
BETWEEN
STEPS

FOR
WET
WASH

MOIRÉ
PRINT

#10
BRUSH

WET WASH
FOR VELVET

145

RENDERING A MULTICOLOR PRINT

You learned how to reduce a print in an earlier chapter. Here is how to render a multicolored print. First you have to analyze its colors. Determine which is the dominant or background color. This color gets painted first as a solid, flat base. After it dries, the paper will be less rippled and you can add a second layer of darker color for a shadow. That shading will soften the silhouette and accent the drape or volume in the fabric. Next, map in the repeat of the print using the major shape or pattern in that print. Then begin to fill in the other colors of the print starting with the darkest one. The lightest colors can go on last, especially when mixed media are used.

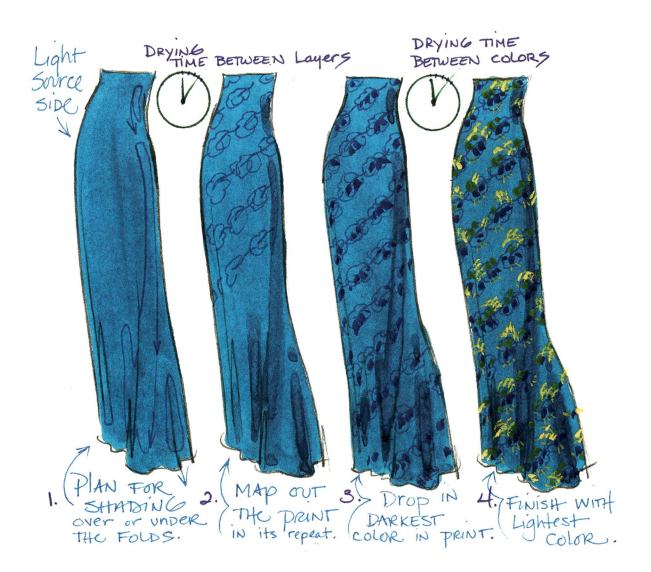

Light Source Side

DRYING TIME BETWEEN LAYERS

DRYING TIME BETWEEN COLORS

1. PLAN FOR SHADING over or under the FOLDS.

2. MAP OUT THE PRINT in its repeat.

3. Drop in DARKEST COLOR IN PRINT.

4. FINISH WITH Lightest COLOR.

GATHERS, PLEATS, AND FOLDS

A long, fluid garment should be drawn with a complementary fluid contour. Sketch the outside shape first, sides only. Next fill in the drape, creating folds that start at the waist or hipline, then sketch down to the hem. At the hem your contour line needs to roll in and out of the folds to imply a certain dimension to the fabric.

Color and shading techniques can imitate the same long, fluid motion. You mimic the outline of the garment with long strokes of both color and shading in any medium. Create strokes independent of the contour lines to animate the rendering; otherwise, it might look too stiff if you only color in the lines.

Pleating on this lengthy shape gets very specific due to construction. Where gathered fabric can look loose, pleated fabric should look more regimented. Rendering becomes structured, controlled by the width of the pleat. Here you can color within the lines because pleats can be tight.

An A-line garment in a long silhouette gets a broader stroke of color slicing into one or two folds to soften the shape and capture the nature of the fabric. Subtle, full rendering in long or wide solid colors is the trickiest because you have to practice to keep streaks out of your coloring process, in paint or marker.

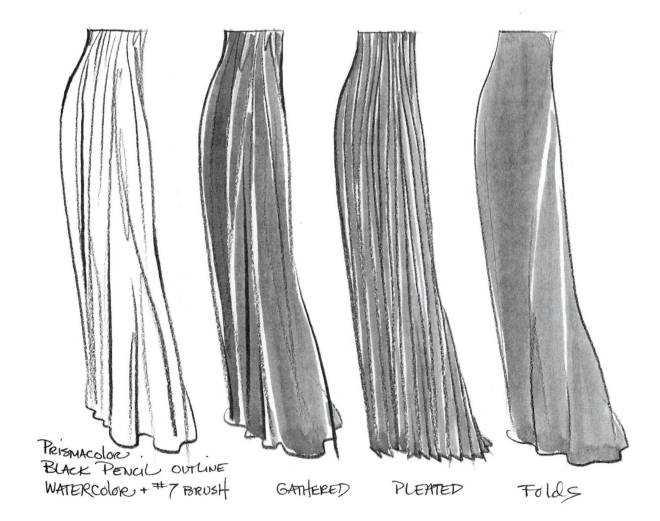

Prismacolor.
BLACK PENCIL OUTLINE
WATERCOLOR + #7 BRUSH GATHERED PLEATED Folds

RENDERING BLACK FABRICS

Working in black fabric means exploring true black coloring. Each marker company has its own version of black. Test them all out. Discover which ones smudge or dry quickly or dry too light. Sometimes the black brush pens can be much blacker and shine more than a basic marker. This type can be used to render a sheen on your black fabric. Black pencil can add a bit of texture or surface black on its own or on top of a black marker or a deep grey one. Get a white pen or china marker pencil for accents on top of your black fabric rendering. White pencils alone are often too pale on top of black markers. Painting in black opens up to a wide variety in gouache. There are ivory, jet, and lamp blacks, to name a few; each has its own shade of black; browner, bluer, and so on. Test these out or at least ask a store clerk to help you choose the one that is right for your needs. Inks are another medium in black. They dry very differently, depending on the paper's type.

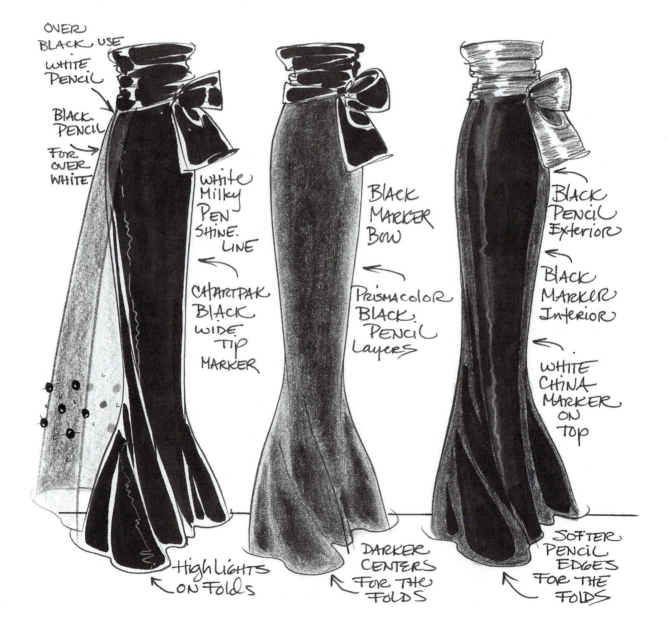

OVER BLACK USE WHITE PENCIL

BLACK PENCIL FOR OVER WHITE

WHITE MILKY PEN SHINE. LINE

CHARTPAK BLACK WIDE TIP MARKER

HIGHLIGHTS ON FOLDS

BLACK MARKER BOW

PRISMACOLOR BLACK PENCIL LAYERS

DARKER CENTERS FOR THE FOLDS

BLACK PENCIL EXTERIOR

BLACK MARKER INTERIOR

WHITE CHINA MARKER ON TOP

SOFTER PENCIL EDGES FOR THE FOLDS

148

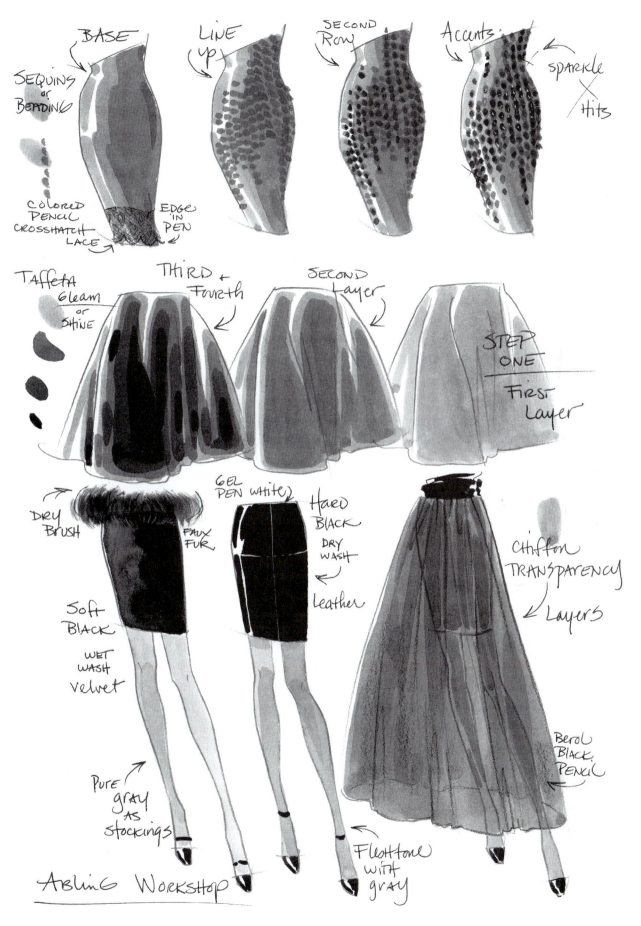

BASE

LINE UP

SECOND Row

Accents

SEQUINS or BEADING

sparkle Hits

COLORED PENCIL CROSSHATCH LACE

EDGE 'IN PEN

TAFFETA GLEAM or SHINE

THIRD + Fourth

SECOND Layer

STEP ONE

First Layer

DRY Brush

FAUX FUR

GEL PEN WHITE

HARD BLACK DRY WASH

Leather

SOFT BLACK WET WASH Velvet

Chiffon TRANSPARENCY Layers

Berol BLACK PENCIL

PURE gray AS Stockings

Flesh tone with gray

ABLING WORKSHOP

149

Black fabrics almost never go out of style. Rendering in black should now be part of your skills. Illustrating black fabrics is always a challenge because black paint or marker tends to overwhelm your interior and exterior lines. Retaining detail then becomes a new priority in execution.

Teach yourself how to render in black through as many media choices as possible—solo, mixed or blended together. Label each step, every layer, and keep all of your notes for future reference. Through trial and error you will find your preference, the method that works best for you.

Whatever your choice, for practice lay out a page where you can compare your results and experiment with your supplies. Keep your hands clean at all times. I wash my hands often during an in-depth rendering technique; it helps to cut down on fingerprints, smudging, and other accidents. Keep your desk and drawing area clean and uncluttered as well so that your paper won't get caught, torn, or bent by accident.

This spread demonstrates both solid and patterned blacks. It is easier to put all of these fabrics on one practice page so that you can see the contrast or variety within these fabric rendering techniques.

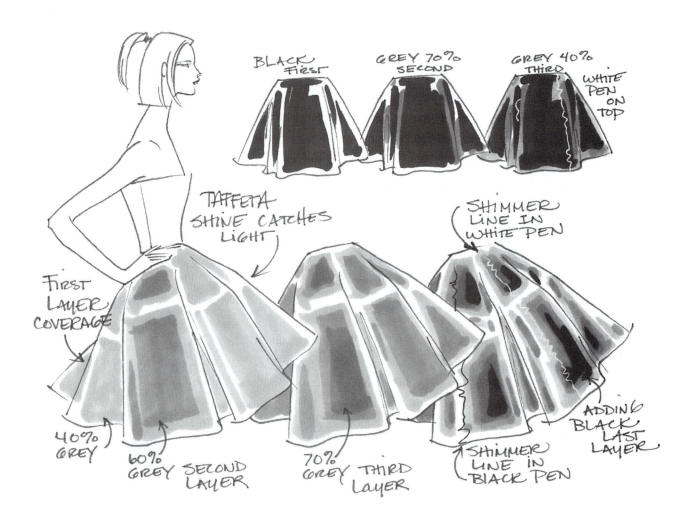

BLACK FIRST

GREY 70% SECOND

GREY 40% THIRD

WHITE PEN ON TOP

TAFFETA SHINE CATCHES LIGHT

SHIMMER LINE IN WHITE PEN

FIRST LAYER COVERAGE

40% GREY

60% GREY SECOND LAYER

70% GREY THIRD LAYER

SHIMMER LINE IN BLACK PEN

ADDING BLACK LAST LAYER

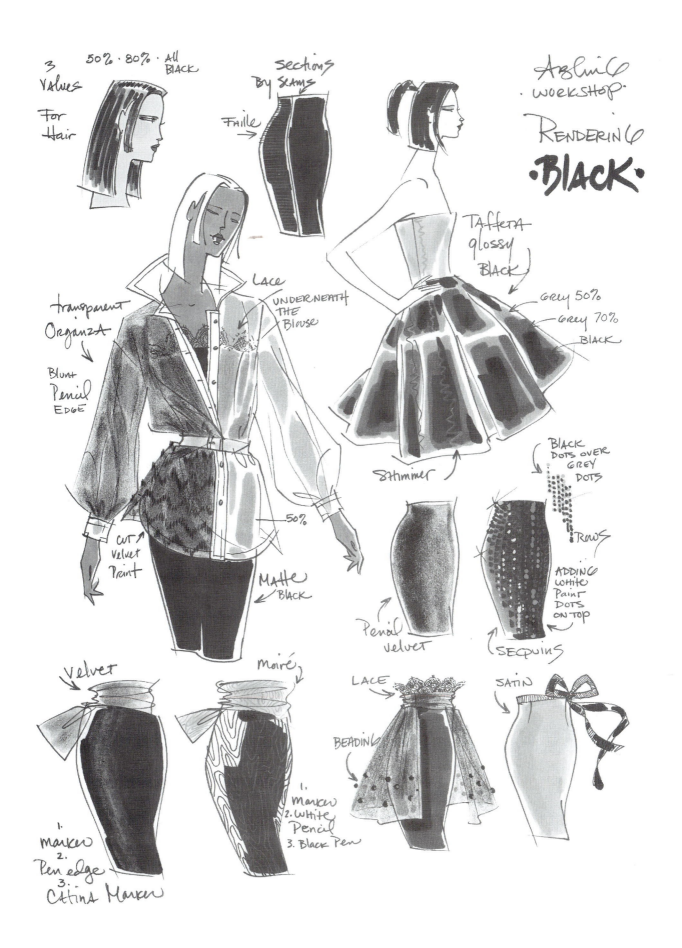

3 Values For Hair

50% · 80% · All BLACK

Sections By Seams

Faille →

Aslin 6 WORKSHOP

RENDERING ·BLACK·

TAFFETA glossy BLACK

transparent Organza

Blunt Pencil EDGE

Lace UNDERNEATH THE Blouse

GREY 50%
GREY 70%
BLACK

Shimmer

CUT Velvet Print

50%

MATTE BLACK

Pencil velvet

BLACK DOTS OVER GREY DOTS

Rows

ADDING WHITE Paint DOTS ON TOP

SEQUINS

Velvet

1. Marker
2. Pen edge
3. Cetina Marker

Moiré

1. Marker
2. White Pencil
3. Black Pen

LACE

BEADING

SATIN

151

RENDERING LACE

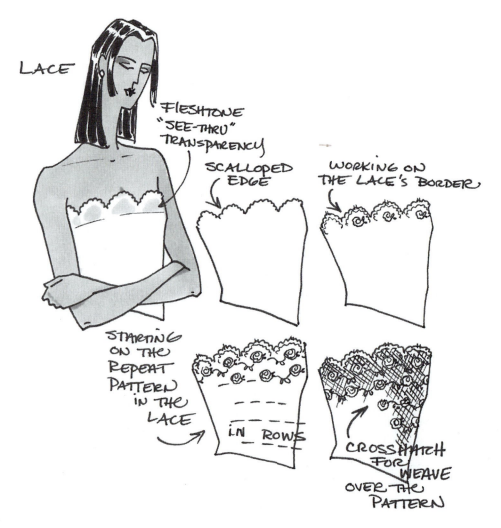

LACE

FLESHTONE "SEE-THRU" TRANSPARENCY

SCALLOPED EDGE

WORKING ON THE LACE'S BORDER

STARTING ON THE REPEAT PATTERN IN THE LACE

IN ROWS

CROSS HATCH FOR WEAVE OVER THE PATTERN

Lace can be designed as peek-a-boo, transparent, or solid (not see through) fabric. To indicate transparency in rendering, break up the flesh tone underneath the area of the fabric covering the body. In design, lace often has a specific border or edge. The edge can be scalloped, and the border can be intricate, pronounced, or subtle. You be the judge of the fabric at hand. Illustrate the pattern by dropping it in by rows or whatever the repeat dictates. The last step is to delicately draw in the weave as cross-hatching over the pattern. Sketch it in lightly, one direction at a time, so that it does not overwhelm the pattern. This is easier to do in pen than in pencil unless you constantly sharpen the pencil's point for a clear, clean line. If the lace's line, pattern, or weave gets too fuzzy it becomes blurred, hard to see, or resembles something other than lace, such as crochet.

RENDERING SEQUINS

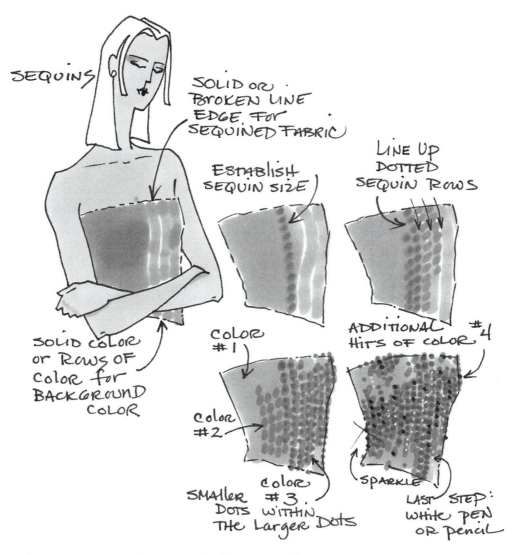

SEQUINS

SOLID OR BROKEN LINE EDGE FOR SEQUINED FABRIC

ESTABLISH SEQUIN SIZE

LINE UP DOTTED SEQUIN ROWS

SOLID COLOR OR ROWS OF COLOR FOR BACKGROUND COLOR

COLOR #1

COLOR #2

ADDITIONAL HITS OF COLOR #4

COLOR #3

SMALLER DOTS WITHIN THE LARGER DOTS

SPARKLE

LAST STEP: WHITE PEN OR PENCIL

Sequins are flat, small, circular discs. Paillettes are larger sequins. They can be placed randomly, in a pattern, or in rows. This is an example of a loose rendering style for sequins or paillettes in rows. (A tight rendering style would be in more exact row formation with more specific sequin sizing.) Sequins and paillettes, especially iridescent ones, change color as they sparkle and catch the light. In a sketch, it takes at least three colors to represent one color of this type of decoration. To render sequins, start with your lightest color as a solid background. Next, in your second color, establish the size of your sequins or paillettes with the first dot that you render, then begin to make these dots in equidistant rows. Set up smaller dots in your third color on top of the larger dots. This can be your final step or you can add darker highlight (random) dots in a fourth color. Finish your rendering technique with splashy white dots (pen, pencil, or paint) for additional sparkle to the fabric.

SUPPLIES

Marker paper pad: Bleed-proof, 11 × 14

 Markers: Color matches to specific fabrics or work in chapter-related colors, often in sets of three analogous colors such as blue, blue-green, and blue-violet. All of equal intensity. It is your choice and budget.

 Colored pencils: White plus others selected to coordinate with your marker range.

 Pens: One fine-point for outlining. Other in colors to match your fabrication.

Watercolor paper: Hot press, vellum finish, approximately 11 × 14

 Paint: Color matches to specific fabrics or work in chapter-related colors, often in sets of three analogous colors such as blue, blue-green, and blue-violet. All of equal intensity. It is your choice and budget.

 Colored pencils: White plus others selected to coordinate with your paint range.

 Palette, water cup, towel wipe

 Pencil: Your choice for outlining

 Brushes: #1 and #7

ASSIGNMENT

Referring back to past assignments in this book, redraw the same shapes—skirts, pants, tops, or dresses—that you drew before. The shapes, in basic silhouettes, don't change as much in fashion as the fabrics. The rendering challenge is to make these shapes look different in sketching—to show the difference between a crisp print, a textured knit, and a smooth velvet. This assignment should be done twice, once in black and again in full color. The layout for rendering black fabrics on page 148 is a good place to start. For materials in color, try page 151 for marker or page 146 for painting. What you want to achieve through this assignment is to develop your own rendering techniques, with help from this chapter, to create a crisp taffeta, a smooth velvet, a moiré print, and the look of sequins. Other fabric characteristics that you can achieve are satin's sheen and charmeuse's matte drape. These take on line quality drawing techniques as well, so you'll be integrating all of your illustrating skills.

CHAPTER 10

PROFESSIONAL RENDERING

Fashion design sketching and fashion illustration on the job or for a portfolio are such individual statements of talent and ideas that they still precede computer graphics and photography as a signature style directive. A sketch is the first complete idea; it creates attitude, shape, and color in a unique shape. It is inspiration pure and simple. In recent years, professional rendering has become more of an in-house trade, for the industry's eyes, instead of being used in advertising. This chapter will show you a variety of styles, methods, and looks that the fashion industry values for their dramatic impact. There are business samples as well as artistic license in the mix to give you an overview of how to put what you have learned in the preceding chapters into focus for current fashion industry trade standards. Fashion design sketching and illustration require a blend of art and business, and this chapter gives you a rare glimpse into several fashion careers.

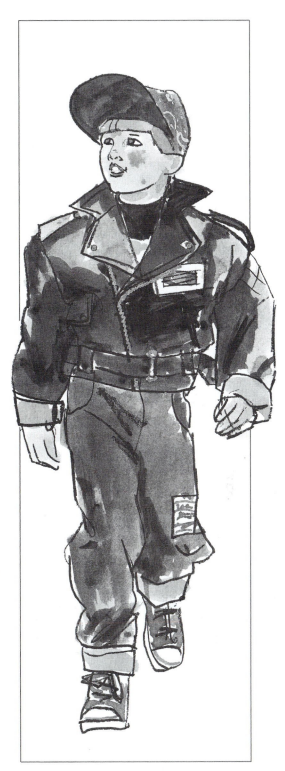

Credit: Michele Wesen-Bryant

RICHARD ROSENFLED

The key to this drawing technique is its speed. It is spontaneous sketching from the imagination or a specific, real object. It is drawn quickly without preliminary studies or planning. Working quickly animates the outline and keeps the interior coloring from looking overworked. This level of talent comes from the confidence that experience and practice can bring to a style. These drawings create an air of sophistication.

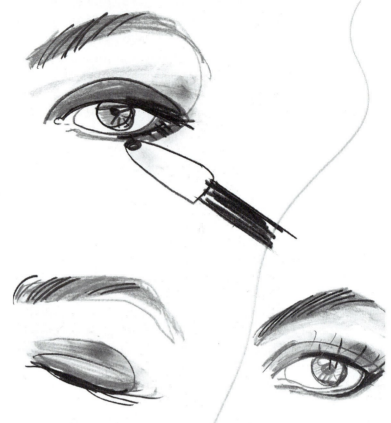

Media: Cold-pressed Bristol paper, vellum finish; gouache; #8 sable brush

FELICE DACOSTA

This is a perfect example of color, form, and silhouette used to create a fashion statement. These bold sketches have a fresh and immediate look to them. In a flash of recognition of these shapes, they are completely on target in their minimalism. In their glamorous simplicity they prove that detail is not the only goal in sketching for fashion. An artist has to learn what to leave out as much as what to put into his or her sketch.

Media: Pastels on watercolor paper

LORETTA TEDESCHI-CUOCO

One artist's range in illustrating can go from sweet and subtle to outright fascinating based on demand. This artist, working within the confines of job description or open to creative nuance, can control her options. It's all integrated into her style as she keeps expanding her focus.

Media: Bold line and ultra fine-point pens; broad-tipped color markers; black pencil shading; gouache; Bristol vellum paper.

Credit: Lawrence Stevens Limited

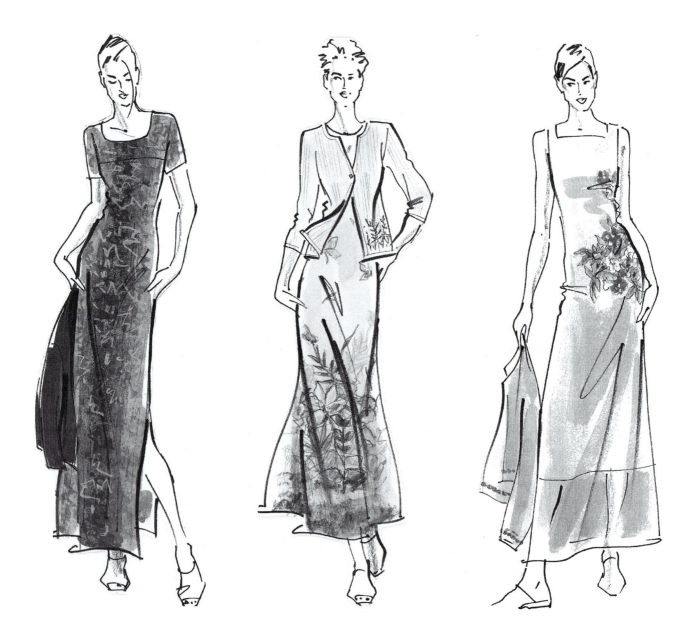

BILL RANCITELLI

These sketches present a powerful, unique drawing style. They represent designer sketching at its best; creating a signature look unique to the artist and to the client. An artist's work is still so individual that it fills the industry's need for identity and direction in the fashion market.

Media: Cold-pressed paper, vellum finish; gouache; #7 and #3 sable brushes

Credit: Ralph Lauren—Purple Label

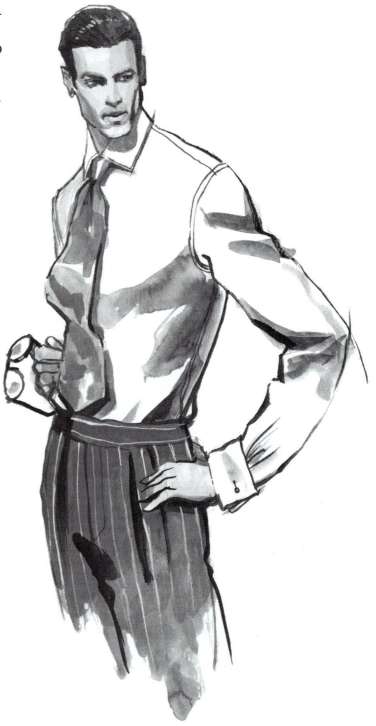

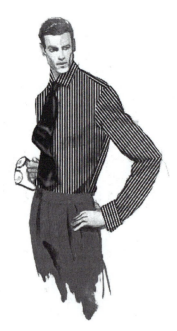

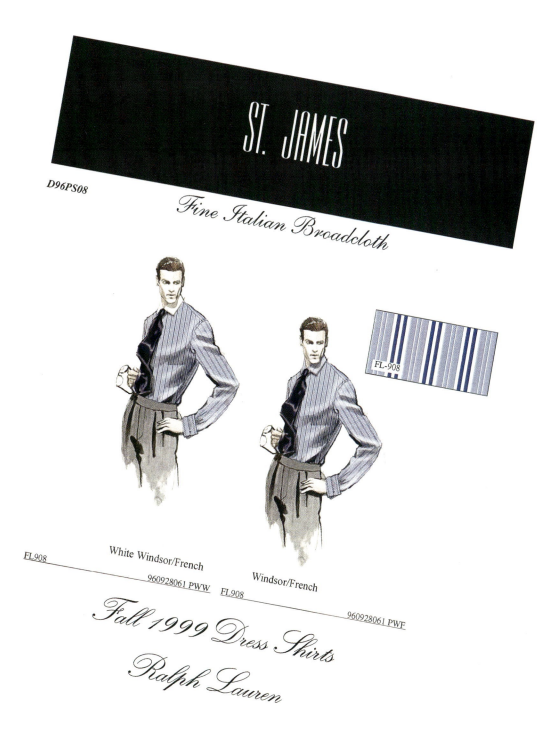

ST. JAMES

D96PS08

Fine Italian Broadcloth

FL-908

FL 908

White Windsor/French

960928061 PWW

Windsor/French

FL 908

960928061 PWF

Fall 1999 Dress Shirts

Ralph Lauren

163

BILL RANCITELLI

The next step for design and original illus-
tration is to collaborate with the
computer. Here the work has been
scanned and recolored and patterns have
been altered with computer software
based on seasonal design directions.
While computers are powerful design
tools, they would be useless without the
inspiration and creativity of designers and
artists.

Media: Cold-pressed paper, vellum finish;
gouache; #7 and #3 sable brushes

Credit: Ralph Lauren—Purple Label

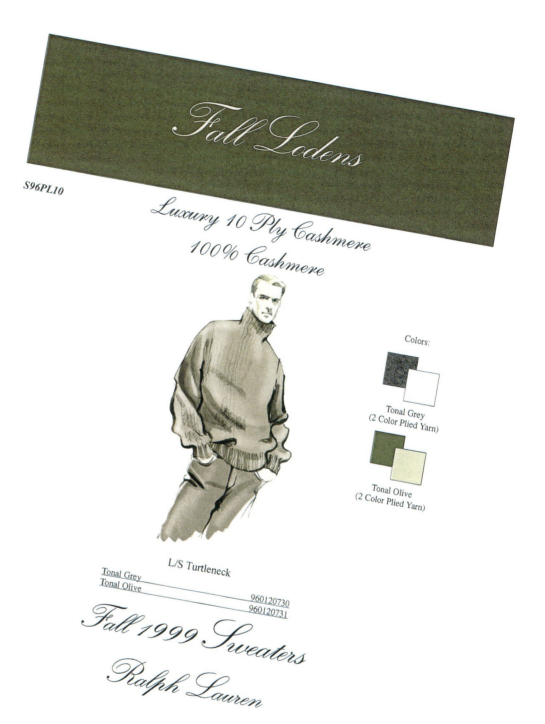

Fall Lodens

S96PL10

Luxury 10 Ply Cashmere
100% Cashmere

Colors:

Tonal Grey
(2 Color Plied Yarn)

Tonal Olive
(2 Color Plied Yarn)

L/S Turtleneck

| Tonal Grey | 960120730 |
| Tonal Olive | 960120731 |

Fall 1999 Sweaters

Ralph Lauren

BILL RANCITELLI

The menswear directive in these sketches has an attitude of elegance, an air of taste in fashion sophistication. The attitude is evident in the artist's style of carving the figure and chiseling the face as if it were sculpture on the page. This work is a design projection mixed with a thorough knowledge of anatomical drawing.

Media: Cold-pressed paper, vellum finish; gouache; #7 and #3 sable brushes

Credit: Ralph Lauren—Purple Label

Cavalry Twill
Polo Retail Exclusive

Colors:

Olive

Peacoat

Olive 96 7227699 FLD

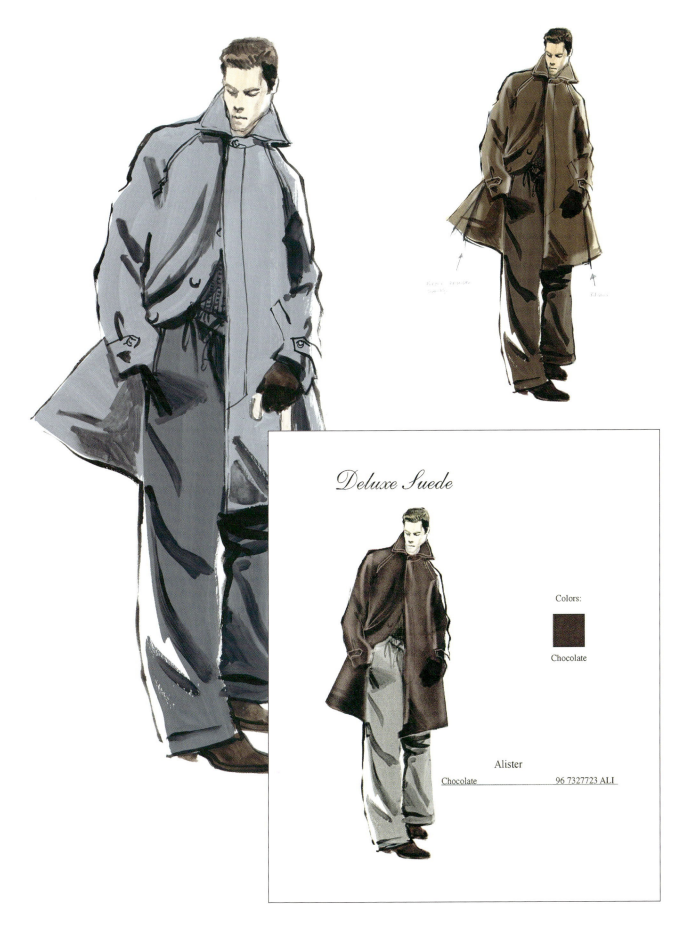

Deluxe Suede

Colors:

Chocolate

Alister

Chocolate 96 7327723 ALI

167

GLENN TUNSTULL

This artist's style of drawing is a breathtaking balance between a delicate line and strength in anatomy. There is a sense of looking at fragile beauty while being aware of a bolder edgy quality. Inherent in this work is the merging of intellect, observation, and creative instincts. The multiple figure work was a collaborative effort with a second artist, Toyce Anderson.

Media: Oil pastels, collage, gouache all on charcoal paper

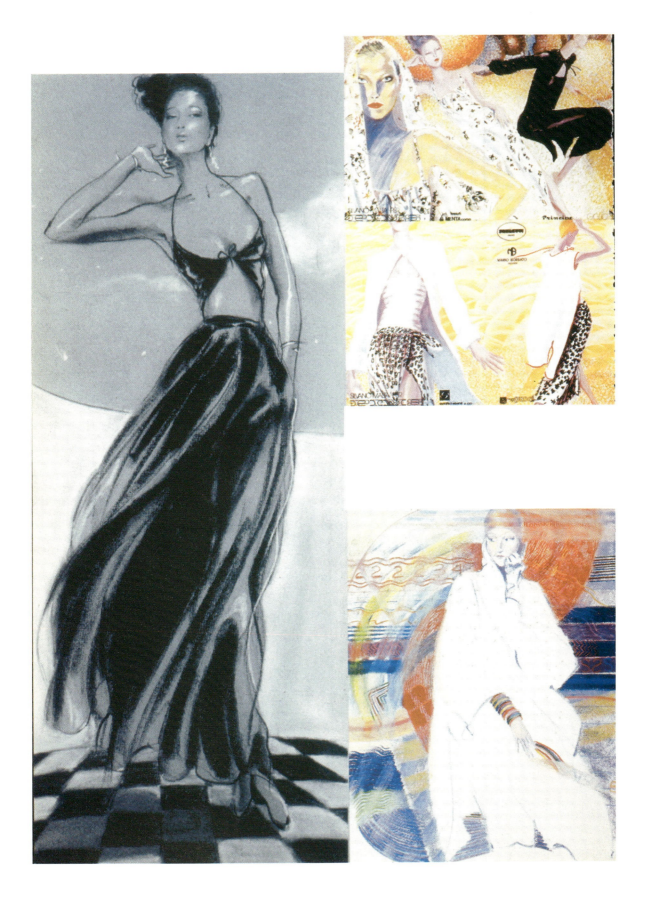

GLENN TUNSTULL

Sometimes the artist's job is to create a mood—to set the stage. Glenn brings this quality to his sketches through the drama in the fabric and the character in his subjects. This drawing style puts art and commerce in total balance. Glenn has captured a commercial look with a fine arts attitude

Media: Pastels on grey charcoal paper; charcoal and gouache on grey charcoal paper.

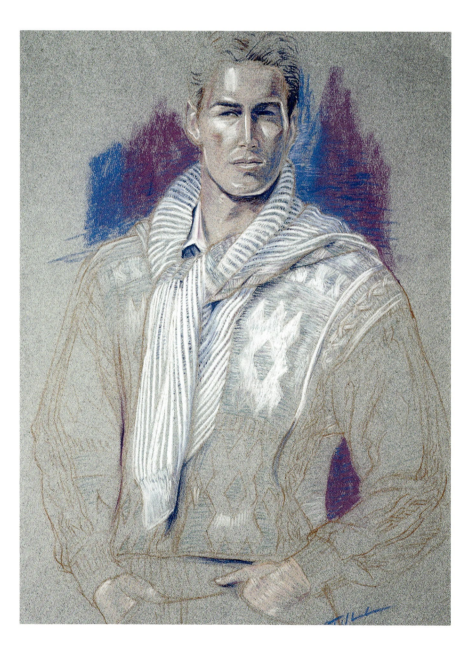

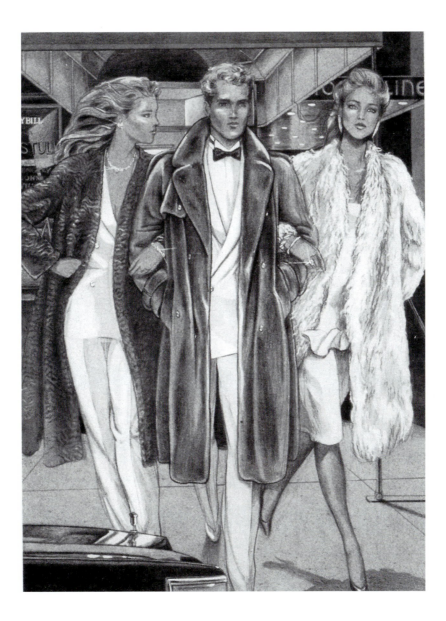

MICHELE WESEN-BRYANT

This artist's scope brings another dimension to the graphic format. She creates a serendipity between positive and negative spaces, merging line and form. Her techniques bring innovative methods, flexibility, and commercial value into the creative territory of fine arts and new technology.

Media: Cut papers, single-edge razor, stenciling, light box, one coat rubber cement; charcoal sketch photocopied onto cold-pressed Bristol paper

Painted with colored inks; #7 and #2 brushes

Michele Wesen

173

ESMERALDA PANAYOTAROU

This designer's drawing talents are a calculated, clever hybrid of gutsy stylization and an edgy, classical realism. This style of drawing presents a freedom in interpretive figure work while establishing a solid foundation for gender differences within the framework of fashion design art.

Media: Gouche on watercolor paper

Figures: HB pencil/#10 sable brush/#4 brush
Colored pencil texture/white pencil accents
Finished outline: ebony or 8B pencil

Flats: Outline—HB/less smudging
Interior—mechanical pencil/harder lead for more control/precision

ESMERALDA

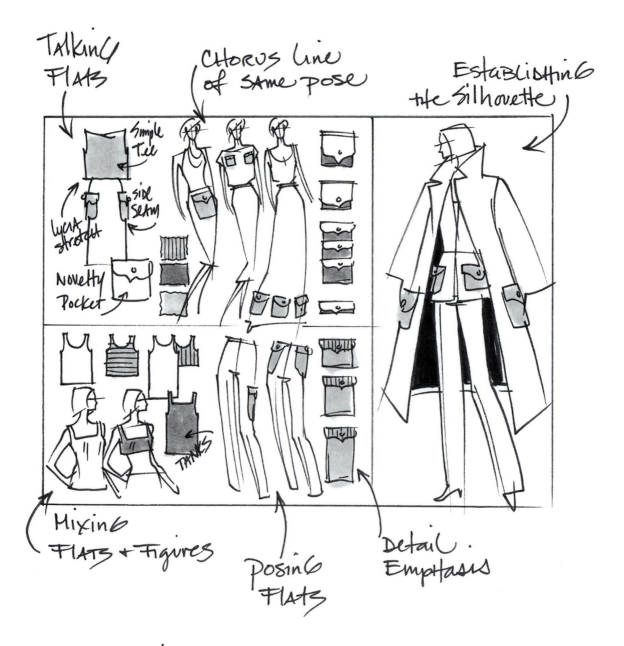

TALKING FLATS

Simple Tee

LYCRA stretch

side seam

Novelty Pocket

CHORUS line of same pose

ESTABLISHING the Silhouette

MIXING FLATS + Figures

TANKS

POSING FLATS

Detail Emphasis

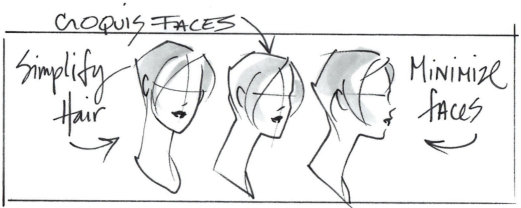

CROQUIS FACES

Simplify Hair

MINIMIZE faces

CHAPTER 11

CROQUIS RENDERING

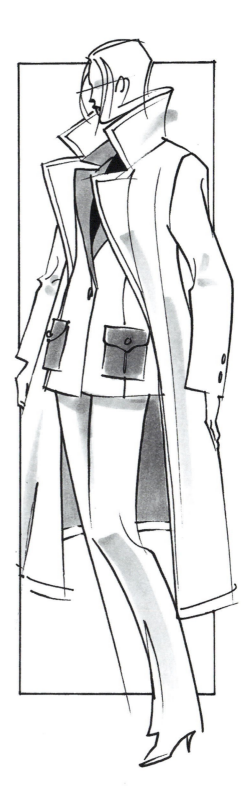

Croquis rendering is a personal process. It starts out as an idea that needs to be expanded on or explored in one of many directions. It's a process of sketching a figure in one's own vernacular of fashion to communicate color, fabric, and fit in any combination of shapes and layers. In fashion design, a concept or direction is an elastic idea with potential that needs to be developed as far as it can go. That development is expressed on paper, in a sketching process that is general enough to be understood by others who must then translate those ideas into real garments. Croquis sketching can be an exciting process, as talent and business merge into a creative spark. This chapter will help you to define and start your process at the simplest form. By the end of this chapter, you will have practiced enough of the basics to strike out on your own croquis rendering invention.

THE POSE

Rendering for croquis begins with the pose. Remember this figure; the croquis represents a frame for the fashion design statement. That fashion statement is made with the garment and a pose that complements its design features. So keep the pose simple. It is not a person but a garment that is being featured in your drawing.

Start your sketch with a strong, easy pose. The croquis pose must relay a certain (customer) attitude that works for the clothing design. For example, the croquis on the facing page is in a casual yet sophisticated pose. The attitude in this pose would complement casual or relaxed weekend city clothes.

An easy pose means that the body is untwisted. The torso can be fairly straightforward so that the center front is easy to follow, easy to locate. This pose is not complicated. It will be easy to design on, to dress.

Another key to a good croquis figure is to make sure it is "grounded" on the page. This means that it is not falling or tipping over on the page.

The balance line, dropped like a plumb line down from the pit of the neck to the floor, acts as a grounding factor. The balance line runs perpendicular to the "floor" on your page, where the croquis is standing, and keeps your frame from tipping over on the page.

Use a checklist to help you focus on creating a strong, easy-to-design-on croquis figure. This checklist will prevent you from creating a difficult convoluted pose that will interfere with your fashion design focus.

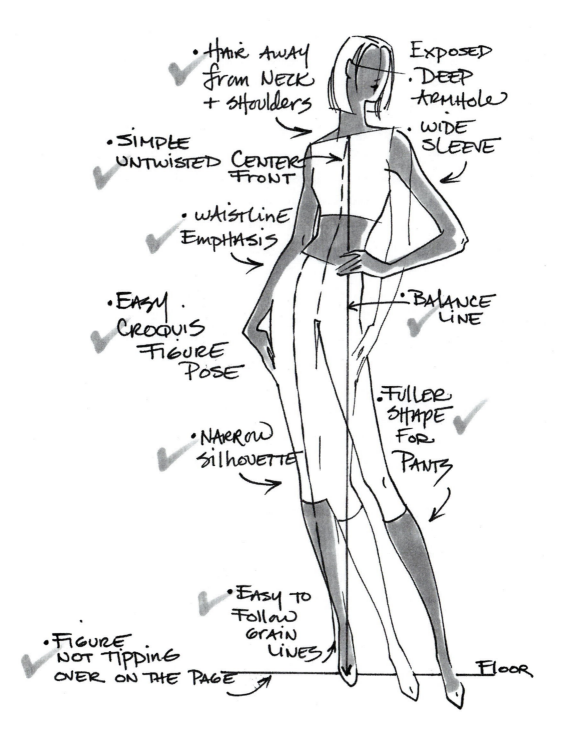

- HAIR AWAY from NECK + SHOULDERS

- EXPOSED DEEP ARMHOLE

- WIDE SLEEVE

- SIMPLE UNTWISTED CENTER FRONT

- WAISTLINE EMPHASIS

- EASY CROQUIS FIGURE POSE

- BALANCE LINE

- NARROW SILHOUETTE

- FULLER SHAPE FOR PANTS

- EASY TO FOLLOW GRAIN LINES

- FIGURE NOT TIPPING OVER ON THE PAGE

FLOOR

179

RENDERING IN GROUPS

Designer collections are often drawn as groups—as a collection of
clothes sketched on multiple figures. These figures are not in spe-
cific poses, but there is a focus on their proportions to display the
clothes to their best advantage. One of the easiest, quickest setups
for sketching a collection is to use the same pose over and over.
This repeat posing, in a row, is a fast "read." It tells the fashion
design story in an instant. This visually compelling layout is a
business function based more on information than art. It's more
about how well you design than how well you pose the figure, al-
though each skill complements the other. You create this grouping
of figures with equal body proportions, to show off the clothes, by
giving them the same ceiling and floor levels. This helps the eye to
glide across the croquis catching all of the design nuances in a
flash of recognition. Notice on the facing page some of the match-
ing proportion levels between the figures that you want to suggest
in your own drawing.

Time is always a problem. You have lots of design ideas that
you want to sketch in an instant. Sketching multiples of the same
pose is a quick solution for a time crunch. As long as it fits your
design's silhouettes, the repeated pose is the easiest to draw in
the least amount of time. It speeds up the process of sketching
while presenting a necessary framework for your fashion
statement.

180

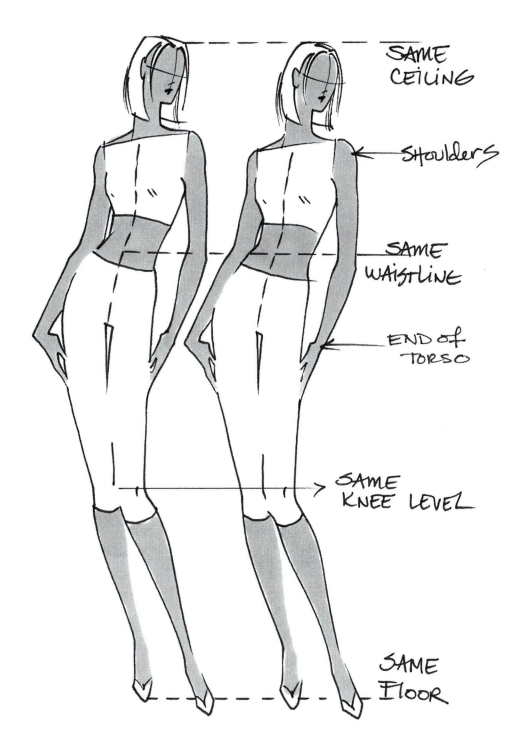

SAME
CEILING

SHOULDERS

SAME
WAISTLINE

END of
TORSO

SAME
KNEE LEVEL

SAME
FLOOR

181

SEWING LINES

Multiple poses, lining figures up in a grouping, is a natural step for fashion design. Designing collections often calls for a number of related outfits: mix and match separates or coordinating or construction treatments. It can always be done in a quick chorus line setup of figures in simple poses. These repeating poses make it easier to focus on proportions rather than dictating to the twists and turns of overworked bodies that confuse the original design focus. The concept is to show off the clothing as fresh, new, and clear. In an industry business sketch, the person wearing the clothes is secondary to that fashion statement, so always draw a croquis putting fashion first and personality second.

To keep the design concept clear, give yourself a set of sewing lines on the figure. You will automatically design on the body in regard to construction and stay focused on the fit and shape of the clothing you are sketching on the body.

Repeating the same pose—locking in the same torso position—can still offer options and the illusion of variety in the posing. While the supporting leg must be stationary, the other nonsupporting or extended leg can be repositioned. The arms also can be reposed in any number of combinations.

182

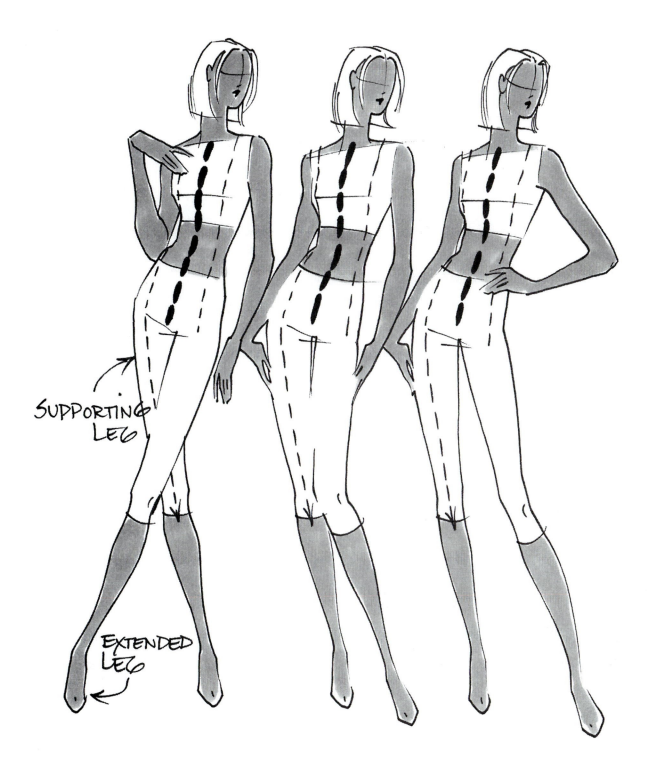

SUPPORTING LEG

EXTENDED LEG

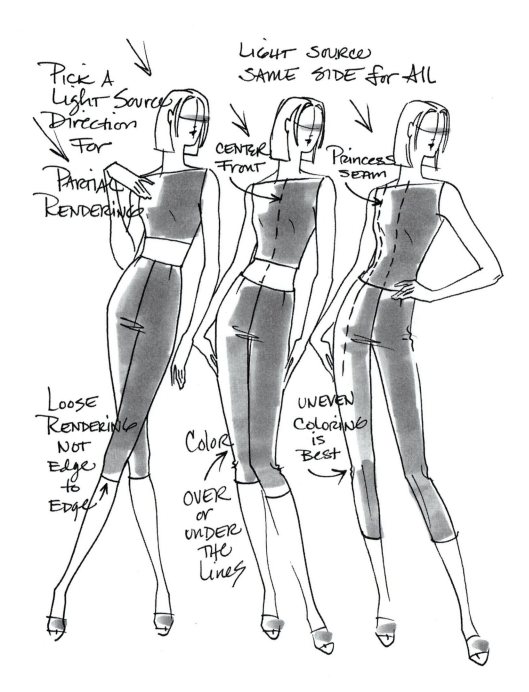

Designer croquis often have that quick loosely drawn look that is enhanced with partial rendering. Partial rendering means filling in only about three-quarters of the coloring. This saves time and still relays enough information in this unfinished but functional format.

Partial rendering should cover up to and beyond center front on a garment. Begin to break off the coloring near one or the other princess seams. Break the color in irregular steps or bend the color to reflect the contours of the body underneath the fabric. Since this is a loose rendering you do not have to color edge to edge. Not being so meticulous is the time saving technique.

184

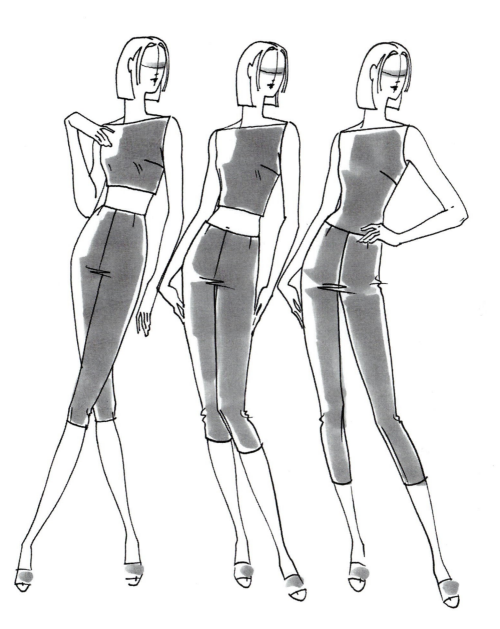

Choose one light source direction for all of the figures in the same group or on the same page. This guarantees visual continuity and sets up a regular pattern of coloring to follow across the clothes on each body. This single light source connects the partial rendering technique that repeats just as the poses do for fast visual communication.

There are two sets of partial renders on this spread. The example with the sewing lines helps you to follow the three-quarter rendering system. The other example shows you, without interior interference of sewing lines, how partial rendering in un-even strokes does not fill in the entire garment's color. This is an example of rendering that is just as important as the tighter finished techniques.

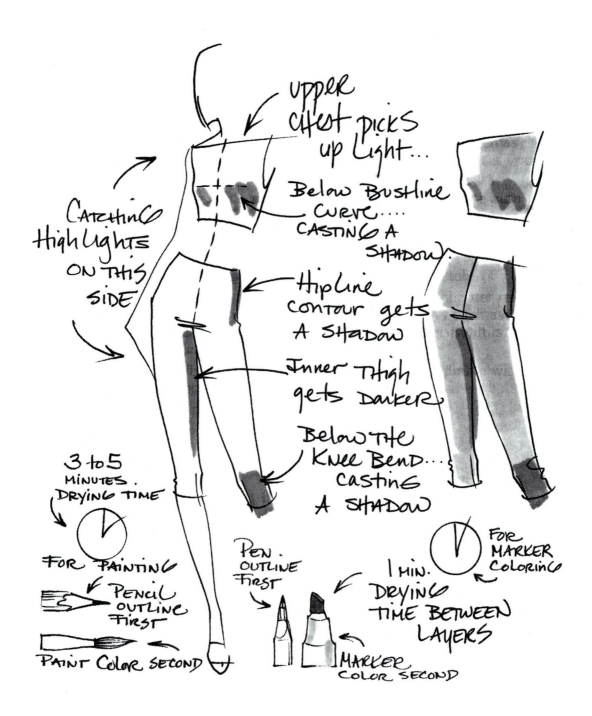

upper chest picks up light...

Below Bustline Curve.... Casting a shadow).

Catching Highlights on this side

Hipline contour gets a shadow

Inner Thigh gets Darker

Below the Knee Bend... Casting a shadow

3 to 5 minutes. Drying time

For Painting

Pencil Outline First

Paint Color Second

Pen. Outline First

1 min. Drying time Between Layers

For Marker Coloring

Marker Color Second

Shading in partial rendering for loose croquis sketches is entirely optional, often unnecessary. If you do choose to add shading, keep it looking as spontaneous as possible to match the rest of the drawing and rendering. Each step in your technique has to complement the others in equal measure.

Check out the shading placement for the example on this page. Each area has its own rationale for its specific location of shadow. Keep in mind that shading, like all rendering, is subject to design, the fit of the clothing, and the nature of the fabrics in your sketch. Each silhouette and every design nuance will be a new challenge to color.

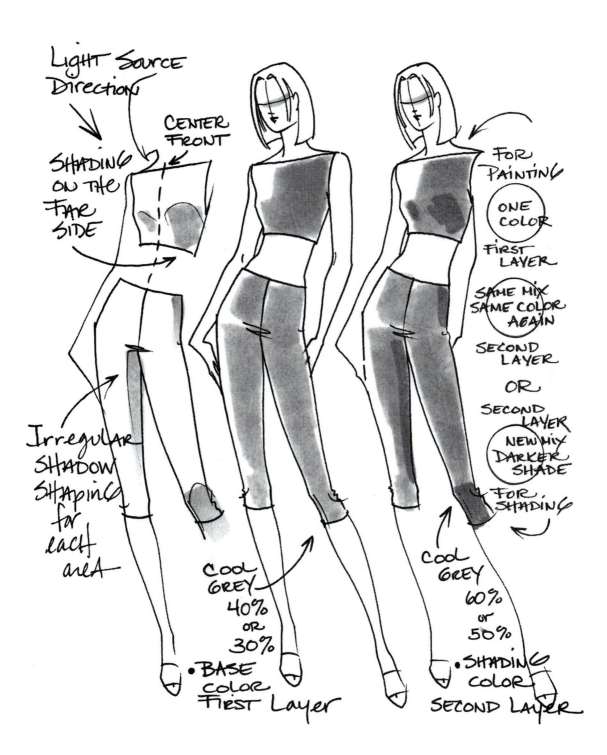

Light Source Direction

Center Front

Shading on the Far Side

Irregular Shadow Shaping for each area

Cool Grey 40% or 30%
• BASE COLOR First Layer

For Painting

ONE COLOR — FIRST LAYER

SAME MIX SAME COLOR AGAIN — SECOND LAYER

OR

SECOND LAYER — NEW MIX DARKER SHADE

For Shading

Cool Grey 60% or 50%
• SHADING COLOR SECOND LAYER

This page slows down the rendering steps. Each step is separated from the others to illustrate their differences. Still, they are both dependent on the same light source direction. There is a balance between the volume of highlighting versus the areas of shading. They are just on opposite sides with the base coloring between them.

In spite of the preplanning for this quick rendering, its goal is to appear as loose as possible. Keep in mind that your personal style of drawing is unique and may need specific approaches or solutions to create the impression of a partially rendered croquis sketch.

GARMENT DETAILING

Fashion design sketching concentrates on construction details as well as on shapes or silhouettes. The examples on these pages accentuate and emphasize specific garment detailing. Shading, as shown here, enhances the drape and adds a bit of dramatic flair to the croquis.

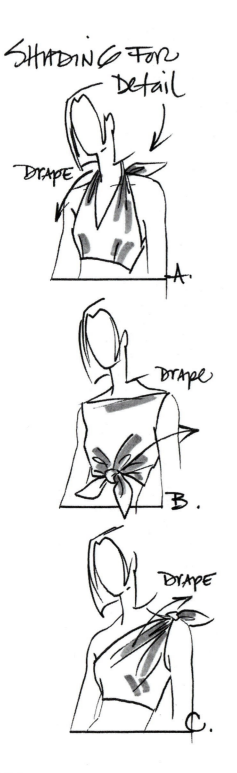

A. The design emphasis here is at the neck as the fabric gathers into a hidden knot at the back. The shading has to follow the drape into the pull of the knot, as it rolls around the neck.

B. This time the design accent is gathered into a knot just below the bustline contour. Form follows function as the shading picks up the drape on both the knot and the curving bustline. The neckline, a flatter area, can also use a gentle fold in shading.

C. Here is an over-the-shoulder knot that drapes down over one armhole and underneath the other while also reflecting the bustline curves. Shading on this croquis helps your eye to follow the fabric's shape.

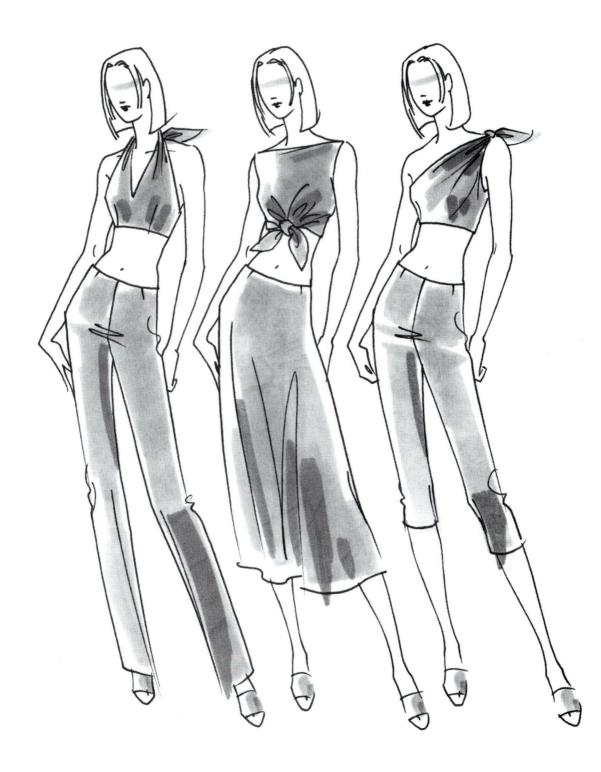

Wrapping the fabric around the form of the figure is always subject to interpretation based on style and drawing technique. Each artist has her or his own method of reaching the same goal: clarity. You want everyone else to be able to see exactly what you meant to draw. That is a successful croquis—one that needs no other explanation because its message comes across loud and clear.

RENDERING PATTERNS

After the other layers of flesh tone, hair color, and accessories, the last step in a croquis is usually rendering the print, patterns, or texture in the fabric. This final touch is done as loosely as possible in keeping with the overall presentation of a quick sketching format. Rendering a print for a croquis is done by suggestion, by mocking up the print: imitating the size, repeat, and location in a freehand manner. It doesn't have to look finished or precise; this is still an exercise in speed sketching. The easiest rendering

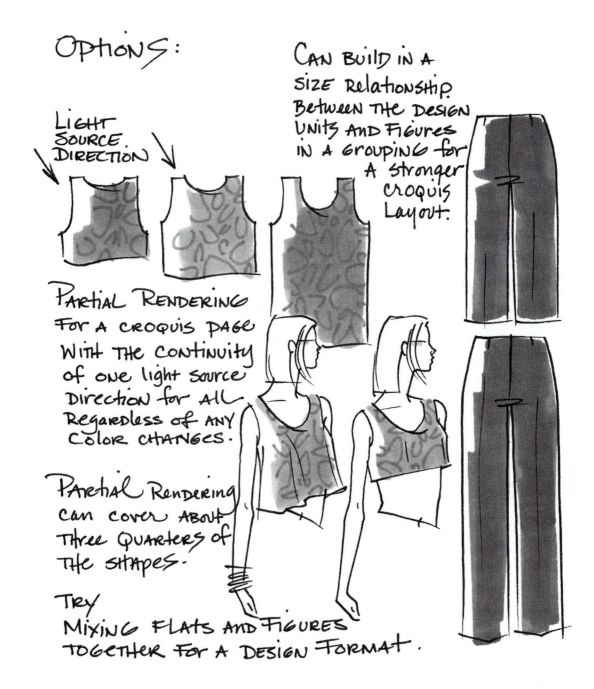

OPTIONS:

CAN BUILD IN A SIZE RELATIONSHIP BETWEEN THE DESIGN UNITS AND FIGURES IN A GROUPING for A Stronger CROQUIS Layout.

LIGHT SOURCE DIRECTION

PARTIAL RENDERING For A CROQUIS PAGE WITH THE CONTINUITY of one light source Direction for ALL Regardless of ANY COLOR CHANGES.

PARTIAL Rendering Can cover ABOUT THREE QUARTERS of THE SHAPES.

TRY MIXING FLATS AND FIGURES TOGETHER FOR A DESIGN FORMAT.

technique is to stagger the print over and across the interior sections of your base color and shading. This can look almost random as this semiplacement of the print sprinkles over your croquis figure. This final step creates a lasting dimensional impression and adds a hint of reality to your style.

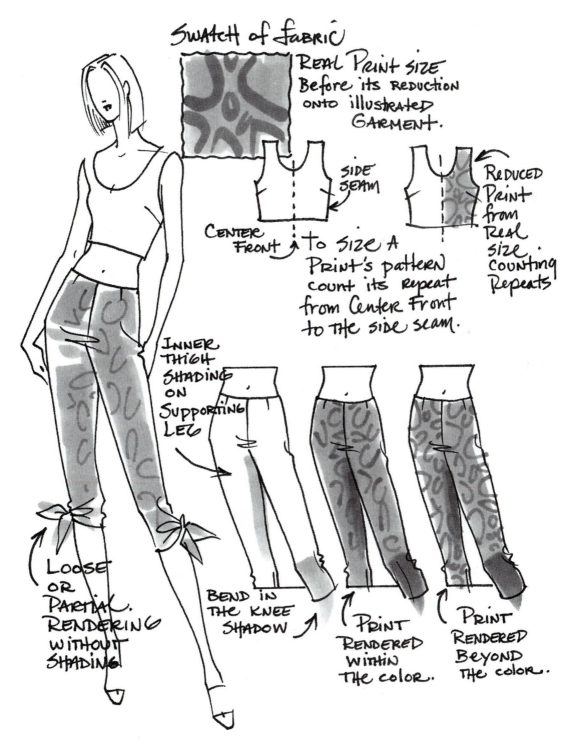

SWATCH of FABRIC

REAL PRINT SIZE Before its reduction onto illustrated GARMENT.

SIDE SEAM

CENTER FRONT

to SIZE A Print's pattern count its repeat from Center Front to THE side seam.

REDUCED Print from REAL SIZE counting Repeats

INNER THIGH SHADING ON SUPPORTING LEG

LOOSE OR PARTIAL RENDERING WITHOUT SHADING

BEND IN THE KNEE SHADOW

PRINT RENDERED WITHIN THE color.

PRINT RENDERED BEYOND THE color.

Practice drawing your own set of croquis, making them as loose and rough as you can and still be informative. Croquis have to imply style, fit, and fabrication. The rendering for croquis can abbreviate the colors, prints, and shading methods. It's all about quick results with a minimal amount of effort in a time-saving crunch. As you work under deadlines you will appreciate the speed with which this type of drawing can be produced.

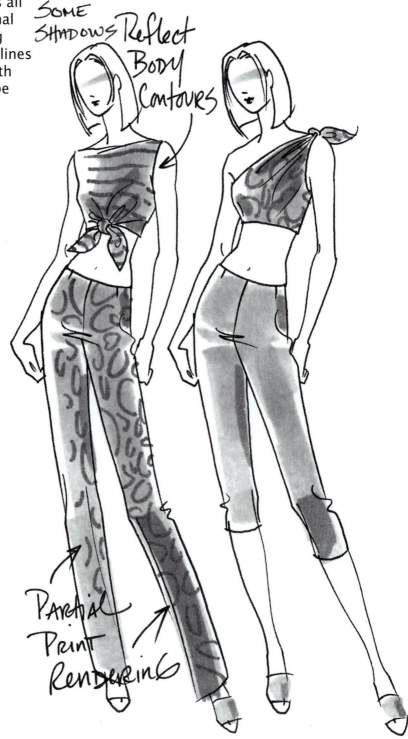

SOME SHADOWS Reflect BODY Contours

Partial Print Rendering

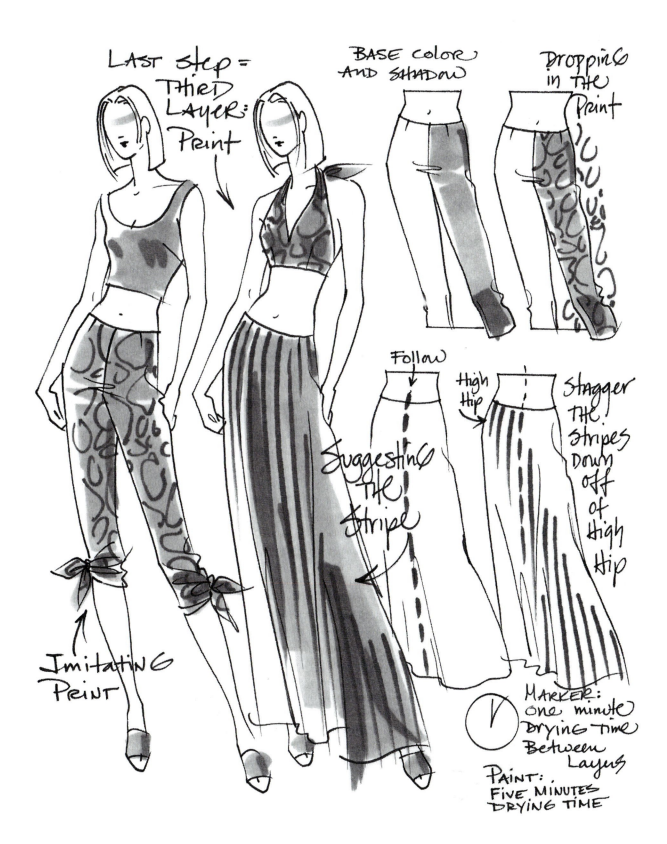

LAST step = Third Layer: Print

BASE color AND SHADOW

Dropping in the Print

Follow

High Hip

Stagger the stripes down off of High Hip

Suggesting the Stripe

Imitating Print

MARKER: one minute Drying Time Between Layers

PAINT: FIVE MINUTES DRYING TIME